Dear Oval Office Occupant:

Letters to the White House in the Age of Trump

by Kathy Hayes

CITY LIMITS
PUBLISHING

For Mom, for writing those letters to President Reagan,
and
for Chris, for everything.

EDITOR'S NOTE

In total, Kathy Hayes wrote 1,411 letters to President Donald Trump, starting on December 1, 2016. The following is a selection of more than 500 of her letters. Minor corrections for consistency, style and punctuation have been made, but otherwise her letters are unedited.

INTRODUCTION

On a chilly March day in 2018 I found myself standing in the rain in my front yard with a few friends, my 88-year-old mother and a large cardboard sign emblazoned with "I ♥ MUELLER" that was growing soggier by the minute in my cold hands. (My mother's sign simply said "RESIGN.")

It's not every day that a presidential motorcade thunders past my house in a small Ohio town, although it had happened once before, during a visit by President George W. Bush to a local union training facility. On that occasion, I stood silently as the cavalcade flew by, amazed at the sheer spectacle of it: The armed men hanging out of burly SUVs, the countless motorcycles, various support vehicles and the multiple, gleaming limousines that made it impossible to determine which one contained the leader of the free world.

This time, I was excitedly waiting to exercise my First Amendment rights in full view of the 45th president and the staff and family members accompanying him. It felt surreal to see my yard transformed into a roadside demonstration, against the backdrop of a bedsheet hanging from my porch that I had hastily painted with the word "Resist."

How did I get here?

On Election Day 2016, my daughter and son were at their respective college campuses and my husband was away on business. In the wee hours of November 9, the comments flying back and forth in our group text grew more and more distressed as it became clear that Hillary Clinton would not be the next president of the United States.

Unsurprisingly, my big-hearted kids were concerned about their LGBTQ friends — would they lose hard-won legal protections? Would they be persecuted under the new regime? Would those friends be safer

if they moved to Canada? I tried to reassure them while panic rose within me.

At work that day I felt stunned. Donald Trump simply didn't have the experience or qualifications necessary for the job. His temperament was volatile and his public pronouncements unpresidential. His staggering level of self-absorption made it seem highly unlikely that he would be able to prioritize the nation's needs ahead of his own. And what about the bankruptcies, bogus university and countless lawsuits against his businesses? What about the ugly comments about Mexicans, women and a disabled reporter?

When the initial shock passed, I felt an overwhelming urge to *do* something — anything — to counteract the toxic combination of fear, hopelessness and anger that I was feeling. Fresh out of other ideas, on December 1, 2016, I wrote him an old-fashioned paper letter, put it in an envelope with a stamp and mailed it to Trump Tower. Throughout December and into January I penned an onslaught of opinions about his tax returns, Steve Bannon, tweets, Michael Flynn, climate change, gun control and much more.

Beginning on Inauguration Day, my letter writing became a daily discipline.

On many days, I viewed my letters as tiny acts of protest made physical — tangible items that the White House would be forced to deal with. At other times, writing felt more like keeping a journal, a private way to express my grief, outrage, frustration and disappointment. I felt free to say what was on my mind without holding back, because surely, no one but a mailroom staffer would ever read what I had written. When I started receiving responses, their boilerplate language and irrelevance to my subject matter only confirmed my suspicion that no one at the White House actually cared about citizens' correspondence.

Like many Americans, my history of civic engagement is mixed. I have voted in most elections, but admit that I've skipped a few in non-presidential election years. I generally have paid attention to the news, but there have been periods when life was difficult and I checked out for a while. I hardly ever attend Village Council or school board meetings. On the other hand, I was active in a grassroots group formed to pass a school levy in our community and have, on occasion, written to other elected officials and to the local newspapers.

As I wrote, and wrote and wrote some more, the powerlessness I had felt about our nation's troubles began to slip away. I started signing petitions, attending demonstrations and calling Congress. My husband and I got some friends together and formed a group to promote tolerance and stand up against hate. That group asked local governments to publicly state their support for diversity and inclusion by passing tolerance resolutions, which a few of them did. I began to think of myself as an activist, someone who might make a bit of a difference in the world.

When the local police notified me that I would be unable to enter or exit my driveway for several hours on the day of the presidential visit, I knew that fate had given me an opportunity I couldn't ignore. That day the motorcade passed by twice — once on the way to the venue where the president was speaking, and once on the return trip to the airport. At the end of the day, damp, but exhilarated, our little band of demonstrators marveled that surely someone in those limousines, maybe even the president himself, had read our signs.

When Trump was elected, I could have tuned out, given in to apathy or turned bitter. Without fully realizing what I was doing, I made different choices.

I chose to struggle to make sense of the daily news and a presidency like no other. Sometimes I failed in that struggle — I was unable to

see the big picture as I drank from the firehose of daily news. I chose to document increasingly bizarre events, presidential statements and behavior, which forced me to pause and recognize that *this is not normal.* I chose to persist, despite the challenges that all of us face at one time or another — a bout of flu, worries over tuition payments, hard days at work and caring for sick pets. The time I came closest to giving up was when the death of my dog in 2017 sidelined my letter writing for two devastating days.

I chose to listen to the voices of immigrants, religious minorities and people of color and to recognize with shame how little I knew of their experiences and how my path through life has been made smoother by my white skin and Christian faith.

And while this project has changed me in some ways (I know that I can never be complacent about our democracy again), in one way, I consciously chose NOT to change. My parents had taught me by word and deed that I should never hate another human being. In my mind, I can still hear Dad saying to my aggrieved, elementary-school self: "Hate is a very strong word, Kathy." As I wrote, I grappled with rising feelings of hate and ultimately won, mentally drawing a line between this pathetic, dangerous man and his actions.

Where would I be if I had not sat down at the computer that December night four years ago? Who would I be? Would I have blithely ignored the turmoil and lies of this administration as I went about my day-to-day life? Would I have filled my time with a new hobby — photography, perhaps — to better block out each day's unsettling news? I'm glad I don't know the answers to those questions. On that cold and bleak night, I thought I was composing a message to the president-elect, but I was really beginning a journey through the four most tumultuous years our nation has seen in my memory.

I have learned never to underestimate the power of writing a letter.

January 20, 2017

President Trump,

Here's your chance. Try hard not to be a fascist dictator, ok?

January 22, 2017

President Trump,

You have got to be kidding me. You trotted Sean Spicer out for the administration's very first "press conference" and he spent most of his time talking about the size of the crowds at the inauguration and lying about the details. He invented motivations for journalists' actions and told them what subjects are fit for their coverage. He angrily proclaimed that no one had numbers for how many witnessed the inauguration and then claimed it was the largest audience ever to witness an inauguration, thus neatly contradicting himself. He refused to take questions from journalists, who were there to ask questions on behalf of the American PEOPLE.

All of this is disgusting, petty and, most importantly, a completely unnecessary trip into the weeds by your administration, which quite frankly, has a lot of work to do, especially since your transition team appears to have been woefully unprepared for your first day at work as our employee. If you can't focus enough to do your job, you will be fired.

January 24, 2017

President Trump,

I suggest that you hire some new speech writers and fire the ones who wrote your inaugural address. They failed on many levels.

The tone was dystopian, depressing and uninspiring. Instead of focusing on the hard work, resilience and passion of the American people, your words painted a picture of a nation in ruins. FYI, America is already great, and we can all work to make it even greater.

You missed a vital opportunity to reach out to citizens who feel threatened by your campaign rhetoric.

The speech featured unintended irony, such as "We will follow two simple rules; buy American and hire American." (The irony is that your businesses have routinely chosen to both purchase foreign goods and manufacture products overseas.)

The speech writers seemed unaware that you are no longer campaigning to your base, you are leading the entire nation. And, they chose to continue to use the phrase "America first," words that are tainted with a history of anti-Semitism. What an ugly message to send to the world.

If you really believe that January 20 "will be remembered as the day the people became rulers of this nation again" then I suggest you listen to us. We want clean air and water. We want clean, renewable energy. We want affordable health care. We want a nation that engages with the world in positive ways to make it a better place. We want fair treatment of immigrants and minorities. We want a country free from harassment and hate crimes. We want an end to gun violence. We want better care for our veterans. We're willing to work for those things. Are you?

Dear Oval Office Occupant

January 28, 2017

President Trump,

I won't mince words: The executive order you signed on Jan. 27 is a Muslim ban in everything but name. It is vile, un-American and, as I'm sure the courts will prove, unconstitutional. It is telling that while no one from any of those now-forbidden countries has carried out a fatal attack in the U.S. during the last 20 years, you chose to continue to allow immigration from Muslim-majority countries that *have* produced such terrorists — notably countries where you have business interests, or have recently pursued business deals. We're not stupid; we can see what you are up to.

Meanwhile, the tragedy in Syria continues, and now women and children fleeing for their lives are refused admittance and have nowhere to turn. Chaos has ensued as thousands of travelers around the world have been put into legal limbo. U.S. congregations preparing to welcome refugee families are now forced to abandon their efforts. And our allies will have no choice but to welcome even more immigrants and will surely resent that we are not doing our part.

The United States of America once inspired these words:
"Give me your tired, your poor,
Your huddled masses yearning to breathe free,
The wretched refuse of your teeming shore.
Send these, the homeless, tempest-tost to me,
I lift my lamp beside the golden door!"

Thanks to you, our nation is no longer worthy of those words, or the monument that bears them.

February 3, 2017

President Trump,

Army Reserve Capt. Allen Vaught served in Iraq in 2003 and 2004, where he had the pleasure of working with a brave Iraqi man whom Vaught refers to only as "Sam" to protect his identity. Why must Vaught protect Sam's identity, you might ask? Because Sam, after serving the U.S. faithfully, and at great personal danger, was on the brink of traveling to the U.S. with his family to start a new life. Your travel ban quashed that plan, and put Sam's life at risk. Militias and Islamic State terrorist groups hunt down translators like Sam. He and his family might not survive the 120 days of the ban. If they do, it is unclear whether they will have to start the process over again and endure further hazards while waiting.

As I have pointed out before, your hastily executed, un-American and immoral travel ban will cause the death of innocents, including staunch supporters who deserve our aid in their time of need. Blood will be on your hands. You have shamed our nation before the world. It's time for you to reverse your executive order and resign immediately thereafter.

February 4, 2017

President Trump,

I'm just another real American who is still waiting for you to release those tax returns, just like you promised on numerous occasions. Some of those promises didn't even carry the caveat that you were waiting for the IRS audit to be complete, so that can't be the excuse for your tardiness. I'm sure you should be eager for me to see them, because they show that you are worth billions and billions of dollars, and give heavily to charity, and pay millions of dollars in personal income tax every year, right?

February 6, 2017

President Trump,

You are not going to build a wall. Mexico is not going to pay for it. The American people are not going to pay for it. We don't have billions of dollars to waste on such folly. Perhaps you should focus on reducing American demand for illegal drugs if you are so worried about drug dealers and their wares coming into the country. They wouldn't bother crossing the border if no one was buying what they are selling.

February 9, 2017

President Trump,

As your boss, I feel that I must bring a sartorial matter to your attention. I expect my public servants to be neat and tidy at all times when they are on the job. You routinely fail to button your suit jacket even on the most solemn and important occasions. This looks sloppy, and also conveys a certain aura of disrespect when you are appearing at a memorial or meeting a foreign dignitary. Please take more care with your appearance when you are conducting business on my behalf.

February 15, 2017

President Trump,

Russia is on my mind. Members of your campaign staff were in contact with Russia before the election. Russia attempted to influence the U.S. election in your favor. Flynn was in contact with a Russian diplomat on the day that Obama imposed sanctions. In the past, you and your family have discussed your many business ties with Russia. Tillerson has

business ties with Russia. When President Obama imposed sanctions and kicked Russian diplomats out of the country, Russia didn't immediately retaliate. Now Russia is flexing its muscles to see what it can get away with and you … do absolutely nothing.

Even an idiot can connect the dots; something sinister is going on. In these situations, it's usually a good idea to follow the money. Only we can't follow all of the money involved, because we don't have your tax returns. Now I know that those returns contain some very damning stuff. For some time I've been thinking that you would be impeached. Now, I think it's likely that you will see jail time. I suggest that you resign now.

February 20, 2017

President Trump,

You know who holds campaign-style rallies after they're elected? Dictators, that's who. I'm not paying you to attempt to satisfy your insatiable appetite for adulation with unseemly and ridiculous rallies. I'm paying you to do your frigging job. Your jaunts to Florida and frequent golf outings are also a waste of my money, as well as being deeply ironic, considering your criticisms of President Obama's golf habits.

Here's my preference: Resign so that you can spend all of your time golfing on your own dime. Vice President Pence is a stable adult whom I would trust with the nuclear codes. You, however, can't be trusted to even understand the basics of what you see on TV, hence your ludicrous "Sweden" comment. The rest of the world is laughing at us because of you.

February 21, 2017

President Trump,

Are you going to apologize to Jake Turx of *Ami* magazine? Your behavior was inexcusable.

February 22, 2017

President Trump,

America's insatiable demand for illegal drugs fuels gang violence in Latin America. That violence sends desperate, innocent people fleeing to the U.S., whether they can enter legally or not. Others suffer in crushing poverty and undertake the dangerous journey to the U.S. with the hope of a better life.

Building a wall is not the answer. Breaking up families and shattering communities is not the answer. Deporting desperate new arrivals is not the answer. Understanding why people come here and reforming our immigration system accordingly is the answer. We are stingy when granting asylum. We need to streamline the process for becoming a legal resident. We need a practical path to legal residency or citizenship for those who are already here and doing their best.

Our economy is intertwined with the labor of the millions of hard-working, undocumented immigrants who harvest our food, clean our workplaces, cook our meals and do thousands of other essential tasks. They pay taxes and purchase goods and services. These are human beings. They have names. They have mothers. They have children. They pray, and sleep, and eat, and work, and suffer, and love, and cry. They are not "illegals," they are people, most of whom have broken only one

law in a desperate bid to escape poverty, violence or even death, and become part of the fabric of this great nation.

Have you heard their stories? Have you heard about Guadalupe García de Rayos? She came here as a child and got a bogus Social Security card so she could work. Now her children — U.S. citizens — are without their mother, and she has been deported to Mexico, where she is a stranger. You would do well to look into the stories of the other families that have been ripped apart since you have taken office.

I acknowledge that some people who come here are drug dealers. Yes, they need to be kicked out. But we need to recognize that they wouldn't come here with their deadly wares if we weren't buying. Comprehensively addressing our drug addiction problem is an essential step in keeping criminals from crossing the border. Focusing on treatment, rather than punishment, for drug addicts is the compassionate, moral choice. It's also opposed by the for-profit prison industry. Locking up sick people is a real moneymaker, so I'm sure that you are in favor of it. The love of money is the root of all evil.

February 24, 2017

President Trump,

I am writing to express my outrage at the treatment of Sara Beltran-Hernandez at the hands of Immigration and Customs Enforcement on February 22 in Fort Worth, Texas. Beltran-Hernandez, an undocumented immigrant from El Salvador, was at Huguley Hospital awaiting brain surgery when ICE agents bound her hands and ankles and removed her to a detention agency in Alvarado, Texas. This is a desperately ill woman in need of life-saving surgery. Detaining her is inhumane, cruel, disgusting and certainly in violation of international humanitarian agreements.

Dear Oval Office Occupant

I demand that Beltran-Hernandez be released immediately and that you issue an apology.

For the love of God, aren't there some legitimately dangerous people upon whom ICE agents can be focusing their efforts? Bullying a desperately ill woman does nothing to make our country safer, and is the sort of action that lowers our standing among other nations. Your policies, crude rhetoric and the actions they inspire are making America less great every day. I demand that you resign.

February 27, 2017

President Trump,

Here's what you said today: "I have to tell you, it's an unbelievably complex subject. Nobody knew that health care could be so complicated." Actually, everyone except you already knew this. Now that you're up to speed, perhaps you will recognize that overly simple proposals that sound good on the campaign trail are not the same thing as real-world solutions. Don't be the guy that makes 20 million people lose their health care coverage.

March 5, 2017

President Trump,

We can draw some interesting conclusions from your most recent tweets concerning President Obama's supposed wiretapping of your tower.

1. If the federal government did indeed electronically monitor your premises, then the FBI must have found some very compelling

9

evidence that convinced a judge that there was probable cause. In this scenario, you are probably screwed, because that means there is an investigation underway that is very, very likely to reveal illegal shenanigans on the part of you or your associates.

2. If your accusations are false, which is the scenario I would bet money on, then you have just provided the most compelling evidence yet that you are delusional and wholly unfit for your office.

A couple more observations: This looks like a last-ditch, desperate effort to distract the American people from the Russian scandal and your imploding presidency. It's not going to work. Additionally, the method in which you decided to inform the public of this alleged wiretapping scandal (Twitter) further undermines your credibility. If you were qualified to perform your job, you would have recognized the extreme gravity of the accusations, and would have presented them to the American people in a formal speech, along with all the requisite evidence, in the presence of the heads of the various government agencies that supplied that evidence. But that evidence doesn't exist, does it? Once again, I must ask you to resign immediately.

March 7, 2017

President Trump,

Today CNN.com reported about the detention of an Afghan family that arrived in Los Angeles on March 2 with special immigrant visas, which they received because their lives were in danger due to the father aiding American forces in Afghanistan. Despite their special visas and the lengthy vetting process they endured, they were detained by federal authorities and held for four days. The father was separated from the family, and the mother, who does not speak English, was left to care

for her three small children alone. They were initially denied access to legal counsel. ICE and Customs and Border Protection have given no explanation for their detention. Thankfully, due to the work of civil rights lawyers who intervened on their behalf, the family, whose identity has not been revealed because of privacy concerns, was released.

It is horrifying to imagine what this family suffered in their home country, and to think of the danger they endured because the father helped our troops. They waited years to come to safety, making an arduous journey with small children. They must have been tremendously relieved upon landing in the U.S., knowing that their permanent home was only one short flight away. And then, the "land of the free" turned on them. It must have been terrifying, confusing and inexplicable.

I can't help but conclude that ICE and CBP agents are overzealous as a direct result of your executive orders, policy statements and inflammatory rhetoric demonizing immigrants, refugees and foreigners. For those reasons and by virtue of your position as president, you are culpable for the disgraceful way this family was treated. As your employer, I insist that you order a thorough review of ICE and CBP policies and training procedures for their agents. I also demand that you order an investigation into this specific incident. Furthermore, the family deserves a formal apology from you as well as from the heads of ICE and CBP. I am eager to hear of your prompt attention to this serious matter.

March 8, 2017

President Trump,

Regarding your tweet on the occasion of International Women's Day: You're asking ME to join YOU in honoring women? Wow. Please let me know when you actually do something substantive to honor women so I can jump on board. Here are a few ideas.

Don't infringe on women's rights to make health care decisions for themselves.

Stand up for equal pay for equal work.

Make sure that girls have equal access to education in STEM.

Support common-sense gun regulations; women are especially vulnerable to gun violence, particularly from domestic abusers.

Don't cut U.S. humanitarian, health and educational aid to vulnerable women around the world, including providing contraceptives and fighting to end child marriage and female genital mutilation.

Promote a culture that respects women. Fight against sexism, harassment, rape and rape culture.

Protect the environment; climate change affects women and children disproportionately.

Publicly apologize to the women you groped or otherwise demeaned.

March 13, 2017

President Trump,

When I was a kid and my family was gathered around the dinner table, my mom or dad or one of my older siblings would present the "word of the day." This was typically an unusual word, or a word that was particularly interesting or pertinent to what was happening in our lives or in the world. I'm sure my mom's intent in instituting this practice was to build our vocabularies, but it also made for some great family discussions. In light of the beneficial effects this custom had on me, I am hereby declaring that your word of the day is "compassion."

Dear Oval Office Occupant

Webster's New Collegiate Dictionary, the 1979 edition, which I received as a prize for winning my school's spelling bee in the same year, defines "compassion" as "sympathetic consciousness of others' distress, together with a desire to alleviate it."

I think that a great many of your problems, and the problems you have inflicted on our country, stem from your seeming inability to feel compassion. This inability is the central characteristic and crucial failing of narcissists and sociopaths, the thing that makes them so toxic and destructive to anyone around them. On the off chance that you are not a narcissist or sociopath (personality types almost entirely incapable of change), I recommend you seek psychiatric help so that you can begin to feel compassion on a regular basis. I'm sure this would be a lengthy, time-consuming process that would involve delving deep into whatever happened in your childhood to make you so callous and unaware. So that you can have more energy and time to devote to therapy, you should resign. This would also have the happy result of benefiting the entire nation.

March 14, 2017

President Trump,

Your word of the day is "decorum." Webster's New Collegiate Dictionary defines it as: "propriety and good taste in conduct or appearance." I consider decorum to be a critical attribute of the president of the United States, vital for conducting the nation's business. Having decorum means knowing how to act in all circumstances. Unfortunately, decorum is just one of many essential presidential qualities that you are sorely lacking. Therefore, once again, I must ask you to tender your resignation so that a qualified, decorous person (Mike Pence) can take over. I eagerly await news of your resignation.

March 19, 2017

President Trump,

Your word of the day is "charlatan," which Webster's New Collegiate Dictionary defines as "one making usually noisy or showy pretenses to knowledge or ability: Fraud, faker." Perhaps I'm the first to break it to you, but people are howling with laughter when you say things like "I know more about ISIS than the generals do." These types of ridiculous, empty brags are so transparently the product of an insecure, narcissistic windbag that it would take an unusually obtuse person to believe them.

In your heart of hearts, you know that you are in no way competent for your job, and your overblown statements about your abilities and knowledge only advertise your insecurity. The longer you stay on the job, the deeper you dig yourself into a hole because you simply don't know what you are doing. The only reasonable course of action is for you to resign. Fake a health crisis if you must, but it's time to let someone of sound mind do the job.

March 20, 2017

President Trump,

Your word of the day is "hypocrite," which Webster's New Collegiate Dictionary defines as "one who affects virtues or qualities he does not have: Dissembler."

I have noticed that you are spending a lot of time golfing, and spending my money going to Mar-a-Lago, staying at Mar-a-Lago and returning from Mar-a-Lago. Yet you loudly proclaimed that, if elected, you would hardly ever leave the White House because you would be working so

hard. You also publicly criticized President Obama for his periodic rounds of golf and expensive vacations. Yet, there you are, burning through the country's money at an alarming rate as you go to and from your favorite haunt. You are on pace to easily spend as much on your vacations and golf trips in a year as President Obama did in eight years. You, sir, are a hypocrite.

Why not try honesty for once? Just tell the American people why you really wanted to be president. We know that it wasn't out of a sense of duty or a desire to serve your country. Power and personal financial gain are the real reasons. But you, being a hypocrite, aren't a big enough man to say so.

March 30, 2017

President Trump,

I was delighted to hear today that Flynn has offered to testify in exchange for immunity from prosecution. While I think that Flynn likely belongs in a jail cell, I welcome this new development and hope that the appropriate authorities accept the deal, so that we can all hear what he has to say about your cozy relationship with Russia and its election hacking.

Over the decades you have avoided jail time for your fraudulent university, for discriminatory housing practices, for bilking contractors and groping innocent women. But at last, I believe, your misdeeds are catching up with you. You are not above the law. And even if Flynn doesn't have the goods on you, others will come forward who do. Your presidency, which was quite pathetic to begin with, is unraveling. Do us all a favor and resign, so we can start putting the country back together again.

April 1, 2017

President Trump,

I am writing to vigorously protest the deportation of Jose Escobar, who arrived here in the U.S. legally as a teenager, fleeing the aftermath of a devastating earthquake in 2001. Due to an inadvertent paperwork error on the part of his mother while he was still a teen, his protected status expired. This 31-year-old is a husband and the father of two young children who are American citizens. He has no criminal record. He was trying to do the right thing, and had acquired a temporary reprieve from deportation and a work permit. He followed the rules and checked in with immigration officials annually. On Feb. 22, when he showed up for his routine appointment, he was detained and subsequently deported.

For the love of God, don't ICE agents have some actual criminals they can focus on? I know that the answer is yes, but your purpose isn't to use limited ICE resources efficiently and for the public safety; your purpose is to create fear.

Ripping apart families like this is cruel, inhumane and contrary to the principals on which this country was founded. The Republican party used to tout itself as the party of family values. What a disgrace you and the party have become. Ronald Reagan is probably spinning in his grave.

Escobar's family fled disaster and created a new life here. Until recently, their lives embodied the essence of the American Dream. Our country used to stand as a shining hope for those who suffered and dreamed of a better life. Now, thanks to your policies, we are a disgrace.

I insist that you take the necessary steps to reverse Escobar's deportation, issue an apology to him and resign.

April 2, 2017

President Trump,

Your proposed budget has drastic cuts that essentially eliminate environmental protections for the Great Lakes. This is moronic, shortsighted and not in the national interest. The United States is blessed with the largest single source of fresh water on the planet; it is a treasure without price. At least 40 million people depend directly upon the Great Lakes for drinking water.

I, like millions of others who care about the Great Lakes, will make sure that Congress is fully aware of our opposition to this particular aspect of your proposed budget. I have a feeling your budget proposal is going to be another huge failure for your administration, as well it should be.

April 4, 2017

President Trump,

I'm still waiting to see those tax returns, buddy. With the web of Russian connections growing ever thicker, I would think you would want to release them to put everyone's minds at ease, right?

April 9, 2017

President Trump,

Despite everything you are doing to distract and confuse the populace, particularly your wild and unfounded accusations of wrongdoing by Obama administration officials, I am keeping my eye on the ball.

I believe there is something impeachable lurking in the tangled web of relationships between you and Russia. Your conflicts of interest resulting from your business activities are becoming even more blatant. And the outrageous nepotism in the West Wing is despicable.

I believe it is in the best interest of the American people for you to resign immediately so as to avoid a prolonged legal battle to remove you from office. The sooner you are gone, the sooner we can achieve some degree of stability and integrity in the White House, which will allow our government officials to focus on the most critical issues of the day, instead of batting cleanup after your ridiculous and delusional pronouncements.

April 10, 2017

President Trump,

Once again, our nation has to endure a tragic shooting. A man with a history of domestic violence killed his wife, a student and himself in an elementary school in San Bernardino. Shootings like this are extreme rarities in many parts of the world, yet they happen here with shocking regularity.

There is bipartisan support in Congress for legislation that would prevent domestic abusers from getting guns. I urge you to push Congress to close gaps in our laws that allow domestic abusers and stalkers to get guns. In the majority of mass shootings, an intimate partner or family member of the shooter is the target. Almost two-thirds of the victims of mass shootings are women and children. This is a women's health issue. This is a public health issue. Speak up. Do something.

April 12, 2017

President Trump,

Put down the phone. Stop tweeting. You are making the world more dangerous and less stable. Incredibly delicate and complex issues of international relations cannot be appropriately handled via tweet.

Specifically, I'm referring to your April 11 tweet in which you said "North Korea is looking for trouble. If China decides to help, that would be great. If not, we will solve the problem without them! U.S.A."

Sir, one of your biggest failings is that you have no conception of the depth of your ignorance. The rest of the world reads your tweets and cringes at your stupidity. Just stop. Resign. You don't really want to be impeached, do you?

April 18, 2017

President Trump,

Buy American? Let's all start by not buying Trump products made overseas.

April 19, 2017

President Trump,

I am writing to strongly protest the deportation of Maribel Trujillo Diaz. As you well know, Mrs. Diaz was continuing to seek amnesty from drug violence in Mexico. She is the mother of four young American children. Her deportation — without the opportunity to say goodbye

to her children — is cruel to them in the extreme. Enforcing the letter of the law in this case is HARMING AMERICAN CHILDREN. Mrs. Diaz is a pillar of her community, exactly the kind of person our country needs.

A good leader knows when to exercise mercy. It is an extreme understatement to say that you are not a good leader. You had the power to stop this and you did not. Furthermore, you are actively promoting this sort of nasty and inhumane action on the part of ICE. Shame on you. You are a disgrace to this country. I demand that you: Take the necessary steps to have Mrs. Diaz returned to the U.S.; issue an apology to her and her family; and resign.

April 22, 2017

President Trump,

Today I marched for science in Cleveland. I marched to support science-based decision-making in our government agencies. We need a robust EPA. We need a robust CDC. We need funding to keep the Great Lakes healthy. The future of our citizens, country and planet depend on good data and well-informed policies, laws and actions.

I know my plea is falling on deaf ears, but let the record show that I stood up for what is right. You have demonstrated that you are ok with raping the planet, poisoning our water and leaving future generations with a barren wasteland, as long as you and your cronies get your money and power now. Once again, I have no choice but to ask you to resign before you do any further damage to our home.

April 23, 2017

President Trump,

Again I must express my outrage at the role your daughter and son-in-law are playing in your administration. If President Obama had done anything similar, you and all those Republican invertebrates in Congress would have been rioting. It is wrong. You are not founding a dynasty. I'm not going to ask you to kick them out and hire someone unrelated to you because what is really needed is your immediate resignation. You are already the worst president in the history of our country.

April 26, 2017

President Trump,

Our national monuments are treasures. Leave them alone. The presidents who created them knew what they were doing and had the nation's best interests at heart.

April 29, 2017

President Trump,

So you miss your old life, do you? Well, I miss my old life too, when I could sleep at night knowing a grownup was in charge of our military. I miss my old life, when I knew that the president was working to protect the Earth for future generations. I miss my old life, when the president never conducted international diplomacy via Twitter. If you miss your old life so damn much, I suggest that you return to private life immediately.

May 8, 2017

President Trump,

Climate change is real, and we are the cause. We are on the brink of destroying the world for our descendants. Please continue U.S. participation in the Paris climate accord. Also, please resign.

May 9, 2017

President Trump,

Have you ever considered being kind? You should try it some time. You would make better decisions if you stopped thinking about yourself and put other people's needs first. Also, please resign.

May 10, 2017

President Trump,

I think we must be getting close to the heart of the matter now. Rest assured, even though you canned Comey, the truth will come out regarding your campaign's involvement with Russia. I wouldn't be surprised to hear that you personally colluded with the Russians to interfere with the election. Heck, you publicly encouraged Russia to hack Secretary Clinton's emails; that statement alone skirted with illegality. Your administration is going down in flames. Resign now to save us the trouble of impeaching you.

May 17, 2017

President Trump,

 Some advice for your upcoming trip overseas: Stick to the script. Listen more than you talk. Learn how to pronounce the names of dignitaries you will meet (it may be a surprise to you, but people take umbrage when you mispronounce their names). Don't tweet. Show the proper amount of respect at sacred sites and memorials by appearing to quietly reflect upon their meaning (I know that you won't actually be reflecting). One last thing: Don't grab anyone by the pussy.

May 20, 2017

President Trump,

 Your anti-women policies are sickening. Literally. Women will get sick and die because of your appalling health care bill, your opposition to Planned Parenthood, your defunding of the U.N. Population Fund and your cuts to foreign aid programs helping women worldwide. I guess I'm not surprised. You have a history of cheating on your wives. You bragged about groping women without their consent. You were known for lurking about the dressing rooms at beauty pageants. You see nothing wrong with publicly mocking women for their appearance. Your lack of respect for and antipathy toward women is glaringly obvious and deep-seated. In other words, you in no way can represent the interests of more than half the population of this country. And you are doing great harm to women and girls at home and abroad. Resign.

May 29, 2017

President Trump,

You may wonder why so many have so little faith in you. I am reminded of the Maya Angelou quote: "When someone shows you who they are, believe them the first time."

Decades ago, you discriminated against minorities when renting your properties. You cheated on your wives in a very public fashion and showed no remorse. You created a shady university that left people poorer, but with no new skills. You bilked contractors. You mocked a disabled reporter. You bragged about groping women without their consent. You praised the physical assets of your own daughter. You have lied so consistently and frequently in public that no one can keep track of all the falsehoods. You contradict yourself with alarming regularity. You publicly mock women for their appearances. You show no intellectual curiosity and appear to have little interest in or understanding of U.S. history. You are unable to stop tweeting.

In other words, you have shown us a thousand times over just exactly who you are. I believe I am well justified in having no belief whatsoever that you can do your job well, or even adequately. As one of your employers, I heartily encourage you to resign immediately.

May 31, 2017

President Trump,

Please stop using Twitter without supervision.

June 2, 2017

President Trump,

I am protesting the detention of Felix Yulian Motino, a Honduran national who has lived in the United States for 12 years. He is married to an American citizen and is the father of two American children. He has no criminal record. He pays taxes. He pays child support. He wanted to do the right thing and voluntarily came to U.S. Immigration and Customs Enforcement offices in Cincinnati to begin the process for obtaining legal status, where he was promptly detained.

Detaining and deporting this man will deprive his American children and wife of their breadwinner. It will deprive U.S. coffers of tax revenue. It will deprive the community of a productive, hard-working member. It will deprive our nation of a man eager to embrace this country as his home.

Federal agents need to focus their efforts on undocumented immigrants who have committed serious crimes such as robbery, assault, drug trafficking and murder. I don't want my tax dollars spent on this offensive attack on decent people struggling to become part of the American Dream. Your policies make me sick. Resign.

June 8, 2017

President Trump,

Your presidency is a disaster in so many ways, but I do think there is a silver lining. An army of ordinary citizens has been stirred from complacency. We are running for office. We are holding our elected officials accountable. We are marching, holding protests, signing petitions and

writing letters to the editor. We are creating ballot initiatives. We are subscribing to newspapers, reading the Constitution and attending city council meetings. Some of us, myself included, have formed grassroots groups. I am horrified at the rise in incidents of hate and intimidation since your election. I am horrified at the atmosphere that you fostered, which has made hateful people feel free to act out against others. That horror led to the creation of my group, which is standing up against hate in our town and state.

My own personal silver lining is this: My community is filled with people who love their country and are willing to publicly stand up for what is right. They are willing to denounce hate and intimidation no matter its source, even if that source is the person occupying the Oval Office. Each one of these people is a far better citizen than you could ever hope to be. You don't deserve your job. You don't deserve to represent these fine, upstanding, caring, dedicated patriots. It's time for you to resign.

Author's note on the June 8, 2017, letter

In the first couple months after the election, my husband and I grew increasingly troubled by the president's bigoted rhetoric and numerous news reports of people engaging in racist and hateful behavior. Feeling we should do something, but not sure exactly what, we gathered with a dozen friends and brainstormed. One idea that emerged was lobbying local governments to publicly affirm their support for diversity and denounce hate.

In the case of my small town, this turned out to be rather easy because the mayor and Village Council president immediately loved the idea, which also was supported by our church congregation, an important part of the community for 200 years. In April 2017, the Council issued a formal resolution entitled "Embracing Diversity and Denouncing Activities of Hate, Intolerance and Intimidation."

A tolerance resolution has no teeth; it can't stop anyone from being a racist or saying horrible things. But, as this presidency has progressed, I have become keenly and painfully aware of how much our leaders' words matter, how much they can influence public discourse and behavior. I am grateful that, at the request of a few citizens, our town's leaders made their position crystal clear.

That early success, the kinship I found in our group and the knowledge that countless individuals and groups across the nation also were hard at work tackling issues big and small buoyed my spirits immensely and inspired me to write this letter.

June 11, 2017

President Trump,

I'm still waiting to see the evidence you claim to have that President Obama "wiretapped" Trump Tower. I am holding you accountable. You promised to provide proof. Either produce it now, or admit that you are a malicious liar and resign.

June 12, 2017

President Trump,

I am still staggered by your bizarre and apparently unplanned disclosure of classified information to representatives of the Russian government. If anyone but the president had done this, he or she would be headed to jail right now. What the hell were you thinking? The source may be compromised (i.e. in mortal danger) and our intelligence-sharing relationships with allies have been damaged. The reality is, you can't be trusted with classified material, because you don't understand or care what will happen if you disclose it. You need to resign.

June 14, 2017

President Trump,

I'm not writing to wish you a happy birthday. I'm writing to urge you to resign, per your request for guidance from the American people that you made in your inaugural address. You are an embarrassment to the nation. I am ashamed to admit that you are my president. It still makes me sick to think of how you publicly mocked a disabled reporter. And my skin crawls when I think of how you describe your nonconsensual interactions with women. And I actually feel pity for you when I realize that you can't tell truth from falsehood. It must be confusing to be you. Please admit that you don't have any of the necessary character traits to do the job and resign.

June 15, 2017

President Trump,

I am sickened by the shooting of Rep. Steve Scalise, just as I am sickened by the senseless gun violence that happens every single day in America. We, as a nation, have the power to stop this. All other developed countries are doing a fantastic job at preventing gun violence while we are failing spectacularly. Since you don't show any signs of resigning immediately, I'm urging you to use the interim until your resignation to call a meeting with House and Senate leadership and Gabby Giffords. A majority of Americans support a number of common-sense measures that will reduce gun violence. Our representatives (that includes you) need to listen to the will of the people and start fixing this obscene problem. The carnage must stop.

Dear Oval Office Occupant

June 17, 2017

President Trump,

It's far past time for a return to civility and bipartisanship in our nation's leadership. This effort needs to come from the bottom up, because I have no faith that you could spearhead such a turnaround. How do I know this? I'm referring to your calls for violence during your campaign. For example, there was the time you spoke fondly of the "old days," when protestors were "carried out on a stretcher" and the time you urged supporters to "knock the crap out of them." And who can forget when you said that it was "very, very appropriate" that one of your supporters had beaten up a protestor?

Are these words in any way acceptable for the leader of this nation? Absolutely not. Are they words that inspire hope that you will listen to and work with political opponents? Hell no. They are the words of a dictator in the making. Those words are unforgivable, disgusting and un-American. Since you are unfit to change the spirit and tone in Washington, the people will do it themselves, by voting out those who don't play well with others. The midterm elections are approaching. I will be voting for leaders who are willing to work hard and compromise on behalf of the American people. Meantime, I urge you to resign. You are not up to the job.

June 19, 2017

President Trump,

I've been concerned for some time about the infrequency of your press conferences. Now the White House has cut back on press brief-ings, as well. I think that the people running the executive branch have

forgotten that they work for the people. The people, through journalists, hold the president and his staff accountable. This trend away from transparency is wrong. Holding press conferences and press briefings may be difficult at times for you and your staff, but it is part of the job. It is also one of the activities that distinguishes the U.S. from a dictatorship. Since the West Wing appears to be in severe disarray, I really have no hope that you will rectify this matter. Therefore, I must, once again, ask you to resign.

June 20, 2017

President Trump,

For once, I agree with you. The American Health Care Act as passed by the House *is* mean! Every resident of the U.S. deserves accessible, affordable health care. It's a basic human right. It's time that we get in step with the rest of the developed world and make health care available for all. When it comes to health care, we look like a bunch of losers compared to our European counterparts. How about we have some of that "winning" you are always talking about?

June 26, 2017

President Trump,

I've been a bit worried ever since I saw the video of you on Inauguration Day, leaving your lovely wife behind at the car while you rushed ahead to meet President and Mrs. Obama. Later, when I saw you push your way past the prime minister of Montenegro, I realized that you never learned basic manners as a child! You must have a great deal of trouble making friends and helping your family to be happy! That probably means that you are unhappy, as well. This situation is

quite unnecessary, and is easily rectified! Everything you need to know is spelled out in the book enclosed with this letter, *How to Behave and Why*, by Munro Leaf. This book has helped generations of children find the secret to happiness, and I'm sure it can help you, too. I hope you give it a try.

Author's note on the June 26, 2017, letter

After witnessing some especially boorish behavior on the part of the president, I spied an old children's book on manners on my shelves and inspiration struck. I underlined key passages and wrote this cheeky inscription on the title page: "Donald, this book helped my kids turn out to be really awesome grownups! I hope you find it instructive. Your friend, Kathy S. Hayes."

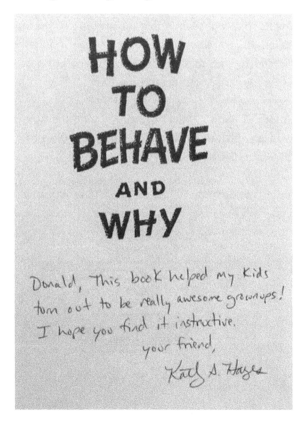

HOW
TO
BEHAVE
AND
WHY

Donald, This book helped my Kids turn out to be really awesome grownups! I hope you find it instructive.
your friend,
Kathy S. Hayes

June 27, 2017

President Trump,

So let's see if I've got this straight: Your son-in-law and Mike Flynn failed to disclose meetings with Russian officials. Before you were inaugurated, Kushner also tried to arrange a back channel for communications with Russia (using Russia's own capabilities!), so that the U.S. intelligence community would have no knowledge of what you were up to. Russia vigorously tried to affect the outcome of the election in your favor, something you just now are admitting is real. You praised Putin for many things, including for not responding to sanctions that President Obama imposed because of Russia's interference in the election. You fired FBI Director James Comey over the Russia investigation. You told the Russian ambassador that the pressure of the investigation had been taken off. You disclosed classified information to the Russian ambassador and foreign minister. You have done business in Russia, but you refuse to release your tax returns.

Furthermore, you are absolutely obsessed with the Russian investigation, so much so that it appears to be sucking up most of the time in which you are not playing golf.

Something is rotten in the White House, and I think you know what it is. Someone will be going to jail. It's just a matter of time. It would be best for everyone involved if you resigned right now.

June 28, 2017

President Trump,

Many in your own party have urged you to stop tweeting, as have I on numerous occasions. But I would like to direct your attention to a June 23 piece by Nada Bakos that appeared in *The Washington Post* and was headlined: This is what foreign spies see when they read President Trump's tweets. In case you don't feel inclined to read it, I will summarize.

When you tweet, you are giving away valuable information about yourself that foreign intelligence agents can use against you and against the United States. I've noted before that your thin skin and penchant for flattery are very obvious. You also demonstrate no impulse control whatsoever. Such personality traits can be exploited by enemies of the U.S. to manipulate you, along with information about what hours you keep, what TV shows you watch, etc.

In fact, I conclude that you are already being manipulated, and don't even know it! For example, I bet you thought that the positive press coverage you received in Saudi Arabia was because you're awesome. Wrong. Those stories were deliberate attempts to influence you.

You need to stop tweeting. And you need to stop being president. Resign.

July 4, 2017

President Trump,

I'm still suspicious that you have not yet read the Constitution, or if you have, that you have not understood it. Therefore, in honor of the

anniversary of the signing of the Declaration of Independence and the founding of our great nation, I'm enclosing a gift: a pocket edition of the Constitution of the United States of America. I'm particularly fond of the first, nineteenth and twenty-fifth amendments. I hope you find them inspiring, as well.

July 9, 2017

President Trump,

I am writing to protest the imminent deportation of Jesus Lara Lopez, the father of four young American citizens. Lopez is an upstanding resident of Willard, Ohio. He is a taxpayer, a churchgoer and a home-owner. He is exactly the kind of person this country needs. His wife will not be able to support their children by herself; I wouldn't be surprised if she will need to rely on public assistance, something the family has never done in the past. Furthermore, when ICE focuses on Mr. Lopez and others like him, that takes valuable resources away from deporting dangerous criminals.

There is absolutely no upside to removing Mr. Lopez from the United States. Your policies have led to this travesty. Please intervene on Mr. Lopez's behalf, apologize to his family and resign.

July 11, 2017

President Trump,

The plot thickens! Russians, Russians everywhere! I have the feeling that your son's revelations are just the tip of the iceberg. Why don't you just come clean with all the details and then resign?

July 20, 2017

President Trump,

 Today the news came out that your team is looking into the scope of your power to grant pardons, specifically, your power to pardon your aides, relatives and yourself. Hmm, feeling a bit guilty, are you? You do realize that if you pardon yourself, you will be admitting your guilt? Furthermore, it's not even clear that legally such an action would stand. Let's just skip the Constitutional crisis and move directly to the part of this fiasco where you resign.

July 22, 2017

President Trump,

 When is the White House going to start responding to We the People petitions on the White House website? The website states that the White House will respond within 60 days to petitions that reach 100,000 signatures, yet I have seen no evidence that it has done so. For example, there are petitions asking for your resignation and the release of your tax returns that met the signature requirement several months ago, yet are languishing in limbo. This failure is yet another example of your Administration's lack of transparency and broken promises to the American people. You don't deserve your job. Please resign.

July 23, 2017

President Trump,

 Man, am I getting sick of hearing you cry "fake news" every other minute, especially since you don't even know what you are talking about. Fake news is false information disseminated with the intent to deceive.

An example of fake news is the untrue stories that Russia promoted on social media during the election to sway citizens to vote for you. Or your blatant lies about President Obama being born in Kenya, or him wiretapping your tower.

If you don't like a news report, that doesn't make it fake news. If you don't agree with a news report, that doesn't make it fake news. If a news report casts you in a bad light, that doesn't mean that it is fake news. The intelligence community's investigation into Russian interference in our election is not fake news. The investigation into whether you or your campaign had inappropriate contacts with Russia during the election is not fake news. It is to the benefit of the American people and our democracy itself to have a fair, thorough investigation of these accusations. Frankly, it's to your benefit as well. It would do you no good to have a brief, slipshod investigation come to conclusions that no one can feel confident in.

So let's stop it with all this "fake news" blathering. And how about you sit back and let Mueller and his team do their jobs unimpeded? And, most importantly, how about you resign?

July 25, 2017

President Trump

A Boy Scout is trustworthy. The definition of trustworthy is: "worthy of confidence: dependable." As has been abundantly clear for decades, you are not trustworthy. You routinely bilked contractors. You defrauded students at your bogus university. You cheated on your wives. You've changed positions on political issues with breathtaking rapidity. You, sir, are no Boy Scout, and have never been worthy of being one. Your speech to the Scouts was an insult and an outrage. Everyone who has

ever been a Boy Scout or who is in any way affiliated with them deserves an apology from you. Furthermore, the public cannot trust that you will put the nation's interests above your own. You need to resign.

July 26, 2017

President Trump,

Your pronouncement today that transgender troops no longer have a place in our nation's armed forces is abhorrent. You should be ashamed of yourself for being such a bigot. Furthermore, you have once again demonstrated that you are incapable of the planning and forethought needed by a commander in chief. What happens to the 15,000 trans-gender troops who are serving right this moment, many of them in combat zones? Are they supposed to abandon their posts and leave their comrades in the lurch?

You are a disgrace to this nation. You are completely unfit to lead our brave servicemen and servicewomen. Resign.

July 27, 2017

President Trump,

A Boy Scout is loyal. Loyal is defined as: "unswerving in allegiance." Your concept of loyalty seems to be allegiance that goes only one direc-tion. Just ask your ex-wives, whom you abandoned for the next conquest. Or any of the devoted lackeys who you've recently thrown under the bus. Or ask Jeff Sessions, one of the earliest and most steadfast supporters of your political career. Your public attacks on him are disgusting and cowardly; if you think he's doing such a terrible job, muster up the balls to fire him and accept the consequences.

Your inability to understand true loyalty is just one of the many reasons that you did not deserve to address the Boy Scouts of America. You also don't deserve to lead our great nation. Resign.

July 30, 2017

President Trump,

A Boy Scout is helpful. Helpful is defined: "of service or assistance, useful." You, sir, are the exact opposite of helpful. You leave a trail of destruction behind you, including bankruptcies, divorces, broken contracts and lawsuits. You encourage violence and lawlessness among your followers. You are actively working to destroy agencies and programs that save American lives. And your hideous buildings ruin previously beautiful vistas. You, sir, are no Boy Scout. Your remarks to the Boy Scouts were a sorry excuse for a speech, and you are a sorry excuse for a president. Please resign.

July 31, 2017

President Trump,

Allow me to introduce you to a form of punctuation known as an ellipsis. The ellipsis consists of three dots in a row. Not four, five, six or seven. Traditionally, it has been used to indicate that words have been removed from a piece of text, or in the case of a narrative, to represent a pause or the trailing off of a thought. More recently, in electronic communications, it is used to indicate that more is to follow. An indiscriminate sprinkling of periods has no meaning and looks like discarded confetti. You might want to keep this in mind when using Twitter.

August 3, 2017

President Trump,

When will you start giving your presidential salary to actual charities, as promised? You get no credit for gutting a federal agency one day and giving it your paycheck the next. I will give you credit for efficiency: You have managed to illustrate both your hypocrisy and mendacity with one small gesture.

August 5, 2017

President Trump,

A Boy Scout is thrifty, which is defined as: "Thriving by industry and frugality; practicing economy and good management." Only a cursory look at your business history, lifestyle and chaotic current job circumstances is needed to determine that you are not a thrifty fellow. In fact, you don't possess a single characteristic of a good Boy Scout, making you conspicuously unqualified to address those worthy lads. You still owe the Boy Scouts, and the nation, an apology for your dreadful speech. I'm waiting to hear it, and also to hear of your immediate resignation.

August 8, 2017

President Trump,

What the hell are you doing? Are you actually trying to start another war? Your comment that North Korea would "face fire and fury like the world has never seen" if it makes more threats is terrifying. So now if North Korea rattles its sabre, you're going to nuke the place? That's how I interpret this statement. You have no appreciation for the level of "fire and fury" that the world has already seen.

Of course, your latest statement follows a lot of other very ill-advised taunts you have directed at North Korea. You really have no idea what you are doing, although I suspect you are egged on by the warmongers around you, some of whom, undoubtedly, stand to get richer off of arms sales if we do get embroiled in another war. For the love of humanity, shut up. Your recklessness could get a lot of people killed.

August 15, 2017

To the pathetic excuse for a human being occupying the Oval Office,

Nazis and KKK members marched openly in Charlottesville, waving flags with swastikas, shouting racial slurs and violently attacking, maiming and even killing those who stood up for peace and love. And what did you do? You promoted a false equivalency between the two sides, claiming today that there were "fine people" among the crowd of hatemongers.

These people are Nazis and KKK members. There are no "fine people" among them. My father almost died fighting Nazis, and suffered for the rest of his life because of the injuries he suffered in the Battle of the Bulge. Your comments are revolting, repugnant and reprehensible. You dishonor my father's memory. You dishonor our nation. You are not a legitimate president. You have no place in public life. I demand that you resign immediately. Also, rest assured that I will do everything in my power to pressure Congress to call for your resignation and begin impeachment proceedings forthwith.

Author's note on the August 15, 2017, letter

Actual Nazis converged on Charlottesville, Va., for the Unite the Right rally in August 2017. As I watched the chilling news coverage of them bearing torches, marching and chanting disgusting, hateful anti-Semitic slogans, I felt physically ill.

Dear Oval Office Occupant

I don't have words to adequately describe the horror I felt when I saw footage of a white supremacist deliberately drive his car into a crowd of counter protestors, killing 32-year-old Heather Heyer and injuring many more.

In the wake of this shocking news, the president initially condemned "this egregious display of hatred, bigotry and violence — on many sides," implying that the folks literally standing up to Nazis and KKK members were somehow equally to blame, when it was one side doing the murdering. After a backlash, he denounced the Nazis at the rally, but then doubled down on his earlier comments, saying that there were "very fine people" on each side.

When I sat down to write this letter on August 15, my contempt for the president was so deep that I vowed to never again address him by his name. I began sending my letters to the "Oval Office Occupant" until someone in the White House mailroom started returning them, apparently confused about to whom I was referring. For a time, I addressed my letters to President 45 as a concession to the inadequacies of the mailroom, but returned to "Oval Office Occupant" later and had no more problems with undelivered mail.

August 17, 2017

Oval Office Occupant,

Last night I attended a vigil in Akron, Ohio, in honor of Heather Heyer. People of all colors, races, ages and abilities sang, prayed and listened, spellbound, to heartfelt and passionate speeches by ordinary citizens and Ohio's own Nina Turner. It gave me hope to spend an evening among these salt-of-the-earth folks, Americans dedicated to creating a more just, peaceful and compassionate America. You may have wealth, power and the platform of your office, but you know what? I'm betting on us. We are kinder than you, we are stronger than you, we are more compassionate than you, and we are smarter than you. Our

nation is not perfect, but history shows that step by painful step we work toward greater justice, freedom and equality. Ultimately, you and your rich, boot-licking cronies will not succeed in your agendas. The American people are awake, and we will not be silent.

August 28, 2017

Oval Office Occupant,

Our transgender troops have been fighting and dying to protect us, and this is how you thank them? You should be ashamed of yourself. You are literally taking away rights from a vulnerable segment of our population because of your own misguided and hateful prejudices.

The kind of bravery it takes to sign up for military service is something you will never know; your heel spurs conveniently got you out of serving in the armed forces. And the kind of bravery it takes to face prejudice and discrimination is something else you will never know, but is a reality that our transgender troops display every day. You need to resign immediately. You are a disgrace to our nation.

September 1, 2017

Oval Office Occupant,

Our nation suffered a terrible loss: The loss of sailors aboard the USS John S. McCain following a collision with a merchant ship near Singapore. And what do you say? "That's too bad." You are unfeeling, uncaring and unprepared to handle even the most straightforward aspects of your job. Our brave men and women in uniform deserve far, far better from their commander in chief. It's time for you to resign.

September 3, 2017

Oval Office Occupant,

"What a crowd! What a turnout!" I admit I'm not surprised by anything anymore, but it is still appalling that as Texans were dead, dying, or fleeing for their lives, you attempted to make Hurricane Harvey all about you, just another campaign stop to show America how great you are. No word of encouragement or compassion for those who have lost everything. No word of sympathy for those who are mourning. You are a small, pathetic person. There's still time for you to do one decent thing: Resign.

September 4, 2017

Oval Office Occupant,

For the record, it is wrong for you to perform your official duties while wearing your campaign merchandise. But, since you've spent your life moneygrubbing and plastering your name on anything you can sell, I'm sure you have no idea what I am talking about.

In addition to the ethical breach, your choice of headgear revealed a lack of respect for the people of Texas. That hat told them that you were using their tragedy as an advertising/money-making opportunity.

Here are some adjectives to describe this latest sartorial debacle: Tacky, crass, shallow, insensitive, disrespectful, shameful and corrupt. You continue to wallow about in a sewer of your own making. Please resign.

September 6, 2017

Oval Office Occupant,

Let me make sure I've got this straight: You spend lots of time at your resorts. To keep you safe, the Secret Service spends taxpayer money ($60,000 or so) to rent golf carts while you are golfing. That money benefits you and your business. Likewise, the Secret Service has to pay rent in your tower in New York when you are there, money that benefits you and your family. This is corruption, plain and simple. The more you stay at your own properties, the more money you make! No wonder you keep spending weekends away from the White House. This is the exact reason why you should have sold your businesses. If you weren't willing to make that sacrifice to serve the American people, you shouldn't have run for office. You are unfit. Resign.

September 7, 2017

Oval Office Occupant,

You are planning to give $1 million to hurricane relief efforts. Good for you! Now let's follow that up with some serious work addressing climate change. Extreme weather events will be more frequent, more severe and more costly as the climate warms. It's time that you and Congress face those realities and act to slow down climate change and work on mitigation.

THE WHITE HOUSE

WASHINGTON

September 13, 2017

Mrs. Kathy S. Hayes II
Richfield, Ohio

Dear Kathy,

Thank you for taking the time to express your views regarding our country's domestic policy. I am committed to unleashing America's full potential through domestic policies that drive opportunity and economic growth, while ensuring the safety and security of the American people.

My Administration will work each day to advance an America First agenda, and we will do it while remaining committed to a responsible fiscal policy that addresses our Nation's mounting deficit and debt. My 2018 Budget, *A New Foundation for American Greatness*, will eliminate job-killing regulations, drastically shrink the size of the Federal bureaucracy, prioritize the safety and security of American citizens, and reduce our unsustainable $20 trillion debt, while protecting programs that our senior citizens depend on, like Social Security.

My budget puts America first by investing in a stronger, safer America. That means making our communities great again by supporting law enforcement, rebuilding our crumbling roads and bridges, fixing our education system so that workers can get good jobs, and fighting to eradicate the scourge of drugs that is spoiling the promise of our youth. We must also return to the values and protect the Constitutional freedoms that made America a beacon of hope and opportunity to the world, including the right to keep and bear arms.

My America First policies will bring a new wave of opportunity to this great land. To learn more about my budget and the steps my Administration is taking to keep America safe, please visit www.WhiteHouse.gov.

Thank you again for your suggestions. Your voice, your hopes, and your dreams will define the next generation of American greatness. Your courage, goodness, and love will guide us along the way. As we look to the future, we know that no challenge will outmatch the resolve of the American people to overcome.

Sincerely,

45

September 15, 2017

Oval Office Occupant,

You really must think the populace is dumber than a bag of hammers. When neo-Nazis and white supremacists spew their hate and kill a woman, you claim to need time to gather facts before condemning those violent racists or calling their actions terrorism. But when a terrorist attacks in London, you are on a hair trigger, immediately declaring on Twitter that it was the work of a "loser" terrorist, even before British authorities confirmed the nature of the incident. You then took things a step further, bringing up your infamous travel ban, implying that the perpetrator is Muslim before the facts of the case were known.

You sympathize with neo-Nazis. You leap to the conclusion that a terrorist is a Muslim. You, sir, are a racist. Two plus two equals four. Even children can figure this out. You have no place in public life or polite company. Please pack your bags and go home.

September 23, 2017

Oval Office Occupant,

It's interesting that you've made such a kerfuffle out of athletes exercising their First Amendment rights. You've gone so far as to abuse the power of your office by calling for their firing. Could it be that you want to distract us yet again from the growing Russian scandal and Paul Manafort's involvement? I'm keeping my eyes on the prize: Impeachment is in your future.

Illegal, unethical, immoral and unconstitutional actions are totally ok by you. Your only regret will be getting caught. Since impeachment will be a lot of trouble, I urge you to tender your resignation immediately. It

would be much better for the country, and help us get on with healing our democracy. Give it a shot!

September 25, 2017

Oval Office Occupant,

I'm longing to travel to the beautiful land of Nambia, where the sun always shines and the people have awesome health care. Wait a minute, Nambia exists only in your mind! If anyone else had prattled on about this fictional nation, I would have chalked the mistake up to a slip of the tongue. However, you have a lengthy record of not doing your homework. Your knowledge of geography also seems limited to the locations of your golf courses and hotels. Therefore, I must conclude that you were wholly unfamiliar with Namibia, and didn't know how to pronounce the name appearing on your teleprompter.

If you want to become more familiar with the nations of the world, I suggest that you try one of the many compelling and fun geography games available online. I was able to memorize all of the countries of the world that way, and can now list them without any trouble, which is an excellent way to keep the mind sharp. I think you should give it a shot. It might save you some embarrassment when meeting world leaders, and may also help wean you from your cable news and Twitter obsessions.

THE WHITE HOUSE

WASHINGTON

September 28, 2017

Ms. Kathy S. Hayes
Richfield, Ohio

Dear Kathy,

Thank you for taking the time to express your views regarding immigration policy.

My first duty as President is to keep the American people safe, and that obligation guides my approach to immigration and border security.

Immigration to the United States is a privilege, not a right, and the Federal Government has the responsibility to enforce all laws passed by Congress, to rigorously vet and screen all foreign nationals seeking entry into the United States, and to keep drugs, criminals, and terrorists from entering our country and threatening our citizens.

Additionally, we must have responsible controls on the future entry of foreign workers to protect jobs and wages for existing United States workers of all backgrounds. I have issued an executive order to help accomplish this goal, as I promised during the campaign.

Further, we have achieved a record reduction in illegal immigration on the southern border, an effort that requires constant vigilance against a wide array of threats and challenges. We are also taking action to confront unlawful sanctuary city jurisdictions that dangerously shield criminal aliens. Crucially, we have also begun planning and preparations for the border wall which we need to stop the trafficking of drugs, guns, weapons, and people.

If we continue to enforce our laws and protect our communities, families, and struggling workers, we will reduce our deficit, increase incomes, and make our communities safer for each and every American—present and future.

Sincerely,

48

September 30, 2017

Oval Office Occupant,

It's impossible to figure out which recent tweet about Puerto Rico was the nadir. Was it the one in which you implied that Puerto Ricans (mostly brown people) are by nature lazy? Perhaps it was the tweet that claimed that San Juan Mayor Cruz (a woman) isn't capable of stating her own thoughts, but is instead a puppet of unnamed Democrats? Or was it when you were whining and playing the victim while Americans were (and still are) suffering and dying waiting for help to arrive?

Your reaction, sadly, was predictable. When I saw Mayor Cruz begging for help, saying that federal relief efforts left something to be desired, I wondered how many hours would pass before you went on the attack. You are like a spoiled toddler with a Twitter account and no soul.

On the plus side, it sounds like you're boning up on your geography. I'm happy to learn that you now know that Puerto Rico is "an island surrounded by water, big water, ocean water." Congratulations! Now that your geographic knowledge has reached a third-grade level, perhaps you can work on getting your vocabulary past the second grade, as well.

October 1, 2017

Oval Office Occupant,

I strongly object to the recent deportation of Pedro Hernandez-Ramirez, who had a legal work permit and also has been the primary caregiver of his severely disabled stepson. His absence will cause severe hardship to his family, who are American citizens.

Additionally, this cruel deportation will cost taxpayers money. Hernandez-Ramirez was gainfully employed, supported his family and

paid taxes. Now, his wife may be forced to put their son into an institution and rely on government services to provide for his care. There are no winners in this situation, only losers.

Under your brief tenure, ICE has become a heartless instrument of evil. I strongly encourage you to take the necessary steps to allow Hernandez-Ramirez to be returned to his family. Then resign.

October 2, 2017

Oval Office Occupant,

Regarding the events in Las Vegas, I urge you to reread my letters of December 14, January 7, February 12 and April 1. The time to end this madness is now. It's time to enact sensible gun-control measures that the majority of Americans support. My right to attend a concert and come out alive supersedes any supposed right others have to carry any and all types of firearms in any quantities they so choose. Stop this uniquely American horror show.

October 8, 2017

Oval Office Occupant,

I am writing to protest your suggestion about how NFL owners should deal with players who kneel during the playing of the national anthem to protest police brutality: "Get that son of a bitch off the field right now, he's fired."

This is a disgusting statement on many levels, but I will address only one here. You, a government official, are publicly stating that such players are sons of bitches and, by extension, calling their mothers bitches. While this is, unfortunately, typically vulgar behavior for you, it is beneath the dignity of the office of the president. You should issue an apology to players in the NFL and their mothers, then resign in disgrace.

October 21, 2017

Oval Office Occupant,

Here are some things I know about you: You don't respect women. You don't respect Congress as a coequal branch of government. You don't respect fallen servicemembers. How do I know this? I quote: "I had a very nice conversation with the woman, with the wife, who sounded like a lovely woman." And: "I didn't say what that congresswoman said, didn't say it at all." Additionally, the family of La David Johnson confirms that you didn't know his name when you spoke to his widow.

Here's what this means: You refuse to show women the respect that is due them by using their names or titles. *Mrs. Johnson.* You can't show the customary courtesy due to an elected representative of the people. *Congresswoman Wilson.* You can't be bothered to conduct the minimum amount of preparation to learn the name of a soldier who died in service to his country. *La David Johnson.*

You remain incapable of doing the most basic duties of your job, and you remain unworthy to lead our men and women in uniform. Resign.

October 26, 2017

Oval Office Occupant,

I am writing to protest in the strongest possible terms the detention of Rosamaria Hernandez, the 10-year-old with cerebral palsy who has been separated from her family and detained by Border Patrol agents for possible deportation. This outrageous treatment of a medically fragile little girl is an assault on human decency. Your morally bankrupt rhetoric and policies have led to this despicable violation of American norms. I demand the immediate release of Rosamaria. Furthermore, I expect

you and the agents and agencies involved to issue an apology. I will be asking Congress to investigate this travesty so that those responsible can be held accountable. Lastly, I insist that you resign. You are unfit to lead.

Cc: Vice President Mike Pence, Senate Majority Leader Mitch McConnell, House Speaker Paul Ryan, Senator Sherrod Brown, Senator Rob Portman, Congresswoman Marcia Fudge, U.S. Customs and Border Protection Acting Commissioner Kevin K. McAleenan

October 29, 2017

Oval Office Occupant,

In your October 18 letter to me, you cited your "America First" policy. As I believe I pointed out after your inaugural address, the phrase "America First" has a loaded, anti-Semitic history. That you continue to use it in official communications is offensive. You are truly the divider-in-chief. Resign.

October 30, 2017

Oval Office Occupant,

Are you getting nervous yet? Indictments and guilty pleas are flying thick and fast, and it's becoming a lot harder to claim that Russia is a "hoax." It's only a matter of time now before members of your inner circle are indicted, as well. I think that impeachment is in your future. Why not resign?

November 7, 2017

Oval Office Occupant,

Things I still want to know: When are you going to release your tax returns, as promised? When are you going to provide proof that President Obama wiretapped your tower? When will you defeat ISIS? When will the "winning" start? When will you realize that you are incompetent and resign?

November 10, 2017

Oval Office Occupant,

Mueller is closing in. Are you feeling a little nervous? Is there anyone from your campaign who hasn't had questionable dealings with Russia? You can tell a lot about a man from the company he keeps, and you seem to attract a lot of dishonest sleazebags. Why don't you get this over with more expeditiously and resign?

November 11, 2017

Oval Office Occupant,

I am writing to strongly protest the revocation of Temporary Protected Status for hundreds of thousands of Central Americans. Instead of kicking these folks out, how about we figure out a way to grant them permanent residency? Many of them have been here for decades. Many have American children. They are productive, working members of their communities who pay taxes. Many still would face terrible conditions in their home countries.

This new move by your xenophobic, nativist administration does nothing to help our country and plenty to hurt a lot of decent people. Unfortunately, it's what I've come to expect from you and your Grinch-like cronies.

November 12, 2017

Oval Office Occupant,

Our intelligence agencies unanimously agree that Russia interfered in our election process, and that the interference originated at the highest levels of government. But you believe Putin. And you're worried that he's insulted. Really, you couldn't look more guilty of being up to no good with the Russians if you tried. And the way you dismiss the competence of our intelligence professionals is pathetic. At no point in your life have you ever had the character or mental abilities to perform the work that the experts at the CIA, FBI and NSA do. Furthermore, you're not capable of even recognizing or acknowledging their expertise. Your incompetence is a hazard to us all, and a danger to our democracy. Resign.

November 21, 2017

Oval Office Occupant,

Considering your own admissions about how you treat women, it is unsurprising that you are siding with Roy Moore. God forbid we let a Democrat take that Senate seat, when we've got a "conservative" with potentially criminal sexual proclivities who will do nicely. Disgusting. Moore should drop out, and you should resign.

November 23, 2017

Oval Office Occupant,

Do you want to know what I'm thankful for this Thanksgiving Day? I'm grateful for Robert Mueller. I wish him health, long life and much success in his current endeavors. Happy Thanksgiving.

November 27, 2017

Oval Office Occupant,

Once again, you have proven that you are utterly incapable of performing the simplest, most straightforward duties of your job. Today, you used a ceremony to honor Navajo code talkers to take a jab at a political opponent in what appeared to be a lame attempt at humor. Big clue: when honoring WWII heroes, it's not an opportunity to score political points. In other words, it's not about you, it's about them. And the fact that you chose to draw attention away from them speaks volumes about your character and raging narcissism.

If that weren't bad enough, you didn't make an ordinary political jab; you used your favorite nickname for Sen. Warren: Pocahontas. How could you even dream of doing this while standing face to face with Native Americans? If you think there is nothing wrong with your comment, then that alone is reason for you to resign. You are an incompetent, insensitive boor.

December 3, 2017

Oval Office Occupant,

What are you doing to promote a peaceful, diplomatic solution with North Korea? Have all avenues of diplomacy been explored? What have you done to build alliances with other nations who can help pressure North Korea in nonviolent ways? The North Koreans see us as an existential threat and are behaving accordingly. You took what was a thorny and fraught situation and made it much, much worse with your threatening rhetoric. Worse, based on some of your own comments, I think you actually are itching to use nuclear weapons. I'm in favor of peace. Are you?

December 4, 2017

Oval Office Occupant,

Of course you endorsed the accused pedophile Roy Moore. It is exactly what I expected. You have a long history of sexual misconduct, from cheating on your wives, to bragging about groping women, to dropping in on teenage beauty contestants while they were changing clothes. Birds of a feather flock together; you and Moore constitute a particularly sordid and slimy species.

December 5, 2017

Oval Office Occupant,

I'm noticing a trend. You insult Native American war heroes by staging a ceremony to honor them in front of a portrait of Andrew Jackson and referencing Pocahontas in a derogatory way. Then you gut

national monuments that are full of Native American artifacts, burial grounds and sacred sites. You are a nasty bigot. Resign.

December 9, 2017

Oval Office Occupant,

You just can't stop bringing up the fact that you won the election, can you? My goodness, that was more than a year ago! And to characterize it as a landslide is delusional. Just a little reminder for you—millions more people voted for Clinton than you. Do you think that there's anyone in the country who is unaware that you are president? Why keep bringing it up? Are you insecure? Obsessed? Unhinged? More likely, it is a combination of those three. Really, your behavior is beyond embarrassing. Resign.

December 10, 2017

Oval Office Occupant,

I am delighted to hear that you will undergo the annual physical that is traditional for all recent presidents. If the military doctor finds that you have mental health issues that impair your ability to do your job, what will you do? Fire the doctor? Lie about the results? Refuse to release them? Perhaps it would be easier to just resign now. Mental health issues aside, there are many ethical and possibly criminal reasons why you need to step down. Please do so immediately so that the rest of us can have a lot more joy this holiday season.

December 14, 2017

Oval Office Occupant,

Here's what your enthusiasm for border security has wrought: a 25-year-old mother of three was dumped off after dark on Dec. 12 in Nuevo Laredo, Mexico, possibly the most dangerous city in the country. Fabiola Hernandez came to the U.S. almost 10 years ago as a teenager. She is the mother of 6-year-old twins and a 4-year-old girl who has cerebral palsy and uses a wheelchair. Her children, her AMERICAN children, are already suffering from her absence. No decent human being would treat a young mother and her innocent children like that. Obviously, ICE is now full of sadistic thugs, the kind of people that you, no doubt, can relate to.

There is an alternative. Instead of deporting Fabiola and others like her, we can choose the humane way, the generous way, the American way, and extend a helping hand: a path to legal permanent residency.

I am sickened and ashamed to know that this is how our country treats the vulnerable among us. You should be sickened and ashamed as well, but I doubt that you are capable of such feelings. Your culpability in this abhorrent incident and others like it is reason enough for you to resign in disgrace.

December 17, 2017

Oval Office Occupant,

"Happy holidays." I love saying it. My small town is blessed to be home to a Sikh temple, a Jain temple, a Hindu temple, a Buddhist temple, a Russian Orthodox monastery, a Catholic church and a Protestant

church. Around town, I bump into people from these various faith traditions, and people of no faith at all. I am glad that I have a way to wish everyone joy in whatever special celebrations they participate in. I greet people this way with sincere good wishes in my heart. Please stop demonizing those of us who choose to be inclusive.

December 19, 2017

Oval Office Occupant,

Why didn't you acknowledge the anniversary of the Sandy Hook massacre? I'd love to hear your explanation.

December 20, 2017

Oval Office Occupant,

The folks at the Pentagon know that climate change is a threat to our national security. Why don't you recognize it in your national security strategy? The U.S. could be leading the fight against climate change, but you've chosen to let other countries take charge. Not only will our planet suffer from our lack of action, but our nation will be less safe. You are not acting in our nation's best interests. Please resign.

December 25, 2017

Oval Office Occupant,

When asked to extend a helping hand to the poor, Ebenezer Scrooge refused, asking "Are there no prisons? And the Union workhouses? Are they still in operation?"

Marley's ghost issued this dire warning to Scrooge: "No space of regret can make amends for one life's opportunity misused." Everyone can learn something from these wise words, but I think they are especially applicable to you. Like Scrooge, you have reached an advanced age. You, like him, are wealthy and powerful. Like that old miser, you have willfully and blindly turned your back on those in need: the millions of citizens in Puerto Rico suffering after a hurricane; sick children with no health insurance; innocent Yemenis dying with our complicity; immigrants fleeing for their lives and seeking succor on our shores.

You should ask yourself: What have I done with my wealth and power to alleviate Ignorance and Want, the twin specters of Dickens' play? Just as it was for old Scrooge, and indeed is for all of us, the clock is nearing midnight. Will you build walls or welcome the stranger? Will you work to ensure that all children receive the schooling they need, or will you undermine public education? Will you intervene on behalf of the wrongfully imprisoned and detained or allow them to languish? Will you support food programs for senior citizens, or let them go hungry? Marley's chains were long, but yours are infinitely longer. Can you feel their weight?

December 27, 2017

Oval Office Occupant,

One hundred and ten days. That's how long you've spent visiting your properties since Inauguration Day. And every day you visit, you enrich the coffers of your businesses using the American people's tax dollars. It's quite a scam you've got going. But you always were a scam artist and a cheat. Your phony university amply demonstrated that. You need to resign.

December 28, 2017

Oval Office Occupant,

 I'm still waiting to see your tax returns. The American people deserve to know how you will benefit financially from the decisions you make in your capacity as president. Cough them up.

2018

January 1, 2018

Oval Office Occupant,

Have you considered making any New Year's resolutions? Here are a few that would help the nation:

Tell the truth. Be kind. Listen more than you speak. Limit screen time to one or two hours per day. Take a brisk walk every morning. Avoid social media. Read a good book every week or two. Also, resign.

January 6, 2018

Oval Office Occupant,

The new interpretation of the Migratory Bird Treaty Act issued by the Interior Department eliminates any incentive for the energy industry to prevent bird deaths. According to the Audubon Society, up to 1 million birds per year die in oil-waste pits, power lines kill 175 million birds per year, and hundreds of thousands die in wind turbines. Once again, energy companies get a free pass, and our natural world gets the shaft. I strongly urge you to reinstate fines; this will motivate industries that routinely kill birds to take effective measures to protect them.

January 8, 2018

Oval Office Occupant,

Please intervene in the imminent deportation of Yancarlos Mendez, a 27-year-old in Springdale, Ohio, who is the sole provider for and primary medical caregiver of a 6-year-old American boy who is a paraplegic and considers Mendez his daddy. Deporting Mendez, who overstayed his visa, will cause severe hardship to Ricky Solis and his mother, both of whom were injured in a terrible car accident. Immigration reform must include more opportunity for judicial discretion in such cases, as well as methods for people in difficult circumstances to more simply obtain permanent legal residency. What has happened to the America I love, the America that has always been willing to give people a helping hand?

January 15, 2018

Oval Office Occupant,

I'd like an explanation for why you fired the remaining members of the Presidential Advisory Council on HIV/AIDS. Is fighting HIV and AIDS no longer important to our country? Will there be new appointees? If so, why would you destroy the body's continuity by starting from scratch with a completely new set of people? Considering the thousands of other positions that you have failed to fill, it seems odd that you would add more empty positions to the workload. Perhaps you are searching for sycophants and toadies to fill the roster, because you don't like hearing viewpoints that differ from your own.

Dear Oval Office Occupant

January 17, 2018

Oval Office Occupant,

How does it feel to witness members of your own party finally turn against you in the most public of ways? I can only hope that the more craven members of Congress will find strength from Senator Jeff Flake's heartfelt and honest words today and denounce your dishonest, racist and anti-American rhetoric and policies. Furthermore, I pray that they find the courage to publicly censure you and call for your resignation. I find the following words from Flake particularly inspiring:

"We must never adjust to the present coarseness of our national dialogue — with the tone set at the top. We must never regard as 'normal' the regular and casual undermining of our democratic norms and ideals. We must never meekly accept the daily sundering of our country — the personal attacks, the threats against principles, freedoms, and institutions, the flagrant disregard for truth or decency, the reckless provocations, most often for the pettiest and most personal reasons, reasons having nothing whatsoever to do with the fortunes of the people that we have all been elected to serve."

I hope that you take Flake's words to heart and resign.

January 19, 2018

Oval Office Occupant,

I don't care how you try to spin it, the government shutdown is all on you and your fellow Republicans. Republicans control both houses and the White House, yet are incapable of coming up with a workable solution. You are no deal maker. Your incompetence is staggering. Please resign.

January 22, 2018

Oval Office Occupant,

The flu is raging through the country. Countless thousands are suffering, hospitals are overflowing and, tragically, people are dying. Yet this unusually severe flu season is only a foretaste of what top epidemiologists tell us is inevitable: a flu pandemic. Experts also believe that we are woefully unprepared to deal with such a pandemic, even though we know it is coming. It is the job of the federal government to fund research for improved flu vaccines and effective treatments, and to implement strategies for tracking and preventing the spread of the flu when it appears. However, spending for those activities is not commensurate with the urgency of the situation.

Does your budget take any of this into account? Have you asked your fellow Republicans in the House and Senate to make this public health issue a priority? Have you spoken with Surgeon General Adams and HHS Acting Secretary Hargan about this? I pay taxes so that the government can provide infrastructure and services that benefit us all, such as roads, schools, libraries, the military and, yes, public health research and initiatives. I'm not interested in your tax cuts; I'm interested in a federal government that does its damn job. I look forward to hearing about your plans for preventing a flu pandemic.

January 23, 2018

President 45,

Yesterday, a letter I wrote to you on December 16 was returned to me with no explanation. It had obviously gone through White House security screenings, as it had been opened, stapled shut again and stamped

with various marks. Why it had not been further processed by your staff is an interesting matter for speculation. Is it the intent of your administration to deprive me of my right to petition the government for redress of grievances?

Today, two more letters (dated December 17 and December 20) came back in similar condition. These had the slightly more informative "No longer at this address remove from mailing list" stamp upon them. Oh, if only that were true!

Perhaps someone in the office that handles your correspondence is being willfully obtuse, and refused to process the letters because I have chosen to address them with the phrase "Oval Office Occupant" instead of your given name ever since your infamous remarks about the evil events in Charlottesville. The idea that there could be any confusion about the intended recipient of my letters is laughable, particularly since dozens of other letters addressed in the same way have not been returned. Indeed, I have even received replies from your office for letters addressed in that fashion. However, in case this is indeed the (flimsy) reason, I will now address all correspondence to "The President."

To allow your staff another chance to do its job — which in this case is to read my letters, presumably note their subject matter in some sort of tracking file and determine if they require a response — I have printed them off and am enclosing them herewith. Perhaps you and your staff are forgetting that the people are your boss and that the sole purpose of your job is to serve them. Therefore, I expect that in the future those in the West Wing will take my concerns more seriously by actually reading my letters and responding to them in a timely and professional way, as they would any other correspondence.

January 25, 2018

President 45,

Yesterday, a letter I wrote to you dated December 15 was returned to me. Like other letters that your staff has chosen to return, it had been opened, stapled shut again and stamped with the words "no longer at this address remove from mailing list."

Does someone on your staff believe that there is a limit to the number of concerns a citizen may contact the executive branch about? Is someone on staff tired of answering letters from pesky citizens and is therefore trying to discourage further correspondence? Is this the snail mail equivalent of being blocked from your account on Twitter?

Tracking the subject matter and opinions expressed in letters from the American people would be one sensible way to gauge what matters are of importance to the public. That your staff seems to be choosing to exclude some of this information from the mix should be a matter of concern. How many others are being ignored? I have enclosed the December 15 letter to give those in charge of correspondence another chance to do their jobs.

January 28, 2018

President 45,

I was delighted to hear that you are looking forward to speaking under oath with Robert Mueller. What are you waiting for? Don't listen to your attorneys, just go for it. Everyone knows that you have all the best facts, and are the best at everything you do; I'm sure your testimony will be a big success. Please set it up without delay!

February 3, 2018

President 45,

Miguel Perez Jr. served two tours of duty in Afghanistan. He returned with a brain injury and PTSD. This father of two American children has lived in this country since he was eight years old, and knows no other home. He has served his time for a drug conviction, which is the reason he is scheduled for deportation. This man deserves the gratitude and compassion of the American people. He should be receiving the medical care he deserves by virtue of his service to our nation. Instead, he will be dumped unceremoniously in a country he doesn't know. Is this who we have become as a nation? Is this how you think we should treat veterans?

February 4, 2018

President 45,

According to the journal *Pediatrics*, shootings are now the third leading cause of death for American children, with more than 1,000 children per year dying this way. Thousands more suffer crippling injuries. Let that sink in. Now think about this: Americans make up less than 5 percent of the global population, but 91 percent of the children killed by guns worldwide are American.

Something is desperately, tragically wrong with our country and how we handle guns. Most of the rest of the world has got this figured out, yet we refuse to learn from what's working elsewhere.

This uniquely American slaughter needs to stop. The Second Amendment does not mean that every single person in the U.S. can

own any damn gun he or she pleases. Some people are unfit, and we need universal background checks to weed them out. We need to force gun manufacturers to adopt new safety technologies that prevent unintentional shootings. We need mandatory safety training for gun owners. I don't expect you to agree with me or do anything about this, since you've shown no interest before. It's long past time for you to resign.

February 7, 2018

President 45,

I would like to draw your attention to your February 3 tweet which reads: "This memo totally vindicates "Trump" in probe. But the Russian Witch Hunt goes on and on. Their was no Collusion and there was no Obstruction (the word now used because, after one year of looking endlessly and finding NOTHING, collusion is dead). This is an American disgrace!"

Let's ignore for now the factual issues and address the bizarre punctuation, random capitalization and the egregious error in which you used the wrong homonym. Because four days have passed and you have not deleted the tweet or issued a corrected version, I have to conclude that you are either unaware of the errors, or don't care that you look like an ignoramus in the eyes of the world.

As I have pointed out in previous letters, "their" is used to denote possession, as in the phrases "their crumbling democracy" or "their insane leader." The word you should have used at the beginning of the third sentence is "there." Here's how to use it in a sentence: There is no doubt his faculties are impaired.

On to capitalization. Please don't capitalize common nouns unless they are the first word in a sentence. Therefore, all of the following should

be lowercase: witch hunt, collusion and obstruction. "NOTHING" is obviously capitalized because you wish to indicate that you are shouting it, so I'll let that one slide.

The most mystifying problem with this tweet is the set of quotation marks around your name. Are you quoting someone? Are you using scare quotes, which can indicate irony or doubt about the words enclosed by them? But if you are indicating doubt, do you mean that someone other than you is vindicated? Perhaps you thought that quotation marks would provide emphasis. (They do not.)

Again, I recommend that you stay off Twitter, or ask an adult to help you compose your tweets.

February 13, 2018

President 45,

My current paycheck is a little bigger than the last one, due to the tax overhaul. I'm donating that $25 to Democrat Sherrod Brown's re-election campaign.

February 14, 2018

President 45,

As I have written multiple times before, I'm sick of the thoughts and prayers of you and every spineless Republican milksop in Congress. There are many, many realistic options for reducing gun violence that could be codified into law, if only our leaders could see past the blood money that the NRA uses to control them. But 17 more people are dead today in a single incident. Across the nation, many others died, as

well. You have amply demonstrated your inability to lead on this issue. It's time for you to resign in shame.

February 15, 2018

President 45,

Yesterday's letter wasn't sufficient to express my outrage at our government's apathy and impotence in response to the unending gun carnage from mass shootings, suicides, homicides and accidental deaths.

It's well past time to ban the AR-15, bump stocks and high-capacity magazines. Now is the time to mandate universal background checks, licensing and extensive safety training as prerequisites for gun ownership. It's time to deny the right to own a gun to those who are restrained by a protection order, guilty of domestic violence or diagnosed with a severe mental illness. It's also time that gun manufacturers be held liable for their products. They've gotten filthy rich for decades while refusing to integrate viable, life-saving safety features into their products — safety features that also should be mandated by law.

The vast majority of Americans want laws like these, but our so-called leaders ignore us. You should be rallying your majority-holding Republican colleagues to respond to the will of the people and protect us from this scourge. If you don't, we will vote the bastards out and replace them with people who will get the job done. We will vote you out as well, assuming you aren't impeached first. I've had enough. The American people have had enough.

February 16, 2018

President 45,

Despite very recent statements you have made to the contrary, in a tweet today you admitted that Russia has, after all, been interfering in our elections. Yet you expressed no outrage, no vow to get to the bottom of it, no desire to impose sanctions or mete out other punishment. You banged the same old self-centered drum, claiming that the timeframe involved is proof that the outcome of the election was unaffected and that you and yours are not guilty of collusion.

Further, FBI Director Christopher Wray testified that you have not ordered him to take any action whatsoever to counter Russia's efforts to meddle in the upcoming 2018 midterm elections. This is gross dereliction of your duty to protect the nation's security. You remain unfit for the office you have been so improbably elevated to. Resign.

February 17, 2018

President 45,

You've set a new record: You have gone a whole year without a formal press conference, a first for modern presidents. This is not a record that you should be proud of. I expect transparency from the Chief Executive, and that means you should be answering tough questions from journalists on a regular basis. I suspect that it's really your handlers who are behind this dubious milestone. Everyone knows how erratic, rambling, contradictory and even nonsensical you are when you don't have a script. That is probably the reason that they are afraid of permitting more opportunities for the "unfiltered" you to appear in public. Why not defy them? Come on, we know you not-so-secretly love talking to journalists; why should your keepers stop you?

February 24, 2018

President 45,

Arming teachers? Really? I suggest you speak to current members of our military and police forces who have been trained to deal with active shooters. They will tell you how incredibly difficult it is for even the most skilled and trained fighters in the world to take down a bad guy without injuring anyone else. To say that our teachers should be expected to take on this responsibility is both ludicrous and irresponsible. You are deranged.

February 27, 2018

President 45,

I am horrified that you publicly berated Sen. John McCain at the CPAC conference last week, despite promises to his daughter that you would no longer take political potshots at the dying war hero. You consistently plumb new depths.

Now juxtapose that unforgivable behavior with your laughable assertion yesterday that you would have run into the school in Parkland during the massacre — unarmed, no less — to save the kids from the shooter. You are delusional. You, draft-dodging Cadet Bone Spurs, fancy yourself some sort of Chuck Norris-like action-movie hero, but can't muster up one iota of respect for a genuine American patriot who is a paragon of bravery. You are a pathetic excuse for a human being.

March 8, 2018

President 45,

Once again, I received a paycheck that was slightly larger than before, courtesy of your ill-conceived tax-cut plan. You'll be happy to know that I donated my windfall to the Giffords' political action committee to fight gun violence. Because your 2016 campaign coffers were awash in $11.4 million from the NRA, I have no confidence that you have any real interest in implementing measures that will save lives but that also will displease your puppet masters. Thankfully, the young people of our nation are leading the way. They are what real leaders look like. You could learn a lot from them.

March 9, 2018

President 45,

Until now I have refrained from writing about your proposed 2019 federal budget, because it didn't seem worth getting upset about — it is unlikely that anything in that document will actually remain intact after Congress has its way with it. However, because it is something of a wish list, it illuminates your priorities. Therefore, I've decided to weigh in. Here are some highlights:

Your proposal would eliminate more than $17 billion for the Supplemental Nutrition Assistance Program. The vast majority of current recipients are children, the elderly and people with disabilities.

The budget for the State Department would be cut by about 29 percent, which will drastically cut spending for diplomatic efforts, nation-building, disaster relief and humanitarian efforts. These are

activities that can promote democracy and generally make the world safer.

The EPA budget would be slashed by more than 30 percent, eliminating or greatly shrinking programs that keep our air and water clean.

Your dream budget includes $3 billion for a down payment on the border wall. You know, the one that you promised Mexico would pay for?

The Defense Department budget gets a 10 percent boost in your proposal, which would bring its 2019 spending to $574.5 billion. Right now, without any increase, the U.S. spends more than any other nation in the world on defense; in fact, it spends about as much as the next eight highest-spending countries combined.

What conclusions can we draw? You care about weapons and walls. Hungry kids, clean water and a stable world? Not so much. I'm not sure how you reconcile these priorities with your supposedly Christian religious beliefs. I'd be interested to know how you manage it.

THE WHITE HOUSE

WASHINGTON

March 14, 2018

Mrs. Kathy S. Hayes II
Richfield, Ohio

Dear Kathy,

Thank you for taking the time to express your views regarding healthcare policy.

Healthcare is a large and complex part of the economy that affects every person and family in America. There are significant challenges in healthcare markets, including reduced competition and rising costs that threaten both family and government budgets. Obamacare has exacerbated these challenges, causing healthcare premiums for individuals and small businesses to drastically increase while choices dwindle. In 2018, more than half of the counties in the country will have just a single insurer from which to buy a plan on Obamacare's exchanges, and average premiums will increase by 25 percent for a second consecutive year. That is why we must repeal and replace Obamacare with reforms that expand choice, increase access, lower costs, and at the same time, encourage quality healthcare and innovation.

Since my first day as President, we have been working to save Americans from Obamacare's failures. On my first day in office, I signed an Executive Order to minimize Obamacare's regulatory burdens and to give states greater flexibility and authority to create a more open healthcare market. And I have worked ever since with Congress to enact permanent reforms that will finally address the needs of our healthcare system.

On October 12, 2017, I signed another Executive Order to expand alternatives to Obamacare plans and to increase competition in order to bring down costs for consumers. The Departments of the Treasury, Labor, and Health and Human Services are acting in response to this order. In the coming months, millions of Americans will have a broader range of affordable coverage options and have greater control over how to finance their healthcare needs.

My Administration will continue to work with Congress to pass legislation that replaces Obamacare with a system that takes the power out of Washington and returns it to the States. This replacement will ensure that Americans with pre-existing conditions have access to coverage. Additionally, the legislation will provide a stable transition for those currently enrolled in Obamacare's health exchanges and Medicaid expansion.

Thank you again for your suggestions. Please visit www.whitehouse.gov to read more about my Executive Order to expand access to more affordable healthcare options. As President, I am committed to providing Americans with more affordable health insurance, access to more choices, and quality care.

Sincerely,

76

March 17, 2018

President 45,

Amid the controversies swirling around high-level firings, accusations from porn stars and senior campaign officials pleading guilty to lying to the FBI, let's not forget that little legal issue that Kellyanne Conway has. Conway broke the law by mixing official business with political views when she took sides in Alabama's special election for a Senate seat. The Office of Special Counsel has said that you are required to consider "appropriate disciplinary action." We all know what you will do: exactly nothing.

Breaking the law (and lying) is par for the course in your administration. I'm sure that having a top aide violate the Hatch Act seems like nothing to you, since you have no problem with wife beaters, liars, traitors and racists. (All the best people!) Indeed, you have assembled a group that reflects your own lack of morality, ethics and scruples. Congratulations, you have turned the "swamp" into a cesspool.

March 21, 2018

President 45,

There's a lot wrong with the way Andrew McCabe was fired. And I won't spend any time speculating about your role in that event, since it has been thoroughly covered elsewhere. What has been troubling me for days is your disturbing March 16 tweet about his firing.

First of all, the president of the United States shouldn't be tweeting, period. Secondly, if the president of the United States felt a need to comment on this particular matter, an official written statement would have been the appropriate way to handle it.

Thirdly, whether McCabe deserved to be fired or not, gleefully gloating about it is disgusting. If, indeed, he is guilty of some misbehavior that merited his termination, then that is a very somber matter that should not bring anyone joy. The fact that his firing DOES bring you joy makes it look as if you are celebrating something. Could you be rejoicing because this is one more part of an ongoing campaign to discredit McCabe, who is likely to be a witness against you in the Mueller probe? Are you celebrating because you view McCabe as an enemy who has been punished? You have publicly attacked him in the past and also have worked hard to undermine our federal law enforcement agencies. These attacks are right out of a dictator's playbook. No American president should ever behave in this way. McCabe's firing was NOT a great day for democracy, as you claimed in your ill-advised tweet. If you want to see a threat to democracy and the American people, look in the mirror.

March 23, 2018

President 45,

What a week. The operations of the White House have become a horrifying, chaotic spectacle as you lurch incoherently from one upheaval to the next, ignoring your advisers, presidential protocol and normal behavior. Swirling around it all is the ever-encroaching investigation into your campaign's ties to Russia, and a parade of women who say they have had sexual affairs with you or been groped without consent.

Here are a few highlights. You congratulated Russian thug Putin on his bogus election victory. News that your advisors told you not to do so immediately leaks. You seethed about it, and that information also immediately found its way to the press.

The stock market plunged because of your announcement that the U.S. will impose tariffs on China. Side note: You continue to show your basic misunderstanding of what trade deficits are and how they work.

Dear Oval Office Occupant

You continued to attack Special Counsel Robert Mueller via error-ridden tweet.

General McMaster, widely seen as one of the few remaining adults in your orbit, got the boot to make way for war hawk and lunatic John Bolton.

The work week ended with the bizarre signing ceremony for the omnibus spending bill, which followed your 11th-hour threats to veto it. The transcript of your remarks at that ceremony reveal a mind that is as confused as the staffing changes and what passes for policy in the West Wing.

In short, the executive branch is out of control. Chaos is not an acceptable strategy for running our nation. The world is watching, and it sees that America is weak and vulnerable, thanks to you. Please resign so our nation can begin to repair the damage you have inflicted.

March 24, 2018

President 45,

Today, at the March for Our Lives event in Akron, Ohio, I had the privilege of helping young people register to vote for the first time. You should be very worried. They are passionate, they are informed, they are engaged and they are voting in the midterm elections this year. These are the folks who will shift Congress from red to blue. And when that happens, impeachment won't be far behind.

By the way, since you claim that you aren't "petrified" of the NRA like other Republicans, why didn't you show up today to join the movement to end gun violence? If security was an issue, you could have sent a televised message. Could it be that you are afraid of the NRA after all?

March 28, 2018

President 45,

Tonight, I got to meet your old nemesis Walter Shaub at a lecture he gave. He is my hero for sounding the alarm early in your administration over your refusal to put your assets into a true blind trust. I also greatly admire him for his successful battle to get the White House to release a slew of ethics waivers (public documents you were withholding) that were granted to your inner circle.

He's still fighting the good fight, speaking out to ensure that the federal government is used to serve the people, not enrich government employees. It's a sickening shame that you have no scruples in that regard. You would have done well to follow his advice from the beginning. I thought you would like to know that he is alive and well, still telling the world about the nepotism, corruption and lack of transparency that are the hallmarks of your administration. And, not incidentally, he's obviously far smarter, better educated and a more gifted speaker than you. You are outmatched by this former career bureaucrat.

March 29, 2018

President 45,

You drove right by my house today; I was no more than 10 feet from your limousine. I hope you saw me. I was the one holding the "I love Mueller" sign, standing in front of the house with the "Resist" banner hanging on it. My 88-year-old mother also was there, holding a large sign that said "Resign." As one of your most faithful correspondents, it was very exciting for me to be able to convey my message to you in person.

Thanks for coming to our little town, screwing up traffic for hours and sucking up local tax dollars that could have been better spent on the actual needs of our community.

April 2, 2018

President 45,

I am writing to register my objection to the continued role your daughter Ivanka is playing in your administration, and specifically her role in the delegation that traveled to South Korea recently. She is unqualified. She has no business attempting to conduct diplomacy on behalf of the U.S.; her doing so is an insult to the career officials who have spent decades to become experts in this area, as well as to the various high-ranking members of the delegation who were forced to report to her. This shameless nepotism is un-American. When a Democrat becomes president in 2020, would it be OK with you if he or she similarly elevates an unfit relative?

April 3, 2018

President 45,

Once again, I received a paycheck that was larger than it had been in the past, thanks to the recent tax "reform" bill. Because of your continued attacks on freedom of the press, I have donated that money to the American Civil Liberties Union. I am glad to use those extra dollars to help fund the ACLU's fight against your un-American agenda.

April 11, 2018

President 45,

I am writing regarding your recent comment that the raid of your lawyer's office is "an attack on our country in a true sense." No, sir, it is not. Investigators followed the rule of law and obtained a subpoena because there is probable cause that a crime or crimes have been committed. On the other hand, Russian interference in our electoral process is an actual attack on our country. You have shown remarkably little interest in protecting our country from such an attack, which appears to be ongoing. You are acting like a very guilty man. What are you hiding? I have a feeling we will be finding out soon.

April 15, 2018

President 45,

My goodness, you really are obsessed with James Comey and his new book! Your tweetstorm this morning guarantees that sales will surge, putting lots more money in Comey's pocket. Was that your intent? I ordered it today, and am proud to have done my part to keep it on the best-seller lists.

You've developed something of a national book club. "Fire and Fury" continues to sell well, many weeks after it hit store shelves. I'm sure your attempts to squelch its release contributed greatly to its success. Additionally, "Russian Roulette" is doing quite well, and is on my nightstand now. I don't think you publicly weighed in on this particular book, but perhaps you should. It would be great for the authors' bank accounts if you would give their book a well-deserved "Trump bump."

Keep up the good work. Exposés on you and your administration are selling like hotcakes, giving the publishing industry a boost, and inspiring people across the nation to spend some time lost in a good read. On a related note, readership of the *New York Times* and *Washington Post* is way, way up. I have been enjoying my subscription to the *Times* very much for quite some time now — thanks for inspiring me to subscribe!

April 16, 2018

President 45,

In a proclamation declaring April National Sexual Assault Awareness and Prevention Month, you stated: "We must respond to sexual assault by identifying and holding perpetrators accountable." I couldn't agree more. Let's start by holding you accountable for all the times you groped, kissed or otherwise violated unwilling women and girls.

April 17, 2018

President 45,

I recently received a letter from the White House dated March 27. It was the usual boilerplate about your immigration policies. This is the third time your staff has sent this particular letter to me; it differed from the previous two only by the addition of a sentence about "chain migration" and the visa lottery.

It is disheartening, but not surprising, that this canned response is all your staff can muster in response to my outrage. I have written numerous times to protest the ill treatment of specific asylum-seekers, including the unlawful separation of children from their parents. I have written to object to the cruel detention of people — including a child

— who were receiving treatment for serious medical conditions when they were forcibly removed from their hospital beds by ICE agents. I have protested the detention and deportation of folks who have served our country honorably in combat and deserve our support and care. I have written to register my dismay that ICE can devote its limited resources and manpower to harming American children by detaining and deporting their taxpaying, hard-working parents, while actual criminal aliens are allowed to roam free.

Your letter states that "the Federal Government has the responsibility to enforce all laws passed by Congress." You are missing the point of my letters: Some laws are flawed, cruel and un-American. And other laws that are supposed to protect asylum-seekers and undocumented immigrants are routinely flouted by ICE and Border Patrol agents.

Instead of ordering investigations into abuses by immigration officials, you are cheering them on. And you should be showing leadership by pressuring Congress to create compassionate, legal routes to permanent residency for veterans; parents and spouses of American citizens; people who arrived here as children through no fault of their own; and the many others who fled danger and poverty and have become Americans in every way but one. Instead, you pulled the rug out from under Congressional leaders who crafted a bipartisan DACA bill. Instead, you demonize and dehumanize immigrants and refugees at every opportunity. Instead, you play on fear, ignorance, racism and hatred to gain support for your policies and your loathsome wall. Our nation needs a rational leader who can balance legitimate security needs with our long, proud tradition of welcoming immigrants and refugees, people who pay our country back by working hard, strengthening the economy and paying taxes. You are not that leader. It's time for you to resign.

April 27, 2018

President 45,

Two days ago, I had the privilege of joining other members of the grassroots group my husband and I founded, Unite Against Hate, on a special tour of the Maltz Museum of Jewish Heritage in Beachwood, Ohio. The tour is called "Stop the Hate" and covers the history of anti-Semitism, the Holocaust, the Klan and many other examples of hatred up to the present day. During the tour, we discussed the significant rise in hate incidents across the nation since the 2016 election, as documented by the Southern Poverty Law Center and the Anti-Defamation League. I just wanted to let you know that while you are fanning the flames of ignorance and bigotry, many wonderful people are working tirelessly to conquer hatred through education and kindness. I pray that kindness may win for the sake of our country and world.

P.S. Are you proud of the many documented incidents in which people hurl bigoted slurs at others while also invoking your name?

THE WHITE HOUSE

WASHINGTON

April 24, 2018

Mrs. Kathy S. Hayes
Richfield, Ohio

Dear Kathy,

Thank you for taking the time to express your views on issues
affecting our country. While we may not agree on every issue, as
your President, I pledge to work with Congress to find common
ground to make the United States stronger and more prosperous.
I look forward to the enormous opportunity we have to work
together in order to solve many of our most important problems for
the benefit of all Americans.

I appreciate hearing your thoughts and knowing we share the same
pride in our country and passion for improving it. If we unite, we
will make America stronger, freer, and greater than ever before.

Sincerely,

86

THE WHITE HOUSE

WASHINGTON

April 25, 2018

Mrs. Kathy S. Hayes
Richfield, Ohio

Dear Kathy,

Thank you for taking the time to write to me regarding the horrific shooting in Parkland, Florida.

As our Nation continues to mourn the innocent lives lost in this terrible act of evil, we pray for the victims and their families and ask God for comfort and strength. In times of tragedy, the bonds that sustain us are those of family, faith, community, and country. These bonds are stronger than the forces of hatred and evil, and these bonds grow even stronger in the hours of our greatest need.

As President, I have no higher obligation than to protect the safety of America and her people. I am committed to working with State and local leaders to help secure our schools and address the difficult issue of mental health. Undermining our Second Amendment rights, however, will not enhance our safety. Rather, my Administration will enforce Federal law and work with State and local officials to keep firearms out of the wrong hands and protect Americans from violent criminals.

As Americans, we must come together to create a culture in our country that embraces the dignity of life and creates deep and meaningful connections with our classmates, colleagues, and neighbors. Melania and I are keeping all of those affected in our thoughts and prayers.

Sincerely,

[signature: Donald Trump]

April 29, 2018

President 45,

I'm still waiting for a presidential press conference. It's been more than a year since the last one. The press deserves regular access to ask you tough questions on behalf of the American people. What are you afraid of?

May 4, 2018

President 45,

I am extremely disappointed that your administration has ended Temporary Protected Status for nearly 90,000 Hondurans who have lived here for decades. This is transparently a political move designed to appeal to your ardent supporters, with no consideration for the actual effects on the people involved, including the 53,000 American children born to these Hondurans.

Honduras is impoverished and one of the most violent nations in the world. Its ability to safely repatriate such a large number of people is doubtful at best. Honduran TPS recipients are rightfully afraid to return to their country of origin, particularly with their American children, who have known no other home than the U.S. The Hondurans want to stay and have woven themselves into the fabric of our nation. Forcing them to leave potentially puts them in danger and leaves them with the horrifying choice of tearing apart their families or raising their kids in an unsafe place.

The answer to the problem is obvious: Create a legal path to citizenship for these folks. Challenge Congress to do it. You've publicly

flopped on numerous prior opinions and decisions, including many of your most prominent hiring choices, so on the face of it, you shouldn't have any compunctions about changing your mind. However, these folks are brown and from a "shithole country," therefore the bottom line is that you just want them gone. "Make America white again" should be your motto — it would be more honest.

May 12, 2018

President 45,

Why didn't the White House issue an apology to Sen. McCain for the crude and insensitive comment from staffer Kelly Sadler? I think you would do well to listen to your wife. Although the name of her cause — Be Best — is bizarrely ungrammatical, the sentiment is correct. Why don't you try politeness for once?

May 13, 2018

President 45,

Sick. That's just one word to describe your invocation of the victims of the Parkland shooting while speaking to the NRA last week. It is quite clear that you have no shame.

May 14, 2018

President 45,

Let's have some fun analyzing one of today's tweets: "The so-called leaks coming out of the White House are a massive over exaggeration put out by the Fake News Media in order to make us look as bad as

possible. With that being said, leakers are traitors and cowards, and we will find out who they are!" Whew! There's a lot to unpack here, so let's get started.

The topic is "so-called leaks" — in other words, not leaks — that also are blown way out of proportion, and not true because the "fake" media is promulgating them for the sole purpose of casting aspersions on your administration. OK, got it. Not leaks. Exaggerated. Also, not true.

The tweet then pivots dramatically: "leakers are traitors and cowards." Whoa there, Nelly! So, now you are saying that there *are* leakers leaking after all! Furthermore, you believe that people (the best people) in your administration who reveal non-classified information to journalists have committed a crime that is punishable by death. Let's say it again: The president of the United States thinks that revealing unflattering information about his administration is equivalent to the crime of treason, which is punishable by death. Full stop.

The tweet ends with the threatening "we will find out who they are!" Yep, you have always been big on revenge.

Dictatorship. It's not just nepotism (Ivanka & Jared) and looting the public treasury (Mar-a-Lago jaunts), it's also about bullying and threatening your staff and criminalizing disloyalty.

When will you abandon the business suits and embrace dictator couture, complete with medals? Ivanka could have some of her underpaid workers overseas whip up some uniforms for you. They could easily be done in time for the military parade you have planned. Stop pretending you care about democracy and let your dictator pride show!

May 18, 2018

President 45,

How many times will I need to write this letter? Three months ago, it was 17 students and teachers dead in Parkland, Fla. Today it's 10 more kids and teachers in Texas. Who will die tomorrow? Or next week? Or next month? The names and locations change, but the heart-sickening tragedy is the same. Our country is awash in guns, and just about anyone can get their hands on one without much trouble.

I'll say it again, although I know it does no good. Congress, which apparently is largely composed of invertebrates, will follow your lead because you are the head of the majority party in both houses, which is a rarity. You have the power to push for the legislation that most Americans want. Close the gun-show loophole. Ban large-capacity magazines. Restrict the ability of those with serious mental illnesses to purchase guns. Ban the AR-15. Ordinary people aren't allowed to use tanks, grenades or rocket launchers, so drawing a new line at the AR-15 is not unreasonable.

And stop pushing the NRA's lies. The NRA represents the interests of gun manufacturers, period. It will say anything to sell more guns, and to hell with the blood running down the halls of our schools. Use your platform to attack the NRA agenda. You have the power to do something about this. The fact that you haven't, and won't, is the definition of evil.

May 24, 2018

President 45,

James Clapper, former director of national intelligence, dared to say it out loud: Russia turned the 2016 election in your favor. Alarm bells should be going off across the land because our nation's sovereignty is in peril. We must work together to understand exactly what happened so that we can prevent another such successful attack from a hostile foreign power. However, you and your cronies, including the majority of the Republicans in Congress, have no interest in getting to the bottom of this dire situation. In other words, staying in power is more important than the future of our nation. It is a dark day indeed for our country.

May 28, 2018

President 45,

In 1944, my father, fresh out of high school, shipped out for Europe as an infantryman in the U.S. Army. He was destined for the bloody Battle of the Bulge, a battle that left him severely wounded when a mortar shell exploded near where he and his buddies were dug in. My dad was lucky: He survived. Most of his comrades were killed. Although my dad did not die serving his country that winter, I still think of him especially on Memorial Day. He was permanently disabled and for the rest of his life suffered physically and mentally because of his war wounds. He died at 75 years old, far too young. I have no doubt he would have lived much longer if he had been uninjured; in essence, he sacrificed his twilight years in service to our nation.

Hundreds of thousands of young men like my dad died fighting fascism in WWII. Countless thousands more answered the call and were wounded. I think of them as well on Memorial Day.

On Memorial Day we expect our president to reflect on the serious-ness of the day, to remind us why we celebrate, lest some among us slip into believing it is merely a good opportunity for a barbecue. You fell tragically short of that expectation this morning with a self-congratu-latory tweet that made my heart sick:

"Happy Memorial Day! Those who died for our great country would be very happy and proud at how well our country is doing today. Best economy in decades, lowest unemployment numbers for Blacks and Hispanics EVER (& women in 18years), rebuilding our Military and so much more. Nice!"

My father was a gentle soul — a pacifist — and a passionate believer in integrity, fairness, human rights and human dignity. It is quite safe to say that he would not be proud of what you are doing to our country. I miss my dad, but I'm glad he isn't here to see the racism, the xenopho-bia, the misogyny, the corruption and, especially, the authoritarianism you, a five-time draft dodger, have unleashed. If you had one shred of dignity in you, you would resign in shame.

May 29, 2018

President 45,

Yesterday, I received an email from your campaign headquarters alert-ing me to a "Memorial Day sale" on the schlock you sell to raise money for your re-election bid. (Not incidentally, a big chunk of that money pays for the campaign's staggering legal fees.) The email instructed me to enter the code "remember" to get the 25 percent discount.

You fail to grasp the gravity of your role as commander in chief of our armed forces. Men and women are dying in service to our nation

on your watch. You have taken the solemn holiday set aside to honor them and perverted it into a clearance sale on a load of dreck.

I cannot imagine how deeply offensive and painful this sale would be to anyone who has lost a loved one in combat.

You owe a groveling apology to our Gold Star families. You owe an apology to our veterans. You owe an apology to our armed forces. You owe an apology to every American citizen. You clearly demonstrate again and again that you do not have the discernment, competence or moral compass to lead our country; resigning immediately is the only decent course of action left to you.

May 30, 2018

President 45,

The federal government failed to adequately help the people of Puerto Rico after Hurricane Maria. Harvard's recently released study pegs the death toll from the disaster at nearly 5,000 people. This is a tragedy of epic proportions, a tragedy that largely could have been avoided with effective leadership. You and your administration are not doing your job to protect American citizens. I think you should spend six months without electricity, a roof or clean water as a form of penance.

May 31, 2018

President 45,

Roxana Hernández, a transgender asylum seeker from Honduras, died on May 25 while in ICE custody. People who knew Roxana say that ICE did not provide her with adequate food and medical care and kept her

in a very cold room. Disturbingly, it appears that ICE's neglect and out-right abuse of detainees is becoming more commonplace. Specifically, LGBT folks may be especially vulnerable. For example, six transgender individuals have died in ICE custody within the last year.

It is doubly tragic that a woman fleeing lethal violence in her own country should reach the supposed safety of the U.S. only to die in federal custody after requesting asylum. I demand a full investigation not only into the death of Roxana, but into conditions at ICE detention facilities in general.

June 3, 2018

President 45,

For a couple of weeks, I have been mulling over your now infamous and controversial "animals" comment. Many people interpreted it as a broad-brush attempt to dehumanize illegal immigrants. Others believe that you were specifically referring to the members of the brutal MS-13 gang.

Within the context of that particular event, your words are ambiguous, mainly because they seem to be a non sequitur. However, within the broader context of your long history of racism, your continued demonization of immigrants and your harsh anti-immigrant policies, I think it's fair to say that this utterance was at the very least a dog whistle to your racist supporters. Not incidentally, it also sent a signal to law enforcement personnel that certain people are "less" than others and not entitled to the same rights and humane treatment.

A subsequent May 21 White House statement about MS-13 uses the word "animals" 10 times. This has a distinct "I'll show them" air

about it, an over-the-top, in-your-face doubling down on the offending word in response to your critics. To say that this is a weird, abnormal and bizarre White House communication is an understatement. I get the feeling that you specifically told the communications staff to use the word "animals" as many times as possible. It reminds me of a kid who has been reprimanded for swearing and then defiantly writes curse words all over a school notebook.

The White House statement ends by saying that the "entire Administration is working tirelessly to bring these violent animals to justice." That is not accurate. Firstly, many members of your adminis- tration have nothing to do with either fighting crime or immigration. Secondly, the deportation machine is spread thin: Instead of focusing on actual criminals, more and more federal resources are deployed to deport peaceful, law-abiding people, regardless of the harm it does to them, their families, their communities, and, in many cases, their American children and spouses.

Dehumanizing and debasing whole groups of people has turned out to be a successful political strategy for you. It is disheartening that a large segment of our populace — and our Congress — is OK with this. But I know that the majority of Americans are decent people who believe in fairness and judge people by their actions, not the color of their skin or their country of origin. This thought keeps me going during these dark times you have ushered in.

June 7, 2018

President 45,

I was recently able to aid a good cause: I donated money to help two women from El Salvador post bond and leave ICE detention. They had languished for months because the judge set the bond unreasonably high.

We treat people seeking refuge like criminals. I believe that we should welcome MORE people who come here fleeing violence and poverty, not fewer. Immigrants are willing to take jobs that are unattractive to most Americans. They are grateful to their new country and work hard to make a better life for their families. In the process, they give back to our communities. They pay taxes. The diversity they bring enriches our culture.

As you so frequently point out, unemployment is very low, so much so that employers are having trouble filling positions. Furthermore, because of ICE's heavy-handed tactics, many immigrants are afraid to come to work, leaving our food rotting in the fields. From an economic standpoint, it makes sense to increase the number of immigrants we allow in and treat those who are here with respect so they can work and take care of their families without living in fear.

Your harsh immigration policies and racist pronouncements are not only morally repugnant, they are counterproductive and shortsighted. It is unlikely that you will have a change of heart in this matter, therefore I will continue to lobby Congress to change our laws and support groups that are protecting immigrants' rights and fighting your administration's actions in court.

June 10, 2018

President 45,

"When will I see my papa?" That is the question 5-year-old José from Honduras asks his foster parents every day, as reported in the *New York Times*. José cries often, has trouble sleeping and clutches two drawings — one of his family and one of his father, who is in detention for crossing the border.

His foster family says it is heartbreaking to watch his suffering.

Multiply this suffering by the many hundreds of children forcibly separated from their parents in recent months by federal officials. This policy (YOUR policy!) is wrong, immoral, insupportable and cruel. It must end NOW, and you must resign. You are a fiend.

June 12, 2018

President 45,

Your behavior before, during and after the G7 summit was beyond embarrassing, it was deeply troubling. You showed up late and left early, which would have been bad enough. You suggested that Russia should be readmitted to the group. You called Prime Minister Trudeau "very dishonest and weak," an outrageous falsehood. Your spokesman Peter Navarro said (obviously with your approval) that Trudeau "deserves a special place in hell," which is really beyond the pale. To top it off, you withdrew from the joint communiqué the group worked so hard to create.

This is no way to treat our friends. You are an impetuous, petulant, spoiled toddler masquerading as a world leader. We will pay the price for your incompetence for decades to come, with shattered alliances, diminished power, lack of credibility and trade wars. I desperately long for a return to civility, diplomacy and negotiating in good faith.

On the plus side, the American people have reached out to Canada in many ways, including the thankCanada hashtag on Twitter. It is heartwarming to see how U.S. citizens really feel about our good neighbor to the North. I took it upon myself to send Prime Minister Trudeau a note of apology and assured him that the American people are working to rectify the humiliating situation we find ourselves in with your presidency. Could you please speed up the process by resigning?

Dear Oval Office Occupant

June 13, 2018

President 45,

You are woefully uninformed about your new best buddy Kim Jong Un and what conditions the North Korean people endure. North Korea is the most repressive regime in the world. Its people are malnourished. North Korea executes people for dissenting, consuming forbidden media and for engaging in forbidden religious activities. Whole families can be punished for the "crime" of one member. Political dissidents are tortured. In addition to presiding over the human rights disaster that is his country, Kim and his family have gotten rich at the expense of the populace. He is responsible for the deaths of family members whom he considered political rivals.

Yet, you lavished praise on Kim and claimed that his people love him. This is not normal. This is not OK. Not only are your comments sickening and disturbing, they only confirm to the rest of the world that you are a complete ignoramus and a dictator wannabe.

June 14, 2018

President 45,

It is beyond despicable that you are falsely blaming your own administration's policy on laws created by Democrats. Your administration publicly declared that it has implemented a new policy to criminally prosecute all immigrants crossing the border "illegally" — even those seeking asylum, a perfectly legal activity.

Furthermore, the stated reason for this policy — deterring illegal immigration — doesn't hold water. Do you think that all these folks

fleeing gang violence and drug cartels in Central America are sitting around watching TV, waiting to hear Sessions' proclamations? Many of them are simply fleeing to save their children's lives. They have no idea that their children will be taken from them and taken God knows where. What is your real reason for this new policy? I think it is to throw a bone to your supporters because you haven't built the wall yet. You are willing to break international law, torment innocent children and mortally wound the soul of our nation to score political points.

You and your administration and the brutes at ICE are to blame for the hundreds, perhaps thousands of children crying themselves to sleep tonight. YOU are to blame for the frantic parents who have no way of knowing where their children are. ICE agents are ripping babies from their mothers' arms, and it is YOUR fault. This is the kind of despotic behavior one would expect from the dictators you are so fond of. This atrocity must end. And you must resign.

June 17, 2018

President 45,

Marco Antonio Muñoz, a Honduran father, crossed the U.S. border in May with his wife and three-year-old son, seeking asylum, which is a perfectly legal activity. Just as any father would, he became agitated when agents said that the family would be separated from each other. Understandably, he would not willingly give up his child; agents forcibly took the child from him, in violation of international law and basic human decency. This 39-year-old father then tried to escape when agents attempted to transport him away from his wife and son to be jailed. Muñoz killed himself in his jail cell the next day.

You can tweet "Happy Father's Day!" all you want, but it won't change the fact that a son will never see his father again, and a father who

wanted to protect his family is dead. You and your minions are hurting fathers, sons, mothers and daughters every day. That harm is egregious and, in the case of Muñoz, irreparable. You are a father, but it is quite clear that the only children you care about are your own.

June 25, 2018

President 45,

Each day is a fresh opportunity for you to demonstrate your deep and wanton ignorance of our nation's laws and the Constitution. I cite yesterday's tweet: "We cannot allow all of these people to invade our Country. When somebody comes in, we must immediately, with no Judges or Court Cases, bring them back from where they came."

For your convenience, I have provided Section 1 of the Fourteenth Amendment below for your reference, with the pertinent words italicized.

All persons born or naturalized in the United States, and subject to the jurisdiction thereof, are citizens of the United States and of the State wherein they reside. No State shall make or enforce any law which shall abridge the privileges or immunities of citizens of the United States; nor shall any State deprive any person of life, liberty, or property, without due process of law; *nor deny to any person within its jurisdiction the equal protection of the laws.*

What your tweet advocates is the ability to throw anyone out of the country at any time for any reason. If we accept your proposal, then by extension we also accept the idea that all citizens must carry their birth certificates or passports at all times, or risk forcible and immediate removal from the country without recourse.

I can't decide which is worse: your authoritarianism or your stupidity.

June 30, 2018

President 45,

Today I was proud to join thousands of men, women and children at a rally in Cleveland to support a simple idea that all Americans can get behind: Families belong together. Blacks and whites and LGBTQ folks, senior citizens, Muslims and Latinas, Christians, immigrants and disabled folks all showed up in their beautiful diversity to demand that our nation treat immigrants decently and allow children to remain with their parents.

The Cleveland rally was part of a much larger movement. Tens of thousands — possibly hundreds of thousands — marched and demonstrated at more than 600 rallies coast to coast. The American people have spoken loud and clear: We are better than your heartless, cruel and racist policies. We will not allow you to destroy the soul of our nation.

July 1, 2018

President 45,

Back in 2015 you posted on Twitter that some journalists "are knowingly dishonest and basic scum. They should be weeded out!" At a public appearance you mockingly mimicked the disability of *New York Times* reporter Serge Kovaleski.

Since the inauguration, you have made at least 245 references on Twitter to "fake news" or the "fake media." In those references you have alternately directed your ire at individual journalists, news outlets or the media in general, using words and phrases such as: "dumb as a rock," "dishonest," "vicious," "fraudulent," "crazy," "dirty," "agenda of

hate," "out of control," "a stain on America," and a "sick and biased agenda." Also on Twitter, you have proclaimed that "Fake News is DISTORTING DEMOCRACY in our country" and, notably, that the media "is the enemy of the American People!"

At public rallies you called Chuck Todd a "son of a bitch" and said of the media in general: "I really think they don't like our country. I really believe that." During a Fox News interview in June you said "I was mugged by the media."

On July 2 of last year, you shared a video on Twitter that shows actual old promotional footage of you punching and wrestling a person whose head had been replaced by CNN's logo.

Last year, Republican congressional candidate Greg Gianforte attacked a reporter for *The Guardian*, an attack you chose to ignore. More recently, at your rallies you continue to whip up your supporters, who are increasingly observed screaming curses at journalists covering the events.

Therefore, I think you will understand why I view with utter contempt and disdain the hollow statement you made following last week's tragedy when a gunman killed five people working at the Annapolis *Capital Gazette*. You said: This attack … filled our hearts with grief. Journalists, like all Americans, should be free from the fear of being violently attacked while doing their job."

As far as I know, you have managed to refrain from criticizing journalists since this atrocity. I suspect that the effort has left you near the bursting point; I anticipate you will vent your spleen on the press sometime in the next few days.

THE WHITE HOUSE

WASHINGTON

July 2, 2018

Ms. Kathy S. Hayes
Richfield, Ohio

Dear Ms. Hayes,

Thank you for taking the time to write to me regarding the welfare of animals. I appreciate hearing from Americans on the issues important to them.

Your comments are valuable, and your suggestions help me better fulfill my duty to serve you and our Nation.

Thank you again for writing and for your concern for wildlife and pets. I encourage you to continue to stay connected by visiting www.WhiteHouse.gov and signing up to receive email updates.

Sincerely,

104

Author's note on the July 2, 2018, letter from the White House

The July 2, 2018, letter from the White House shown on the prior page thanks me for writing about animal welfare. As far as I can determine, this is in response to my June 3 letter decrying the president's use of the word "animals" to describe immigrants. Is anyone in the White House mailroom actually reading citizens' letters?

July 5, 2018

President 45,

I believe that you wouldn't be occupying the Oval Office if it weren't for the machinations of Vladimir Putin, who is the driving force behind Russia's interference in the 2016 election. You owe him a lot, which explains why you refuse to say a word against him. Furthermore, Putin is brilliant and a ruthless and shrewd negotiator. You? Not so much, as evidenced by your recent meeting in North Korea.

Thus, I find it alarming and beyond fishy that you plan to meet him without aides in Helsinki. What will you talk about? Will you give him the go-ahead to continue to blitz U.S. social media with inflammatory and divisive content ahead of the midterms? Will you assure him that the U.S. will look the other way as he poisons journalists and political rivals? What are you giving him right now for his help? There is literally not one single good reason for you to meet with him off the record. This can only mean bad news for America.

July 6, 2018

President 45,

Congratulations! You've set a record 61 percent turnover rate in your administration. There's no continuity, just turmoil and confusion

as aides and appointees whirl through the revolving door, some fleeing the toxic environment, others forced out with a cloud of corruption over their heads. You really can't blame anyone else: You picked these people and you are running this circus. You are completely incompetent. I demand that you resign. The American people deserve, at the very least, an executive branch that is functional.

July 22, 2018

President 45,

Last month, Nikki Haley, U.S. ambassador to the United Nations, announced our country's withdrawal from the U.N. Human Rights Council, labeling that body "hypocritical." While the HRC has its flaws, labeling it "hypocritical" is itself a fine example of hypocrisy, a case of the pot calling the kettle black. Haley, setting forth your administration's official position, accused the HRC of political bias, yet the U.S. has stood in support of human rights abusers who are political allies, both in its capacity as a member of the HRC and otherwise. You, yourself, have lavished praise on human rights violators, most notably Putin, Duterte, Kim and Erdoğan.

Furthermore, the U.S. itself has a long history of human rights abuses, including the separation of immigrant children from their parents at the border. It is not a coincidence that the U.S. withdrew from the HRC the day after the U.N. lambasted the U.S. for this tragedy of your own making. Obviously, you and your cronies can't tolerate an international body holding our country accountable.

On a related note, it is striking that the U.S. is the only nation that has refused to sign the Convention on the Rights of the Child, a situation that, unfortunately, I don't expect you to rectify. How we cannot be

party to a treaty prohibiting child pornography, child prostitution and child soldiers is beyond me.

The U.S. is now in the fine company of Eritrea, Iran and North Korea in refusing to participate in the HRC. Claiming that our delicate sensibilities have been violated by the HRC's flaws, while our own nation is violating human rights and basing decisions on political concerns rather than principles of human rights, is disingenuous. If we as a nation really care about promoting human rights, then we should rejoin the pre-eminent global body dedicated to that cause.

August 2, 2018

President 45,

I am deeply disturbed by your continued attacks on journalists. Your July 31 retweet of a video showing attendees at your Florida rally making obscene gestures and chanting "CNN sucks" clearly shows you condone such behavior. You continue to promote the lie that journalists are the enemy of the people. You whip up your suggestible followers to fear and hate journalists as if they were mass murderers. Someone in the media is going to get hurt, and it will be your fault. Furthermore, the damage you have done to our democracy by eroding trust in the Fourth Estate is incalculable.

August 4, 2018

President 45,

LeBron James, my hometown hero, is a self-made man. He started with nothing and through God-given talent and a staggering amount of hard work he made it to the top. Mr. James is a bona fide philanthropist

and a decent human being. He's young, good-looking and smart. No wonder that you, an insecure bigot, felt the need to cast aspersions on his intelligence. The only person looking stupid because of your tweet is you.

August 6, 2018

President 45,

When fires ravage large swaths of our country, when firefighters die and citizens lose their homes, the correct response is for the president to offer condolences and words of comfort. But not you. Every event, no matter how tragic, is an opportunity for you to spread discord and attack things you don't like (and don't understand), in this case, environmental laws and how California manages its water. I can't even imagine the suffering my fellow citizens are experiencing; your callous disregard for their misery is a slap in their faces. You are, quite simply, incapable of handling the most straightforward responsibilities of your job. Your impeachment can't come soon enough to suit me.

August 10, 2018

President 45,

Finally, nearly a year after Hurricane Maria, my fellow Americans in Puerto Rico have power. They also have just received confirmation of a truth that was self-evident: The hurricane killed many more people than the 64 tallied in the official count, probably about 1,400 souls. Who will be held accountable for the failure of our federal government to appropriately respond to the crisis, a failure that contributed to those deaths? I don't expect you to demand answers, order an investigation or fire those responsible, because in the immediate aftermath, you were the

dope jovially telling Puerto Ricans that they should be "proud" of the low death toll. You never did care about what was going on in Puerto Rico, and you still don't. If those folks were blond and blue-eyed, I bet your response would be very different.

August 11, 2018

President 45,

The pattern of illegality, deception and ill-intent is obvious. From the moment your administration implemented the zero-tolerance policy at the border until today, you and your lackeys have shown a complete lack of human decency, competence and integrity.

Firstly, children were forcibly taken from their parents with no intent to reunite them and no means in place to do so. Elizabeth Holtzman, a DHS Homeland Security Advisory Council member who resigned in outrage, said the failure to create records to track parents and children demonstrated "utter depravity." "This is child kidnapping, plain and simple," she wrote in her resignation letter.

Secondly, many of those targeted were seeking asylum; the government broke the law by not granting them the due process to which they were entitled.

Thirdly, numerous credible allegations of abuse and neglect of the children at the hands of their jailers have come to light. No, it was not like "summer camp," as one of your minions stated. Babies were left in dirty diapers. Children were forced to sleep in cold rooms with the lights on and told they would never see their parents again. Chillingly, detention facility staff medicated children with psychotropic drugs to keep them docile. A federal judge in Los Angeles ruled that this practice must stop.

After a judge ordered that your regime reunite the separated families, you failed to meet the court's deadline, largely because more than 400 parents were forcibly deported without their kids. Your thugs then claimed that 120 parents who had been deported had willingly left without their children. But in the face of court proceedings, your evil empire was forced to admit that it was only 34 parents who did so. Judge Dana Sabraw said: "The reality is, for every parent who is not located, there will be a permanently orphaned child, and that is 100 percent the responsibility of the administration."

And what is the latest outrage? Two asylum seekers whose case was before the court were deported while their hearing was in progress! Your administration wanted to deny them due process! District Judge Emmet Sullivan blew up and ordered them returned; he also threatened Attorney General Jeff Sessions with contempt of court, a threat I dearly hope he will make good on.

In short, you and those around you are duplicitous law breakers intent on ruining people's lives. You belong in jail.

August 15, 2018

President 45,

I shouldn't even have to say this: It is not OK for the president of the United States to call a woman a dog. Misogynists have long embraced that term to denigrate women for their appearance. Furthermore, racists in our country (yes, I'm including you) have long used dehumanizing language to describe people of color. Your horrifying tweet about Omarosa Manigault is a stomach-turning combo of sexism and bigotry. You are utterly unqualified to serve in any elected office in this nation. Please resign. You make me sick.

Dear Oval Office Occupant

August 21, 2018

President 45,

I have known all along that you were as guilty as sin, and now Michael Cohen has confirmed it, admitting that he committed campaign finance violations at your direction. His confession included the unsurprising information that you paid Cohen back the $130,000 he gave to Stormy Daniels to ensure her silence about your indiscretions just prior to Election Day.

Cheating, lying and crooked dealing have long made up your repertoire. Perhaps you finally will be held accountable. I'm hoping so; the country would be better off if you were behind bars.

August 22, 2018

President 45,

For a guy who claims to be all about "zero tolerance" and law and order, you are awfully squishy when it comes to Paul Manafort. I cite today's tweet: "I feel very badly for Paul Manafort and his wonderful family. "Justice" took a 12 year old tax case, among other things, applied tremendous pressure on him and, unlike Michael Cohen, he refused to "break" - make up stories in order to get a "deal." Such respect for a brave man!"

Are you saying that felonies aren't important if they were committed 12 years ago? What about the misdemeanor offense of crossing the border illegally if it occurred 20 years ago when the perpetrator was 5 years old? Are you ready to forgive people for that offense and feel "badly" for them?

I also take issue with your use of quotation marks around the word "Justice," an obvious attempt to negate the validity of the court's decision. How dare you dismiss the prosecutors and jury who worked so hard to do their civic duty? These continued attacks on the judicial process are an attack on our nation's rule of law.

Lastly, your phrase "respect for a brave man" speaks volumes about your character. Manafort is a convicted felon, a man who repeatedly and willfully committed fraud to make himself rich. He is not brave, nor is he worthy of respect. Yet, I fully expect that you will abuse your authority by granting him, a fellow swamp creature, a pardon. You are an embarrassment.

P.S. For your enjoyment, here are some language pointers so that you can improve your tweets in the future. "I feel badly" is incorrect. The correct phrase is "I feel bad," unless you are specifically referring to an impaired ability to feel. The phrase "I feel" generally takes an adjective, not an adverb. "12 year old" should be hyphenated (12-year-old) because it is modifying "tax case." The hyphen before the word "make" should be replaced with a dash. And "deal" doesn't require quotation marks, unless you are implying that you are referring to something that actually isn't a deal. You're welcome.

THE WHITE HOUSE
WASHINGTON

August 22, 2018

Ms. Kathy Hayes
Richfield, Ohio

Dear Ms. Hayes,

Thank you for taking the time to express your views regarding abortion.

The right to life is fundamental and universal. As President, I am dedicated to protecting the lives of every American, including the unborn, and to supporting women's health services.

As I have made clear, Federal funding should not be used for abortions, nor provided to organizations that have inadequate separation between their abortion and non-abortion activities. For this reason, I was proud to sign into law a bill that allows States to prioritize how they spend their Federal family planning grant money, including affording them the choice to withhold taxpayer funding from organizations that continue performing abortions. Also, in May 2018, the Department of Health and Human Services announced proposed updates to its regulations governing the Title X family planning program, which provides funding for family planning services for low-income or uninsured Americans. By requiring a clear financial and physical separation between projects funded by Title X and programs or facilities where abortion is performed or promoted as a method of family planning, the rule would ensure compliance with the program's existing statutory prohibition on funding programs in which abortion is a method of family planning. While the rule would prohibit Title X-funded programs from referring for an abortion as a method of family planning, it would not prohibit non-directive counseling on abortion.

Further, I am dedicated to ensuring that America does not fund abortions abroad. That is why one of the first actions I took as President was to reinstate and modernize the Mexico City policy, which ensures that American taxpayer dollars are not used to fund organizations that perform or encourage abortions in foreign countries.

At the same time, I remain deeply committed to investing in women's health and supporting Federal funding for programs that provide world-class services for women, such as cardiovascular care, breast and cervical cancer screenings, family planning and gynecological care, and obstetrics and prenatal care. I will continue to advocate for policies that promote better healthcare for women.

Thank you again for writing. Please visit www.WhiteHouse.gov to read more about how I am delivering on these issues for the American people.

Sincerely,

113

August 24, 2018

President 45,

More than 500 children remain separated from their parents. Their suffering is unimaginable. A lot of people should go to jail for this atrocity, starting with you, because you gave the order for it to happen. I want to know exactly who will be held accountable, and what reparations we will offer all the affected families.

August 31, 2018

President 45,

Earlier this week I joined some friends at a Panera to write 300 postcards reminding progressive voters to show up at the polls on Nov. 6. Studies show that handwritten notes are a surprisingly effective way to increase voter turnout. What is interesting about our little gathering is just how commonplace it is; countless concerned citizens across the country are doing the exact same thing every single day. They also are registering voters, phone banking, canvassing on behalf of specific candidates and making plans to drive voters to the polls. Locally, we have a large number of people who are extremely involved in such pursuits.

I think you are in for a surprise this fall. You and your crooked cronies may have the money, but we have the numbers. The American people will not stand for the lies, the corruption and the hate. Congress will flip this fall. Then let the impeachment proceedings begin!

September 2, 2018

President 45,

Even in death, John McCain is the bigger man.

Author's note on the September 2, 2018, letter

Senator John McCain was a war hero. Period. His love for and dedication to his country were unassailable, yet DJT famously disparaged the senator and former prisoner of war by saying "I like people who weren't captured."

After McCain's death, flags throughout the nation's capital flew at half-staff, with the notable exception of the flag atop the White House. The president initially refused to lower Old Glory in McCain's honor, and did not immediately release a statement about the senator's death. After an outcry, he ordered the flag lowered and released a statement … that began by referencing the men's differences of opinion. His behavior was the pettiest thing I have ever heard of.

Since then, 45 still hasn't let it go, periodically complaining about Senator McCain. Years after his death, Senator McCain still towers over the small man occupying the Oval Office.

September 4, 2018

President 45,

You're the guy who approved tax cuts that will expand the deficit by $1.5 trillion over the next 10 years. You're the same guy who is spending millions of taxpayer dollars every single weekend so you can golf at your resorts. And you're also the guy who announced just ahead of Labor Day weekend that he is cancelling the tiny pay raises of federal workers,

workers whose wages haven't kept up with inflation. When making that announcement, you had the audacity to cite a desire "to put our nation on a fiscally sustainable course," without any apparent awareness of the irony. What a slap in the face to federal workers. Yeah, you sure know how to look out for ordinary Americans.

THE WHITE HOUSE
WASHINGTON

September 4, 2018

Ms. Kathy Hayes
Richfield, Ohio

Dear Ms. Hayes,

Thank you for taking the time to express your views regarding military service by transgender individuals.

The United States military is the greatest fighting force in the world. Our brave men and women in uniform risk their lives each day to protect our freedom, and we owe them a debt of gratitude we can never repay. There are many factors and conditions that must be met to qualify for service; these restrictions are designed to maximize preparedness and lethality, so that our Armed Forces are ready and able to fight and to win.

As you may know, I have directed the Secretary of Defense and the Secretary of Homeland Security to return to the longstanding policy and practice on military service by transgender individuals that was in place prior to June 2016. I have directed them to do this until sufficient basis exists upon which to conclude that terminating that longstanding policy and practice would not hinder military effectiveness and lethality, disrupt unit cohesion, or tax military resources.

Thank you again for writing. Keeping our Nation safe and secure is my top priority and a fundamental function of our Government under the Constitution. I will uphold this sacred trust as your President.

Sincerely,

September 5, 2018

President 45,

There are fewer than 450 North Atlantic right whales left, and their situation is precarious. Your plan to allow energy companies to use seismic air guns for oil and gas exploration off the Atlantic coast must not go forward; it could spell extinction for these beautiful animals. Please put the health of right whales and our coastal waters ahead of the interests of Big Oil.

September 6, 2018

President 45,

I've got some doubts about your proposed "Space Force." Firstly, how are you going to pay for this new military branch? The deficit is projected to balloon by more than a trillion dollars under your leadership, you are still insisting that we need to spend billions on a border wall and you continue to fritter away millions every weekend on your golf jaunts. Meanwhile, many of our veterans and even active-duty service members are not receiving the care and services they need.

Secondly, the U.S. is a signatory to the Outer Space Treaty, which seriously limits the military activities we could legally pursue in space. The U.S. agreed that we will not test weapons or establish bases on the Moon or any other celestial body. Furthermore, the treaty prohibits us from placing weapons of mass destruction in orbit. That does leave open the possibility that we could use conventional weapons, but that activity could be on shaky legal ground; I think it violates the spirit of the treaty, which says that the peaceful exploration of space is for the benefit of all nations and that all countries are free to explore space.

I don't know how a U.S. military presence in space would be "for the benefit of all nations."

Please, if you want to protect us from something, direct more government resources toward defending our elections from Russian hijacking. Oh, wait, that's the one kind of attack on our country that you're ok with. How does it feel to be Vlad's tool?

September 11, 2018

President 45,

One day. Just one full day of you acting presidential was too much to expect. On this date when we remember one of our nation's worst tragedies and mourn the loss of so many lives, you greeted the morning by tweeting about your purported innocence of collusion with Russia. Shortly thereafter, you shared this doozy on Twitter: "17 years since September 11th!" Why on earth is there an exclamation point at the end? What is there to be excited about?

Next, you treated those gathered for a memorial service in Pennsylvania to a display of triumphant fist pumps as you arrived. Did it not occur to you that some of those in attendance may have lost loved ones on that evil day? The fist pumping was followed by numerous thumbs-up gestures.

Your inability to recognize and respect the feelings of others is both pathological and tragic. Is there anyone left in the U.S. whom you haven't offended?

September 15, 2018

President 45,

Francis Anwana arrived in the United States 35 years ago on a student visa, when he was 13 years old. He is deaf, has cognitive disabilities and lives in a Detroit adult foster care facility, where he is a model resident. Somewhere along the way, his caretakers lost track of his paperwork and failed to renew his visa. Now, ICE plans to deport him to Nigeria.

This gentle man is hurting no one. He is a threat to no one. He is happy here and has no understanding of what deportation means. Advocates say that returning him to Nigeria is equivalent to a death sentence. Do our immigration officials have no means by which they can exercise discretion anymore? Or is this now the preferred U.S. policy — to be as cruel as possible at every opportunity? It is within your power to stop this inhumanity. Will you?

September 22, 2018

President 45,

Climate change is already here. Look at North Carolina. Look at the fires out West. Look at how "500-year" floods are coming every few years.

It is long past time for the U.S. federal government to lead the way to protect the planet for future generations. But since you and your cronies have nothing to gain financially from promoting renewable energy and conservation, it's not going to happen under your watch. Gutting the EPA and freeing businesses to pollute are much more your style.

Fortunately, mayors and city councils across the country are showing true leadership by ignoring your abandonment of the Paris Accord; they are committing their cities to converting to 100 percent renewable energy. My beloved Cleveland is the latest to get on board. It heartens me that the American people, despite a lack of moral guidance from the highest office in the land, still step up to do the right thing. Frankly, we don't need you. Please step aside and get out of our way.

September 23, 2018

President 45,

I am concerned that National Security Adviser John Bolton recently declared that the International Criminal Court is "illegitimate," "ineffective," and "dangerous." The world must have a mechanism for holding despots and warlords accountable for crimes such as genocide. The ICC is that mechanism. The robust participation of the U.S. in the ICC is necessary to strengthen and improve the court. We must show the world that the U.S. is a defender of human rights. Denigrating and abandoning the ICC is a lousy idea. (As was hiring John Bolton.)

THE WHITE HOUSE
WASHINGTON

September 25, 2018

Ms. Kathy Hayes
Richfield, Ohio

Dear Ms. Hayes,

Thank you for taking the time to express your views regarding trade policy.

Open, fair, and competitive markets increase opportunities for American workers and employers and contribute to a higher standard of living. Many Americans, however, have not seen clear benefits from international trade agreements. For too long, other nations have engaged in unfair trade practices, gamed the system, and taken advantage of America. This must stop.

My Administration will modernize and improve existing trade agreements, negotiate new trade deals based on fairness and reciprocity, reform the international trade system, and take strong enforcement actions against trading partners that break the rules.

This work is well underway. We have begun negotiating to modernize the North American Free Trade Agreement (NAFTA), which was signed before the internet was a part of daily life, and we are seeking substantial improvements to the United States-Korea Free Trade Agreement to give American workers a fairer deal.

My Administration is using available leverage to ensure that more markets are truly open to American goods and services, and I am prepared to make new bilateral trade agreements with any nation that wants to be our partner and will abide by the principles of fair and reciprocal trade. We are working with like-minded nations to bring much-needed reform to the World Trade Organization, which has not always been fair to American interests.

I will not tolerate unfair trade practices that harm American workers, farmers, ranchers, and businesses. The United States Trade Representative has already initiated an investigation of possible discriminatory trade practices by China, and other enforcement actions are ongoing.

Thank you again for writing. To learn more about what I am doing to ensure that trade deals work for all Americans, please visit www.WhiteHouse.gov. As President, I am committed to expanding trade in a way that is fairer for the United States and leads to a more effective and balanced world trading system.

Sincerely,

121

THE WHITE HOUSE

WASHINGTON

September 26, 2018

Ms. Kathy Hayes
Richfield, Ohio

Dear Ms. Hayes,

Thank you for sharing your views on energy and environmental policy.

My Administration is strongly committed to environmental protection, including keeping our air and water clean and being good stewards of our environment. This requires all of us to do our part, and I want to thank you for your commitment to preserving our environment for future generations.

As we continue to protect our environment, we must also ensure that American workers have greater opportunities to provide for their families. That is why my Administration is also committed to protecting American workers and American companies from unnecessary regulatory burdens. Going forward, regulations must balance our stewardship of the environment with the needs of a growing economy.

Thank you again for sharing your views. As President, I am committed to unleashing America's economic potential, while also protecting the environment. I am confident that together we can preserve America's natural blessings for future generations.

Sincerely,

October 1, 2018

President 45,

Watch out, your misogyny is showing! I am referring, of course, to your bizarre comment today to journalist Cecilia Vega, "I know you're not thinking. You never do." This particular press conference also featured you interrupting, shouting at and wagging a finger at other women reporters. That's quite a repertoire of disrespectful behavior for one event. Of course, none of this is a surprise. After all, you're the guy who bragged about grabbing women by the pussy, walked in on teenaged beauty pageant contestants, publicly cheated on his wives and said about women: "You have to treat them like shit." And that's just the tip of the chauvinism iceberg; I could go on about your numerous public instances of denigrating the looks and intelligence of accomplished women, but I will refrain so that I can keep this missive to only one page.

I thank God I was raised by a kind, gentle and decent father who respected women and girls as equals. I also am grateful for my husband and son, both of whom treat women and girls with the honor and dignity they deserve. In fact, I am fortunate to spend most of my time around good guys, men who would never dream of behaving as you do.

It is disturbing and deeply sad that you are unable to comprehend the true worth of half the human race. And it is tragic that you and your Neanderthal attitudes are on full display at the pinnacle of our system of government. Please resign; you are shaming our country every day that you remain in office.

October 3, 2018

President 45,

I am still steaming mad that last night you publicly mocked Dr. Ford, a private citizen. Additionally, I'm appalled that you are claiming that men, not women, are being treated unfairly. Women falsely accusing men of sexual assault is a rare phenomenon. However, men raping women and getting away with it is tragically commonplace. I find it absolutely shocking that there is even one woman left in this country who supports you. Your behavior and comments are not only unpresidential, they are inhuman. Please resign. I'm sick of listening to your garbage.

October 4, 2018

President 45,

How does it feel to be exposed in the *New York Times* as a cheater, tax-dodger, crook and complete fraud? You reap what you sow, buddy.

October 6, 2018

President 45,

Today, Brett Kavanaugh joined the Supreme Court.

This is a man who has been accused of sexual assault by multiple women who had nothing to gain by coming forward. This is a man who plainly lied, exaggerated and dodged questions under oath. This is a man who was born with a silver spoon in his mouth, yet claims that he achieved success purely through hard work. This is a man who displays a breathtaking sense of entitlement. This is a man who is quick to blame

others for his inability to keep his anger in check. This is a man who deepens divisions with partisan rhetoric.

Does that sound familiar? It should, because the nation's newest judge is the perfect reflection of your temperament, priorities and morality. Not content with debasing the administrative and legislative branches, you have managed to infect the judiciary, as well. Congratulations. It will take generations to restore the nation's faith in our courts.

October 9, 2018

President 45,

The ICE detention facility in Adelanto, Calif., is abusing, neglecting and clearly violating the civil rights of detainees. This was made plain after the Department of Homeland Security Office of the Inspector General released its findings from a surprise inspection.

These folks, many of whom are desperate asylum seekers, are in civil detention, but are being treated worse than criminals. A disabled man was left in his wheelchair for nine days. Detainees have no way to seek legal counsel. One man had multiple teeth fall out because he had no access to dental care. Guards inappropriately used physical restraints. Worst of all, Adelanto staff have been cavalier about preventing suicides, an alarmingly common problem in ICE detention facilities.

I'm not calling for cleaning up the Adelanto facility. I'm asking you to shut it down. I want ALL of those detainees released and financially compensated for their cruel treatment. Additionally, those seeking asylum should have their cases fast-tracked for quick resolution. It is absolutely unconscionable that my tax money is being spent to torment fellow human beings.

October 20, 2018

President 45,

This morning I was pleased to donate to the campaign of Stacey Abrams, who hopes to be the next governor of Georgia. Later, I saw that you had been tweeting about the Georgia governor's race. Unsurprisingly, you endorsed the voter-suppression king, Georgia Secretary of State Brian Kemp, citing his success "at whatever he has done." Presumably, you approve of his success in preventing people of color from voting.

The tweet featured this rich bit of irony: "His opponent is totally unqualified." With her law degree, history of public service and six years in the Georgia Statehouse, Abrams is eminently qualified to serve as Georgia's next governor. And who are you to make such a judgement about Abrams? With no prior experience in public service, the law or elected office, you are the least-qualified person to occupy the Oval Office in my lifetime, or possibly ever. When we throw in your countless incidents of bilking contractors, an extensive history of evading taxes and your lack of scruples about Russia helping your campaign, it is clear that you are also the most corrupt president in my lifetime. The way I see it, the only position you are qualified for is prison inmate.

October 21, 2018

President 45,

I shouldn't have to say this, but, unfortunately, I must: It is not ok for you to call any woman "horseface."

October 24, 2018

President 45,

Your administration, via the Department of Health and Human Services, is considering legally defining "sex" as "a biological, immutable condition determined by genitalia at birth," according to reporting from the *New York Times*. This would be a dangerous step backwards for the civil rights of transgender and nonbinary individuals as it could have broad-reaching implications for protection from discrimination under the law.

Aside from that important point, such a proposal is ridiculous because it ignores biological fact: Not everyone is born with either the XX or XY combination of chromosomes, or even definitively "male" or "female" genitalia. Human sexuality is far more complex than we are led to understand in middle school health class. What will become of the thousands upon thousands of Americans who physically don't fit neatly into one of the two proposed boxes? This proposal needs to be consigned to the rubbish heap, and is yet another example of how your administration chooses to ignore science when it doesn't suit your purposes.

October 27, 2018

President 45,

"I'd like to punch him in the face." "Maybe he should have been roughed up." "The audience hit back. That's what we need a little bit more of." "Knock the crap out of him, would you?" The previous sentences are all statements you made regarding Americans who dared to exercise their First Amendment rights by protesting at your rallies.

"Any guy who can do a body slam, he is my type!" In this recent remark, you express your approval for Rep. Greg Gianforte's assault on a reporter doing his job.

And who can forget when you tweeted a video depicting you beating up a person whose head had been replaced with the CNN logo?

In contrast, here's the number of times that the mainstream media (the *Wall Street Journal*, *USA Today*, the *New York Times*, the *Washington Post*, NPR, CNN, MSNBC, etc.) have condoned or encouraged violence: Zero. Yet, following the news that a terrorist had mailed bombs to some of your most vocal critics, you blamed the mainstream media for the "anger" in our society.

It is a fact that you publicly promote violence against people who criticize you. Instead of blaming journalists, you should look in the mirror.

October 28, 2018

President 45,

Amid the horrors of the past week I carved out a little bit of peace, writing letters and postcards reminding my fellow Americans to vote. For example, I wrote 300 notes to voters in key districts as part of the Need to Impeach campaign. It felt good to be among the thousands of people across the country who committed to sending 1.5 million personal messages to voters who believe that you are unfit to serve. I also helped organize postcard parties recently where friends and I prepared get-out-the-vote postcards on behalf of the ACLU and Vote Forward.

As I wrote, I found myself feeling a connection to each stranger, realizing that even though we don't know each other, we share a love for our country and a desire to put it on the right path again.

It is heartening to know that many millions of my fellow Americans care passionately about the wellbeing of our democracy and are willing to spend time, money and energy to protect it. I know people who are making phone calls on behalf of Democratic candidates multiple times per week. I know others who are canvassing weekly, or even more often. I have friends who are giving money to Democrats' campaigns — for many, this is the first time they have ever felt the need to donate. I even know a few folks who are doing all three things; needless to say, their time is full and their wallets are lighter.

This is the silver lining of your presidency. Your misogyny, incompetence, racism and anger have motivated countless good souls to fight for the country they love. Despite the divisions you continually stoke, I believe that the general decency of the American people will again prevail, beginning with our choices at the ballot box on Nov. 6. Let the hard work of healing begin as we elect leaders who will hold you accountable for your authoritarian, unethical and un-American policies, actions and rhetoric.

October 29, 2018

President 45,

I am still reeling from the murder of all those innocent people at the Tree of Life synagogue. Even now I am not sure I have collected myself enough to write coherently on the subject, but I will try.

Your suggestion that things would have turned out differently had the congregation had armed guards was a callous example of blaming the victims. How foolish of worshipers not to protect themselves, you seem to be saying! If only they had had the brains to pay for armed guards! You miss the point entirely; instead of arming everyone to the

teeth, let's create an America where people can worship without violating the tenets of their religions by arming themselves. Sanctuaries, by definition, are places set apart from violence and weaponry.

To help prevent the next atrocity, we must address the multiple elephants in the room, the first of which is the ocean of guns drowning our nation and, more specifically, the availability of the AK 47, the gun of choice for mass shooters. We desperately, desperately need universal background checks that will keep guns and/or ammunition out of the hands of domestic abusers, criminals and those suffering from severe mental illnesses. Furthermore, it is time to outlaw the AK 47. Citizens do not have the right to own anti-aircraft guns; I don't see any problem with drawing a similar line at the AK 47. Your refusal to support such measures is unconscionable.

The second pachyderm in the room is the precipitous rise in anti-Semitism, white nationalism, hate crimes and open racism during the past two years. Not only is your administration doing nothing to fight these scourges, you have fostered such hate with your open demonization of immigrants, Muslims, Mexicans and others, as well as your "both sides" false equivalencies. You are aided and abetted in this campaign by your cronies at Fox News, who are only too willing to spread your lies and misinformation.

The last elephant on my list is this: the mass shootings, mail bombings and other acts of domestic terrorism are overwhelmingly committed by U.S.-born white men. Your efforts to stoke fears among the populace about the supposed dangers of immigrants and Muslims are a complete red herring; the people we need to worry about are white, male, homegrown terrorists radicalized on the internet. Frightening people over bogeymen to serve your political purposes is immoral and dangerous.

My heart goes out to all those injured in Pittsburgh and the families of all the victims. I will strive to honor their memory by working for peace and tolerance, as well as continuing to speak truth to power.

November 3, 2018

President 45,

Here's what I wanted to hear from the president when the caravan of refugees began approaching Mexico:

My fellow Americans, as you may already know, a large number of desperate families fleeing violence and poverty are traveling together on foot from Central America to Mexico and possibly further North to the southern border of the United States. Today, I spoke with the president of our close ally Mexico and offered to provide any assistance he may require to avert a potential humanitarian crisis.

Furthermore, I have been in touch with the Pentagon to make sure that a limited number of troops, including medical personnel, will be available to assist should a large number of these refugees reach our border in the coming weeks. Those troops would help maintain order and ensure that every man, woman and child requesting asylum has a safe place to sleep, food to eat and medical care while waiting for border officials to process their claims. Additionally, I have been in touch with the governors of Texas, New Mexico and Arizona to let them know that members of my administration are available at any time to help, should the need arise.

Lastly, I have spoken to the head of the American Red Cross and have been assured that it also is monitoring the situation carefully and stands ready to assist, so that every brave person who has struggled to reach the promise of our shores is cared for with kindness and dignity.

As I have made clear, I take the security of our nation very seriously. I have faith that the professionals protecting our border will continue to do their jobs carefully and thoroughly so that no criminals enter the country. America is at its best when it is compassionate in its strength. I am personally monitoring this situation as it evolves to ensure that we meet our legal and moral obligations to every person with a legitimate asylum claim, while also turning away any who wish to harm us.

Honestly, this shouldn't be hard: It took me no more than 10 minutes to write the preceding paragraphs. The problem is, you've got that little brownshirt, Stephen Miller, writing your "American carnage" speeches and telling you that your racism is OK. It's not. Please resign.

November 4, 2018

President 45,

Today, my church congregation had a special collection to support HIAS, the Hebrew Immigrant Aid Society, in solidarity with and in honor of the members of the Tree of Life Synagogue. But that is only a small part of the story. The Jain, Hindu, Buddhist, Sikh, Lutheran and Catholic communities within our town also took up special collections to support HIAS. I was humbled to be a part of this communal effort to support such a noble cause.

A huge outpouring of support for our Jewish brothers and sisters has come from the American Muslim community. Those good folks have raised hundreds of thousands of dollars to pay for funerals, medical expenses and other needs of those affected by the horrific attack on the Tree of Life Synagogue.

Why am I telling you all this? Because in the absence of moral leadership in the White House, the American people, the ordinary folks in

ordinary towns like mine, are stepping in to fill the void. We care about basic human decency, fairness, inclusion, diversity, peace and justice, and we will not be deterred. We will continue to do the hard work of making our country a safe, just and welcoming place for all, in spite of the hate and division you spread.

November 6, 2018

President 45,

This morning I received an email from your campaign with a message from you reminding me to vote. Your message read, in part: "We absolutely cannot hand over control of our country to the Democrats who have used violent rhetoric to incite mob rule, harassment, and ruthless intimidation tactics to impose their radical agenda of open borders and socialism. To give them the keys to our country would be no different from handing matches to arsonists."

Once again, you are promulgating a pile of venomous lies to frighten gullible people and vilify those who disagree with you. This dangerous language is completely unbecoming of the commander in chief.

Your email is a great reminder of why I chose to vote for every Democrat on the ballot today. If this makes me in favor of mob rule, radical agendas, socialism and arsonists, so be it. Cheers.

November 7, 2018

President 45,

It was no surprise that you asked Attorney General Sessions to resign today — I also found it predictable that you didn't have the balls to

fire him outright, or deliver the message to him in person. I knew this would be an essential step in your plan to derail the Special Counsel's investigation into Russian interference in our election and any coordination it may have had with your campaign. Therefore, bypassing Rosenstein for the position of acting AG today also was completely expected. However, since Acting AG Whitaker has been openly critical of the Mueller probe, he also should recuse himself from overseeing the investigation.

You continue to claim that the investigation is a "hoax" and a "witch hunt." If that were true, you would have nothing to worry about and could let it run its course. You are acting like a very worried and very guilty man.

P.S. I called Senator Rob Portman today to urge him to do everything in his power to support and protect the Special Counsel's investigation.

November 9, 2018

President 45,

Twelve died in a mass shooting, and it was just another Wednesday in the U.S.A. In the last couple weeks, men bent on carnage and terror have gunned down innocent Americans practicing yoga, shopping for groceries, attending synagogue and enjoying music at a bar. These bloodbaths are so commonplace now that they often don't hold the headlines for more than a day.

It's long, long past time for Republicans to get on board with universal background checks and other reasonable measures (measures supported by the vast majority of Americans) to get guns out of the hands of criminals, domestic abusers and the dangerously insane. You have the

power to help fix this tragic state of affairs, but since the killers aren't immigrants, members of ISIS or people of color, you turn away and murmur platitudes about thoughts, prayers and treating mental illness, while simultaneously suggesting that we turn our schools and houses of worship into armed fortresses.

I have zero confidence that you will choose to do anything to protect me and the rest of the country from this epidemic. Furthermore, Republican lawmakers have abdicated their responsibility by prostituting themselves to the NRA. Therefore, today I am making yet another donation to Gabby Gifford's PAC in the hopes that her vision of a safer America will be realized. True leadership, something you are incapable of, is coming from those whose lives have been forever altered by gun violence. I stand with them.

November 20, 2018

President 45,

Wantonly casting aside even the pretense of possessing scruples, you have officially given Saudi Arabia and other bad actors the green light to murder journalists and other critics with impunity. Your poorly written statement today (with the heading "America First!") clearly spells out that what the U.S. really stands for is making lots of money selling arms to evil people.

From Saudi involvement in the attacks on 9/11 to the bombing of civilians in Yemen, to the barbaric murder of Jamal Khashoggi, the kingdom has been hip-deep in nefarious goings-on for decades. With your cowardly exoneration of MBS and the kingdom you are now officially complicit in their crimes. Criminals don't belong in the White House; it's time for you to resign.

November 22, 2018

President 45,

On this day of thanksgiving, I am, of course, grateful for myriad blessings I enjoy. But I find myself especially thankful today for the Judicial Branch of the federal government.

Specifically, I am appreciative that Judge Jon S. Tigar issued a restraining order blocking your rule that would have prohibited immigrants from seeking asylum if they enter the country anywhere but an official port of entry. Judge Tigar's order reads, in part: "Whatever the scope of the president's authority, he may not rewrite the immigration laws to impose a condition that Congress has expressly forbidden." These wise words show that the federal judiciary is fulfilling its role as a branch coequal to the executive branch. Judge Tigar has my gratitude.

Additionally, I am thankful that Supreme Court Chief Justice Roberts saw fit to publicly explain to you that judges are not partisan hacks ready to serve your every whim. Sadly, you seem to be laboring under the misapprehension that, like an authoritarian dictator, you can direct the courts to do your bidding. Chief Justice Roberts deserves a big thank you for defending the integrity and independence of the courts.

November 23, 2018

President 45,

Yes, the irony is staggering: Your daughter used a private email account for official White House business and claims to have had no idea that it was wrong. I can't blame all those who are calling you a hypocrite for not seeking to "lock her up." However, the more important legal

question is: What is she doing working in the White House in the first place? Her presence in the West Wing is nepotism, pure and simple. Everything she does in an official capacity is illegal by definition. Lock her up? The courts will have to decide on that matter. But for now, how about throwing her out?

November 24, 2018

President 45,

"He's not a war hero. He was a war hero because he was captured. I like people who weren't captured." With that statement in 2015 about Sen. John McCain, you launched your ignominious hobby of dishonoring the nation's troops and their families.

You were publicly disrespectful to Mr. and Mrs. Khan, whose son was killed in combat.

You bungled a call to the widow of Sgt. La David T. Johnson, causing her further distress. Instead of graciously apologizing, you publicly suggested that the grieving widow was a liar.

Nearly two years into your occupation of the Oval Office you have not visited troops in combat zones.

You used troops as political pawns by sending them to the U.S.-Mexico border as a vote-getting stunt before the midterm election.

You couldn't be bothered to visit Aisne-Marne American Cemetery in France with other world leaders to commemorate the 100th anniversary of the end of WWI. Nor could you take an hour on Veterans Day to honor service members who rest in Arlington Cemetery.

You publicly criticized former Navy SEAL Admiral William H. McRaven, saying he should have killed Osama bin Laden sooner. (McRaven and his team performed their mission within hours of learning of it.)

Then, on Thanksgiving, you performed a traditional duty of the president by calling members of the armed services serving abroad. If you had stopped after expressing gratitude for their service, all would have been well. But, as usual, you couldn't stick to the script, and decided to grouse about the judiciary and brag about border security and the economy, unnecessarily politicizing the call and drawing attention away from the troops and onto yourself.

You are the commander in chief of the nation's armed forces in name only. You are incapable of providing the leadership our brave service members deserve. It is long past time for you to resign.

November 26, 2018

President 45,

Our government tear-gassed children and babies at the Mexican border, and you're defending it.

This could have been handled completely differently. A competent leader would have appointed ambassadors to Guatemala and Honduras to engage the governments there about problems that are driving the exodus of their citizens. A competent leader would have worked to build up the number of immigration judges so that asylum claims can be processed expeditiously. A competent leader would have offered humanitarian assistance to Mexico to help it care for migrating refugees with dignity. A competent leader would have sent additional

personnel to the border to process asylum applications. A competent leader would have marshalled aid organizations, federal agencies and yes, even the military, to make sure that all asylum applicants receive food, shelter and medical care while their claims are being processed. A competent leader would not have ended the cost-saving Obama-era policy of releasing asylum applicants with tracking bracelets to ensure that they attend their hearings while allowing them the basic human dignity of freedom of movement.

You manufactured this crisis at the border. You slowed legal entry into the country to a trickle, forcing desperate people to languish outdoors for months in the hope that they would be able to enter and request asylum — which is their legal right. It's no wonder that they organized a peaceful protest. And it's not surprising that some, reaching their breaking point, tried to force their way across the border. What is horrifying, is how government agents responded.

Our government tear-gassed children and babies at the Mexican border, and you're defending it.

November 29, 2018

President 45,

It is obvious today that Michael Cohen has told Robert Mueller everything he knows. And I've noticed that you appear a little on edge lately. Is something worrying you?

Dear Oval Office Occupant

THE WHITE HOUSE

WASHINGTON

November 30, 2018

Ms. Kathy Hayes
Richfield, Ohio

Dear Ms. Hayes,

Thank you for taking the time to express your views regarding relations between the United States and North Korea.

On June 12, 2018, I met with Chairman Kim Jong Un of the Democratic People's Republic of Korea (DPRK) in Singapore. No other United States President has taken such a bold step, but I felt it was necessary because the DPRK's nuclear and ballistic missile threat against the United States and the entire world had become unacceptable.

As a result of this historic summit, Chairman Kim committed to achieve the complete denuclearization of the Korean Peninsula. Multiple United Nations Security Council resolutions require North Korea to eliminate all of its weapons of mass destruction and ballistic missile programs. The final, fully verified denuclearization of the DPRK, as agreed to by Chairman Kim, remains the United States' policy. Sanctions will remain in effect until the DPRK denuclearizes.

In addition, Chairman Kim and I committed to recovering the remains of those brave Americans who made the ultimate sacrifice in the Korean War, including the immediate repatriation of POW/MIA remains already identified.

Ensuring the protection of human rights remains a key focus of the United States' policy toward the DPRK. I raised the DPRK's human rights record during the Singapore Summit, and my Administration will continue to raise this issue going forward. Our commitment to achieving the denuclearization of the Korean Peninsula does not minimize our efforts to press the DPRK to respect the fundamental freedoms and human rights of its citizens.

While much progress has been made to establish relationships between the United States and the DPRK, there is still much more work to be done. The Singapore Summit was a first step, and I remain determined not to make the mistakes of past administrations. Our eyes are wide open, but peace is always worth the effort.

Thank you again for writing. As President, I look forward to working with our friends and partners around the world, whose values and interests align with those of the United States, to promote peace, prosperity, and the security of the Korean Peninsula and of the world.

Sincerely,

140

Dear Oval Office Occupant

December 1, 2018

President 45,

Every night, Mike Benavides, Sergio Cordova and a handful of volunteers cross the U.S. border into Mexico to feed and clothe stranded asylum seekers. The couple goes even further, hosting dozens of asylum seekers in their own home and providing them with necessities before they make the next leg of their journeys. The men have done this for months, using money from their own pockets, as well as donations. The couple's GoFundMe page has raised about $38,000; I was happy to make a donation recently and hope that a few folks got a hot dinner on me.

Benavides, Cordova and their helpers are true humanitarians and an inspiration to any who have heard the story of their big-hearted kindness. But their generosity shouldn't even be needed; if we didn't have your bigotry and political calculations guiding our actions at the border, the U.S. would be completely capable of processing all of the men, women and children seeking asylum in a timely and humane manner.

When I think of the selfishness, greed, fear and hatred running rampant in your administration, I begin to think there is no hope for our country. But then I read about good people like Benavides and Cordova, and my faith in our nation is restored. They are the ones who make America great. They will persist in bettering our country long after you are impeached.

December 6, 2018

President 45,

Humble, gracious, dignified and kind are just a few of the words used in recent days to eulogize President George H. W. Bush, a man who led an extraordinary life, much of it spent in service to the nation. Being human, he was not a perfect president; he was well aware of his mistakes. But despite his failings, I am sure he always strived to do his best for the American people.

My hope for you is that you will reflect upon his presidency and how it compares with your own. And, following that reflection, that you will recognize that the best and most dignified action you can take to serve your country is to resign.

December 11, 2018

President 45,

I'm confused. Why are you threatening to shut down the federal government if you don't get funding for a border wall? Didn't you promise that Mexico would pay for it?

December 16, 2018

President 45,

Despite your promises to get rid of the national debt in a mere eight years, it is mushrooming out of control under your "leadership." Conveniently for you, economists predict that the most devastating economic consequences likely will hit after you leave office. I'd really

rather not see the country go through the Great Depression, Version 2.0. Please resign so that someone who is willing to take advice from economic experts can take charge.

December 18, 2018

President 45,

Good news today: Your phony charity has been shut down, and you and your family have again been exposed as crooks. The court has ordered that the assets that have escaped your plundering be disbursed to actual charities. I have a few ideas on where that $1.7 million can go.

The Women's Refugee Commission and the Hebrew Immigrant Aid Society work tirelessly to protect and support displaced people seeking a better life. I think $100,000 each would help them counteract a bit of the harm you have caused to people fleeing dangers of all kinds.

The Refugee and Immigrant Center for Education and Legal Services (RAICES) provides legal aid to immigrants in Texas who hail from Mexico and Central America. Those folks need a lot of assistance because of problems you created for them, like kidnapping their children. I think a cool $100,000 would ensure that some worthy people get the legal representation they deserve as they seek asylum.

Islamic Relief USA and the International Rescue Committee are on the ground providing relief to the starving people of Yemen. Checks in the amount of $250,000 for each organization would fill a lot of bellies. It won't make up for our support of Saudi Arabia's genocide, but it would still be the right thing to do.

Journalists all over the world are in mortal peril simply for doing their jobs, a situation that you have made worse with your ugly attacks on

the press. The Committee to Protect Journalists is protecting reporters and their vital work; your foundation should pony up $100,000 for this worthy cause.

The remaining $800,000 should be split equally among the following: The ACLU, for protecting our rights against the ravages of your administration; the SPLC, for its work counteracting the racist hate that has blossomed under your tutelage; OutServe-SLDN, for advocating for LGBTQ service members harmed by your policies; Plant-for-the-Planet, for planting more than 15 billion trees to counteract global warming; RAINN, for helping victims of sexual assault; ShelterBox, for providing shelter to Syrian refugees, people we refuse to let into the country; the Brennan Center for Justice, for defending our systems of democracy and justice; and Stomp Out Bullying, for doing the exact opposite of what you do.

December 19, 2018

President 45,

Border security seems to be your signature issue. So why do you keep spelling it "boarder"?

December 20, 2018

President 45,

Holy international chaos, Batman! Without consulting our allies or Congress, and apparently against the advice of military brass, you abruptly announced that you are pulling U.S. troops out of Syria (and Afghanistan!), dismaying our allies and prompting the resignation of Defense Secretary Mattis. But, on the plus side, your master Putin seems

pretty pleased. And we're on the brink of a government shutdown, which you easily could have avoided. And the Dow is plummeting.

Then there's the legal peril of your family, friends, business associates, transition team and administration; lots of people are going to jail. Many key positions in the executive branch remain unstaffed nearly two years into your administration through your sheer incompetence; others are empty or filled on an interim basis because of the masses of resignations and firings; in short, staffing is in complete disarray.

This is the exact opposite of how a country should be run. Please do the right thing and resign.

December 21, 2018

President 45,

Hooray for the Supreme Court! Today it affirmed that your most recent policies restricting asylum seekers are not legal. Again and again, you have tried to implement policies that are motivated by racism and exceed your legal authority. I am grateful that the courts are acting as a check on some of your worst impulses.

Today's ruling is just another indication that you are failing in every aspect of your job. Please resign.

December 22, 2018

President 45,

You have caused American farmers a great deal of suffering by sparring with China on trade. The Farm Bill contains relief for them, as well

as other important provisions, such as the administration of supplemental nutrition benefits for the needy. That's serious stuff. Embarrassingly, you decided to inject some levity into the situation by tweeting an old video of you wearing overalls and singing the theme from "Green Acres." The presidency is not a TV show. It is not entertainment. Get a grip on yourself.

December 25, 2018

President 45,

Shortly after his birth, the Bible tells us, Mary and Joseph fled their homeland with Jesus to protect his life from a murderous tyrant. Today, parents are fleeing murderous gangs, drug lords and other dangers and seeking safety in our country. Providing asylum to those who merit it is the law, and also is the right thing to do. And, if you are a Christian, helping those fleeing persecution is required by your faith. It is, simply, what Jesus himself would do.

Today, I have a special Christmas prayer for you: May you fully understand Matthew 25:35-40 (for I was hungry and you gave me food, I was thirsty and you gave me drink, I was a stranger and you welcomed me...), and apply its lessons to your day-to-day responsibilities as president.

December 31, 2018

President 45,

Dear me, you truly are obsessed with President and Mrs. Obama, who, unsurprisingly, are the man and woman Americans most admired in 2018, according to a Gallup poll. Perhaps Gallup's recent announcement of their place in Americans' hearts was galling you when you

composed yesterday's weird tweet: "President and Mrs. Obama built/ has a ten foot Wall around their D.C. mansion/compound. I agree, totally necessary for their safety and security. The U.S. needs the same thing, slightly larger version!"

There are several things wrong with this tweet, other than your unhealthy fascination with the Obamas and your weird attempt to use their residence to justify your border-wall fetish. First of all, the subject and verb of the sentence don't agree. And "ten foot Wall" should be "10-foot-high wall." And the Obamas don't live in a compound; do you know what the word "compound" means?

Lastly, THERE IS NO WALL, 10-foot or otherwise, around the Obama residence. What are you smoking?

January 1, 2019

President 45,

Did you follow the tragic story of Abdullah Hassan? The two-year-old died in California last week, where his father brought him for treatment of a genetic brain disorder. His father is an American citizen, but his poor mother, Shaima Swileh, being a citizen of Yemen, is subject to your Muslim travel ban. She was unable to be with her dying son until the very end, and then only because she successfully sued the State Department.

This is what your travel ban has wrought. A child — a citizen of the nation you ostensibly lead — was denied the comfort of his mother's presence in the last months of his life because of your xenophobic policy. A mother suffered unfathomable distress as she tried for months to find a way to see her dying baby. A father endured not only the tragedy of his son's death, but also the cruelty of being unable to have his wife by his side during a time of great hardship.

Your ill-intentioned policy is harming real people. There is nothing you can do to make this right for the Hassan family. You can however, avoid harming others who are subject to the Muslim travel ban. End it, apologize and resign.

January 2, 2019

President 45,

It would be reasonable for me to expect the top elected official in the country to lead by example, to hold himself to the highest standards for integrity, dignity and personal conduct. Sadly, I have no such expectation with you, because to do so would mean daily disappointment.

Retired four-star General Stanley McChrystal publicly and accurately stated that you don't tell the truth and you are immoral. In response, you fired off a tweet that compared him to a dog, that implied he's not really a general and included the words "big, dumb mouth," a phrase that is unsuitable for use by adults.

You are incapable of ignoring a slight. You are unable to rise above anything. Every criticism elicits a knee-jerk juvenile outburst. Your behavior is not normal. It is not OK. Please stop.

January 4, 2019

President 45,

So, you don't want to look "foolish" by accepting a plan from the Democrats to end the government shutdown, and are willing to let it go on for "years."

While you are worrying about your image, very real consequences are hurting actual people. Federal workers are unable to pay their bills. Businesses they customarily support, such as coffee shops and restaurants, are suffering, as well. Our national parks, including some of Washington D.C.'s most iconic monuments, are filling up with garbage.

Native American communities are enduring a variety of hardships, including unplowed roads, limited law enforcement and lack of medical care. If the shutdown continues much longer, children and elders using food stamps will go hungry. The IRS will not issue refunds to families who, in turn, will be unable to spend that money on necessities. Everything from transportation, to education, to food safety, to weather forecasting and more is negatively impacted by the government shutdown.

As the effects of the shutdown ripple throughout the economy, the consequences will become more and more severe. How foolish do you think you will look if the shutdown is the catalyst that sends our nation spiraling downward into the next Great Depression?

The point is, you already look pretty foolish, obsessing about a wall that most Americans don't want, and refusing to do your job. Please resign.

January 7, 2019

President 45,

It is most curious that your Bedminster golf club not only hired undocumented workers, but also facilitated their procurement of phony green cards and Social Security cards. Even more astonishing, managers quietly removed undocumented workers from lists of people the Secret Service needed to vet and allowed them to continue working without the proper security checks. Your fortune, in part, is built on the backs of immigrants, both documented and undocumented — the very same people you demonize nearly daily and blame for the nation's woes. Your businesses also broke the law to fill your wallet. You truly have no shame.

January 13, 2019

President 45,

Your most recent cabinet meeting was, in many respects, a repeat performance: It featured cabinet members abasing themselves by licking your boots and you tossing lies about like confetti. But this meeting had a decidedly weird new touch: On the table sat a movie-style poster with an image of you and the words "sanctions are coming" in obvious mimicry of a phrase from "Game of Thrones."

What the heck, dude?

You posted this image on your Twitter feed in November to announce that the U.S. would be imposing sanctions on Iran (not an acceptable way to announce foreign policy decisions). What it was doing in poster form on that table during a very important meeting is really anyone's guess, since no one there ventured to bring it up and you offered no explanation. Perhaps you were hoping that someone would comment on how photogenic you are?

Although you obviously have no capacity for embarrassment, the rest of us still do. Please stop shaming us with silly stunts by resigning immediately.

January 19, 2019

President 45,

For a couple years now, I've been carefully following the ever-widening web of connections between you, your campaign and the Russians. It's so complicated that PBS has created a detailed timeline with hundreds of

entries, from your selling an absurdly overpriced mansion to a Russian billionaire in 2008, to your denials of Russian hacking, to the convictions of your close associates, to your fawning praise of Putin. You should check it out online; it's rather interesting.

You have shown a clear and disturbing pattern of promoting Russian interests and denying or downplaying its wrongdoings. Whether that is to benefit your own financial interests or because the Russians have dirt on you is not yet publicly known. That pattern makes it quite understandable that the FBI launched a counterintelligence investigation to determine if you were knowingly helping Russia — in other words, if you are a traitor to our country.

It seems to me that the current chaos — the partial shutdown of the federal government — plays right into the hands of Putin, who seeks to weaken the West to make Russia ascendant. I believe that you are working to promote Russia's interests over those of the U.S. right this very minute, in plain sight. Whether you started out as an unwitting dupe or an eager participant remains to be seen. Either way, Putin has played you for a fool.

January 25, 2019

President 45,

My goodness, you really had a big day today! One of your best pals, Roger Stone, got arrested before dawn for charges brought by the Mueller investigation. Then, Nancy Pelosi taught you an important lesson: You can't hold the federal government, federal workers and the American people hostage any time you don't like how Congress decides to spend our tax money.

As you feared, you're looking pretty foolish. But that's what happens when you surround yourself with crooks and don't understand how to do your job.

January 28, 2019

President 45,

Let's take stock of the fruits of Robert Mueller's labors thus far. Five of your associates — Cohen, Manafort, Papadopoulos, Flynn and Gates — have either pleaded guilty or been convicted of a range of charges, including lying to Congress and the FBI, fraud and conspiracy against the U.S. Additionally, your pal Roger Stone has been charged with lying to Congress, witness tampering and obstruction of justice. Furthermore, 28 other people, mostly Russians, have been charged with conspiracy, money laundering, etc.

I think that it's very interesting how many of your buddies lied about their contacts with Russians. If there's no collusion (or treason, or conspiracy) as you claim, then why would anyone commit a crime — risking jail time — by lying about an innocent phone call or meeting or email conversation with a Russian ambassador or Putin-connected oligarch?

I am eagerly awaiting the Special Counsel's final report. I want to see how many more "witches" he'll find on his "witch hunt." Perhaps some of them share your name.

February 1, 2019

President 45,

Regarding your January 28 tweet, what, exactly, is Global Warning? Enquiring minds want to know.

February 5, 2019

President 45,

I was stunned and appalled a couple of days ago to receive an email from your campaign telling me that if I donated, my name would be displayed during a live stream of the State of the Union address. Truly, there is nothing that you won't monetize, even the official business of your office. To say that this is unethical and a violation of the public trust is a gross understatement.

Adding insult to injury, the email implies that the State of the Union is for the "American Patriots" who support you, and certainly not for Democrats. So much for the "unity" that your advisors claim you will be promoting in your address. No, I won't be tuning in tonight; I have better things to do than watch the shameless posturing and theatrics of a money-grubbing charlatan.

February 6, 2019

President 45,

Two weeks ago, a gunman walked into a bank in Sebring, Fla., and killed five women. What is really shocking about this incident is that … it isn't shocking. Nationally, the shooting was the top news story only briefly, almost completely dropping off the radar shortly thereafter. We have become terrifyingly numb to these outrages.

I have written to you many times about my disappointment that you have squandered your power by failing to take any meaningful action to stem the epidemic of gun violence destroying countless American lives. Although it is an exercise in futility, I am writing again to remind you of

your failure to address this epic public health crisis. In the absence of leadership at the top, I continue to place my hope in Gabby Giffords and Mark Kelly. Today, I made a donation to Giffords PAC, which is fighting an uphill battle to end gun violence. It is heartening that Giffords and Kelly are exhibiting the leadership that you are incapable of providing.

February 18, 2019

President 45,

Crooks and malfeasance hang around you like a miasma. Consequently, it should surprise no one that federal prosecutors are investigating your inaugural committee for potential illegal campaign donations from foreigners, money laundering and election fraud. I doubt that there is any aspect of your political, business or personal life that is untainted by impropriety or corruption. Wouldn't it be preferable to resign now than to be removed from office in handcuffs?

February 19, 2019

President 45,

Nothing says "national emergency" like the guy in charge spending a leisurely weekend golfing and ordering up omelets at his country club. You're not helping your own case at all.

Author's note on the February 19, 2019, letter

On February 15, 2019, the president declared a national emergency on the Southern border and ordered that billions of dollars Congress had designated for use by the Department of Defense be diverted to build his wall. Using an emergency declaration to circumvent Congressional funding in this way was unprecedented.

An emergency is commonly understood to be an urgent and serious situation, a pressing need that requires immediate action. In an actual emergency, wouldn't the president need to spend the weekend working with his advisors to implement a plan? Images of him spending days enjoying country club amenities belied the urgency of his declaration.

February 25, 2019

President 45,

Yesterday, you tweeted that on July 4 there will be a celebration in Washington, with "an address by your favorite President." I'm so glad to hear that President Obama will be speaking to us on the anniversary of our nation's birth!

February 27, 2019

President 45,

Today your former lawyer testified under oath to Congress that you are a racist, a conman and a cheat. My own observations and common sense are all that is needed to know that Cohen was telling the truth. You don't belong in the White House; you belong in jail.

March 2, 2019

President 45,

Here is what your $1.5 trillion tax cut has wrought: The national debt has exceeded $22 trillion, a new record. No one, and I mean no one, thinks this is a positive development. A few years ago, even you could understand the dangers of a ballooning national debt, saying that if it

were to reach $21 trillion under President Obama's watch, "Obama will have effectively bankrupted our country."

Well, guess what? This one's largely on you. Despite your frequent claims that you are the guy who can fix our country's debt problem, you have drastically worsened a trend that began during President Obama's tenure while he was dealing with the Great Recession.

Please resign and let someone who will listen to financial experts take over.

March 10, 2019

President 45,

It's interesting to contrast your varied reactions to natural disasters, depending on where they occurred. Tornados recently killed more than 20 people in Alabama and caused millions of dollars in damage. You responded quickly and assured residents that you told FEMA to give them "A Plus" treatment. But when residents of California suffered devastating wildfires, with dozens of people killed, you were quick to heap blame on the state and even dish out threats. And, as I have pointed out before, your treatment of the people of Puerto Rico following Hurricane Maria was despicable.

It seems that some citizens are more important to you — more "American" — than others, perhaps based on their political leanings or heritage. That alone disqualifies you from effectively and equitably performing the duties of your office. Please resign.

March 12, 2019

President 45,

Patrick Moore, an energy-industry lobbyist masquerading as a founder of Greenpeace declared on Fox News (aka state-run media) that climate change is a bunch of hokum. You gleefully tweeted his statements, bolstering and perpetuating his bogus credentials while misleading your followers. There is no reason I should be surprised by this. Regardless, let the record show that this is completely abnormal behavior for a president. It's also not OK. For all your dangerous lies, I again ask you to resign.

P.S. My letter dated Jan. 20, 2019, never made it to the White House; the Post Office returned it in pieces. A new copy of the letter is enclosed herewith.

March 13, 2019

President 45,

I am appalled that you have revoked the requirement that U.S. intelligence officials publicly report the number of civilians killed by CIA drone strikes outside of declared war zones. This lack of accountability and transparency is a recipe for disaster; it gives the agency free rein to secretly expand military operations and escape investigation or punishment if it kills civilians in the process. This situation also is ripe for fostering long-term hatred of the U.S.; civilians who lose their loved ones will be powerless to seek redress. Furthermore, the government is unlikely to even apologize for wrongful deaths because it won't be acknowledging that they occurred.

This sinister development must not stand. The American people have a right to know if their tax dollars are being misused to kill civilians.

March 16, 2019

President 45,

I received an inflammatory email from you today, asking me to donate to the "Official Wall Defense Fund," which is a misleading way of asking for money for your campaign. Sadly, gullible supporters will think they are pitching in to build a wall on the southern border when, in fact, they will be paying for your campaign's legal bills. But I digress.

What really concerns me about the email is the fact that our nation's top elected official uses language like this: "when I asked American Patriots (the people that matter) over 93% said YES VETO & FINISH THE WALL. When the people talk, I always listen." And this: "As your Commander-in-Chief, I will NEVER put politics over the safety of American Citizens, so help me God."

It is stunning that you view the opinions of your supporters — who are in the minority — as the only valid point of view. The American people *are* talking, and the majority of them don't want a border wall. But that doesn't matter one whit to you, because you absolutely are putting politics over the well-being of our citizens.

It is truly pathetic that you never pass up an opportunity to mislead, lie and divide. Clearly, you have no concept of what being president entails.

March 22, 2019

President 45,

As I have repeatedly pointed out in previous letters, your daughter and her husband should not be conducting government business; it is shameless nepotism. And, as I also have previously noted, they would be unable to gain security clearances if they weren't your relatives. New revelations — that Jared used WhatsApp to communicate with world leaders, and Ivanka still uses her private email for government business — show their wanton disregard for rules they don't believe apply to them.

Could it be that you feigned your concern for the law and the nation's security when you pilloried Hillary Clinton for having a private email server? If your concern then was genuine, I expect you to show no less enthusiasm now, and lead your followers in a rousing chorus of "lock them up."

March 25, 2019

President 45,

Congratulations on being cleared of actually conspiring with the Russian government. However, your passivity about protecting the 2020 election signals loud and clear that the Russians are welcome to keep on interfering — hey, it worked out the last time for you! You don't have to be indicted for a crime to be a traitor to your country.

March 26, 2019

President 45,

Customs and Border Patrol recently detained a 9-year-old American girl for 32 hours. She had her U.S. passport with her and was making a routine trip across the border to attend school, but agents accused her of lying about her identity and locked her up.

Border agents have become overzealous under your tutelage. Your hostility toward immigrants and anyone who isn't white is tainting everything you touch. Sometimes I don't recognize my country anymore.

March 27, 2019

President 45,

It was breathtaking how seamlessly you changed your assessment of Robert Mueller, confirming this week that you believe he acted honorably, now that you can manipulate his findings to your advantage. Previously, you described him as "totally discredited," "highly conflicted," "disgraced and discredited," and "a conflicted prosecutor gone rogue." Additionally, you said that he made Joseph McCarthy "look like a baby."

Mr. Mueller hasn't changed at all; it is you who are stunningly inconstant. It is a deep mystery how your followers can accept your conflicting statements as gospel.

March 28, 2019

President 45,

I was disturbed to learn that both ICE and Customs and Border Protection are routinely violating the religious liberty rights of immigrants in custody. Examples include CBP providing a Muslim with only pork sandwiches to eat, agents seizing rosaries of Catholic immigrants and denying detainees access to holy texts, religious head coverings and clergy. This is in clear violation of the First Amendment, which does, indeed, apply to undocumented immigrants and people who are being detained.

The federal government must end this practice immediately, conduct a thorough investigation into these abuses and hold those responsible accountable. Realistically, I have no expectation whatsoever that you care about this problem, considering your near-constant demonization of immigrants. Therefore, I must ask you, once again, to resign so that someone else can do your job. And please take Mike Pence with you.

March 29, 2019

President 45,

Ladies and gentlemen, I give you the president of the United States: "Little pencil-neck Adam Schiff. He has the smallest, thinnest neck I have ever seen. He is not a long-ball hitter. But I saw him today — 'well, we don't really know, there could still have been some Russian collusion.' Sick. Sick. These are sick people."

You, sir, are nothing more than a bully.

April 6, 2019

President 45,

No, the noise from windmills doesn't cause cancer. What is wrong with you?

THE WHITE HOUSE
WASHINGTON

April 9, 2019

Ms. Kathy S. Hayes
Richfield, Ohio

Dear Ms. Hayes,

Thank you for your generous words of encouragement and your prayers. The firm resolve of the American people to face challenges boldly is a great blessing to our country.

Our Nation is experiencing a new tide of optimism and renewed faith in the American Dream. I remain confident that together, with trust in God, we will continue to build a stronger and more prosperous country for future generations.

I appreciate you taking the time to write. Your support means a great deal to Melania and me.

Sincerely,

April 15, 2019

President 45,

The world watched in horror today as Notre Dame burned. And you? You felt compelled to offer advice via tweet: "Perhaps flying water tankers could be used to put it out. Must act quickly!"

Why, oh why, do you do things like this? Do you really think that the firefighters of Paris don't know that time is of the essence in their line of work? And do you fancy yourself a firefighting expert? This tweet is a surpassingly offensive combination of ignorance and arrogance; you have outdone yourself.

April 16, 2019

President 45,

Seeing as how I have written roughly 800 letters asking you to resign, I was somewhat mystified yesterday upon receiving a note from the White House thanking me for my support. Since I have yet to offer you "generous words of encouragement," "prayers" or "support," I am wondering if the mailroom staff has confused me with someone else.

Or perhaps tallying letters of outrage as expressions of approval is a perverse new way to boost the metrics for positive mail in the quest to shore up your fragile ego.

Regardless, let the official record show that I unequivocally disapprove of the job you are doing and heartily desire your resignation.

April 18, 2019

President 45,

Today the world found out that you ordered other people to obstruct justice, but they refused. Therefore, you were unsuccessful at obstructing justice, but only because of the scruples of others. You have violated your oath of office by instructing others to break the law. You should resign.

April 20, 2019

President 45,

Our country is legally obligated to grant asylum to people seeking protection from persecution because of their political opinions, religious beliefs, race, nationality, ethnicity, etc. Yet, as the Southern Poverty Law Center has recently revealed, more than 100 Cuban asylum seekers have been left to rot in Louisiana detention facilities for more than a year, despite the fact that they entered the country legally and are seeking asylum according to the law. The government has determined that they have a credible fear of persecution or torture, yet it flouts the law by keeping them locked up. Furthermore, the conditions under which they are living are inhumane, with inadequate food and medical care.

These asylum seekers must be released immediately! Furthermore, they should be granted reparations for their unlawful detention. Finally, you should resign because your administration has permitted and encouraged such cruelty.

April 21, 2019

President 45,

In the space of 24 hours, you went from ballyhooing the Mueller report on Twitter ("No Collusion – No Obstruction!") to decrying its "total bullshit" as news of the less-flattering parts came to your attention. Which is it? And why does the president of the United States think it is ok to use the word "bullshit" on Twitter?

April 26, 2019

President 45,

To the long list of not-normal-and-not-OK things, let's add your tweet from April 16: "I believe it will be Crazy Bernie Sanders vs. Sleepy Joe Biden as the two finalists to run against maybe the best Economy in the history of our Country (and MANY other great things)! I look forward to facing whoever it may be. May God Rest Their Soul!"

The presidential election is not a professional wrestling match; the sitting president should not call the other candidates names. And what do you mean by "May God Rest Their Soul"? Are you expecting them to die soon? And do you think that they share a soul? Half a soul each would still be more than what you've got! Or are you incorrectly using "Their" to refer to one person?

Regardless, all the current candidates have you beat in the soul department, the grammar department and the not-being-an-actual-crook department. You've got your work cut out for you. Why don't you save yourself a lot of trouble and resign?

May 2, 2019

Oval Office Occupant,

I've been reading Robert Mueller's report, and it's plain that Russia significantly interfered in the last presidential election. Yet, you have expressed no interest in protecting our electoral process from such meddling. In fact, administration sources report that they can't even discuss this vital security issue in your presence because you can't bear to hear even the hint of a suggestion that Russia helped you win. Your inability to handle this problem is a dereliction of duty. You need to resign.

May 5, 2019

Oval Office Occupant,

Last week, former FBI deputy director Andrew McCabe spoke to a packed room in a nearby town, and I was lucky enough to get a seat. He spoke passionately about the men and women of the FBI, their mission and his life of public service. He concisely and clearly explained the circumstances that led the FBI to investigate whether members of your campaign conspired with Russia. Likewise, he delineated the reasons for investigating whether you obstructed justice. Clearly, the FBI was obligated to investigate you based on the evidence. As Mr. McCabe explained in his talk, if the FBI had chosen NOT to open an investigation, that would have been a partisan act.

In short, I found Mr. McCabe to be intelligent, eloquent, informative and funny. Mr. McCabe has spent his entire career protecting the American people, sometimes at considerable risk to himself and great inconvenience to his family. His devotion to his country is palpable.

However, you recently called ousted DOJ and FBI leaders (presumably referring to Mr. McCabe, among others) as "scum." I have noted a number of times in the past that you accuse others of the flaws you most fear in yourself. I think this is one of those times.

May 6, 2019

Oval Office Occupant,

Today, in an open letter, several hundred former Justice Department officials said that the only thing standing between you and multiple felony charges for obstruction of justice is the fact that you are currently president.

These experts are of all political backgrounds and have served under Kennedy, Johnson, Nixon, Ford, Carter, Reagan, both Bushes, Clinton, Obama and yourself.

I'm sure it has crossed your mind that the best way to avoid prosecution for your acts of obstruction is to remain president as long as possible. To what extremes will you go to make that happen? Just a couple days ago, via re-tweet, you floated the idea that you should have two years added to your term to make up for time "stolen" by the investigation into Russian interference. This is Dictator 101 stuff, as are your ongoing attacks on the press.

Will you continue your diatribes against immigrants, people of color and Muslims? I think this course of action is a given; you know that fanning the flames of hate among misinformed, frightened and bigoted people can only work to your advantage.

To better your odds of staying in power, will you send troops into

one of the world's hot spots? Creating a crisis and then using it as an excuse to extend your stay in office is another classic authoritarian move.

Your so-called presidency bears no resemblance to what our founders envisioned. You have gone full-on dictator on us. I am deeply alarmed and truly frightened about what you might do between now and Election Day in 2020. I will continue to lobby Congress for your impeachment as well as urge my fellow citizens to do likewise.

May 8, 2019

Oval Office Occupant,

I'm crying as I write this. Yesterday, yet another young person died in a mass shooting. Many more were injured; all were brutally traumatized. A nation grieves. Next week, it will happen again. What should be unthinkable is now commonplace.

We need background checks on every single gun purchase in this nation, period. We need buyback programs for unwanted guns. We need to force gun manufacturers to use technologies that can prevent accidental shootings, such as fingerprint access. We need the federal government to treat gun violence as the public health issue it is, a strategy that succeeded in dramatically reducing deaths from car accidents.

But the NRA has bought and paid for Congressional Republicans, and you too have no desire to anger the NRA. Our only hope is if Democrats control the White House and both chambers of Congress, so that's what I will be working hard for between now and November 2020. Our children's lives depend on it.

May 12, 2019

Oval Office Occupant,

It's Mother's Day. I'm fortunate, because I know where my kids are and that they are safe. But an unknown number of immigrant mothers are spending today in agony because they remain separated from their children, children your administration kidnapped. Adding to the horror, the government is not even sure where they all are, or who belongs to whom. A judge recently gave you six months to reunite the children with their families, but I have no confidence whatsoever that you and yours can meet that deadline. You and Stephen Miller belong in jail for this disaster. And the government should pay reparations to the families it ripped apart.

May 16, 2019

Oval Office Occupant,

Today your campaign sent me an email begging for money and trying to frighten me with this lie: "U.S. Customs and Border Protection apprehended over 109,000 criminals trying to cross our southern border illegally in April. That's the highest number of border arrests in 12 YEARS."

No, those 109,000 people aren't all criminals; not even close. Firstly, those people who are seeking asylum — probably the majority of that number — are engaging in a lawful activity. And others who have crossed without the intent of seeking asylum are innocent until proven guilty of a misdemeanor. Your obvious insinuation that they are all dangerous felons is intentionally false and inflammatory.

Further, there's a lot of reason to believe that your public statements are a significant factor in the increase in border crossings; the possibility of a closed border or a border wall are fueling an "it's now or never" mindset among desperate people in Central America.

Depressingly, this email, as vile as it is, is nothing compared to the news that another immigrant child has died while in ICE custody. And that you planned mass arrests of immigrant families and only backed off after Kirstjen Nielsen resisted because it would have been a wasteful use of limited resources. And that immigrant children are sleeping in the dirt in Texas, waiting to be processed. And that your newly unveiled immigration plan is wholly inadequate, doing nothing to address the issue of Dreamers or the needs of immigrants who don't "merit" admittance because they aren't doctors, scientists or the like.

I don't have all the answers for how our immigration system should work. But I do know that immigrants are good for our country, especially now as our birthrate falls and employment is high. I do know that we should honor our proud history of welcoming the tired, the poor, the huddled masses yearning to breathe free. To do that, we need to admit many more refugees and immigrants, not fewer. We need to receive asylum seekers at our border with a compassionate system that doesn't exacerbate the trauma they have already experienced. A program piloted under the Obama Administration was very successful — the vast majority of asylum seekers returned for their hearings, all without the expense and humanitarian concerns of detention.

In short, from campaign emails, to proposed policies, to actual policies, you are completely failing on immigration. I am heartily sick of your cruelty and incompetence. Resign.

May 18, 2019

Oval Office Occupant,

I've put off writing this letter because I first had to muster up the courage to read about the United Nations' upcoming report on biodiversity. What I read terrifies me. In short, a million species of plants and animals are likely to go extinct because of human activity, with devastating effects on the ecosystems we depend on for our existence.

This is the most important problem of our time. We should model our response on the program that put a man on the moon, engaging our top scientists to work to avert our doom. As a nation, we also must take advantage of the knowledge we already have regarding conservation, best agricultural practices, renewable energy and so on. Furthermore, we must work collaboratively with our allies and trade partners to maximize our collective impact.

We must do these things, but will we? Not with you at the helm. You are anti-science: Your administration has scrubbed federal websites of scientific information; and you have eroded the role of science in public policymaking while allowing industry an outsize role in the process. You also are an isolationist, eschewing engagement with our allies and denigrating the United Nations.

The world desperately needs the leadership and involvement of the U.S.; the fate of humanity may very well hang in the balance. Since you are incapable of providing that leadership, I ask you to resign.

May 20, 2019

Oval Office Occupant,

I finished reading the Mueller Report today. Plainly, you attempted to obstruct justice multiple times. It's no wonder you're desperately trying to keep Don McGahn from testifying to Congress. Congress has a duty to impeach you.

May 31, 2019

Oval Office Occupant,

I am deeply opposed to your administration's proposal to allow taxpayer-funded shelters to discriminate against transgender people. The proposed rule from the Department of Housing and Urban Development is a blatant attempt to remove essential protections for transgender people.

Homeless transgender folks, especially teenagers, are extremely vulnerable to being victimized by criminals and abused by bullies. Allowing homeless shelters to turn them away for "religious" or other reasons could mean death.

The fact that this change is even being considered says a lot about who you are as a leader; the cruelty flows down from the top.

June 3, 2019

Oval Office Occupant,

I have been thinking a lot about Robert Mueller's recent statement, that Russia's effort to interfere in the 2016 election "deserves the

attention of every American." However, since you directly benefited from that interference, you choose to deny it; protecting our electoral system from Russian meddling for the next presidential election is antithetical to your goal of getting re-elected.

Between Russian interference, gerrymandering, "big money" funding campaigns and a supine Congress that refuses to hold you accountable for your authoritarian and unlawful behavior, I am truly afraid that I am witnessing the end of our representative democracy. But I'm not going down without a fight. I will continue to press Congress for your impeachment while doing everything in my power to make sure you aren't re-elected.

June 6, 2019

Oval Office Occupant,

Normandy American Cemetery is hallowed ground, a sacred place to reflect, to mourn and to remember the nearly 10,000 soldiers buried there who gave their lives. And today, the 75th anniversary of D-Day, is a time for solemn reflection on the unimaginable hardships, horrors, heroism and sacrifices of those who fought in WWII.

Today, in front of rows of white crosses, each marking the spot where an American soldier takes his final rest, you made various crass political comments and attacked fellow American and public servant Nancy Pelosi, calling her "a disgrace" and "a nasty, vindictive, horrible person."

As the daughter of a WWII veteran who was wounded in action, your comments were so offensive to me that I felt physically ill and began crying when I watched the interview. You have desecrated a holy place.

June 11, 2019

Oval Office Occupant,

The resistance is real! Your administration denied multiple requests from U.S. embassies to fly the pride flag during LGBTQ Pride Month, but overseas diplomats have gone ahead and flown them anyway. Good for them for sending a positive message of diversity and inclusion! It's sorely needed to counteract the bigotry you continue to foster.

June 12, 2019

Oval Office Occupant,

During an ABC interview televised today, you said that you would listen if a foreign government wanted to give you damaging information on a political opponent. Holy cow. You are inviting foreign nations to interfere in our elections. No federal employee could get away with making a statement like this. You are a threat to our national security and a threat to our election process.

I'm suspicious that you secretly want to be impeached.

June 13, 2019

Oval Office Occupant,

Today, something unprecedented happened: You caused me great joy. I couldn't stop laughing over your tweet referencing the "Prince of Whales." Ah, yes, royal cetaceans. My day is complete.

Dear Oval Office Occupant

Author's note on the June 13, 2019, letter

My husband felt inspired to add a drawing of a whale to this letter

P.S. I hope you enjoy the drawing, courtesy of my husband! →

June 14, 2019

President Trump,

To our country's shame, Fort Sill in Oklahoma was used to illegally imprison about 700 people of Japanese descent during the 1940s. Now, your administration is planning to use the same site to lock up immigrant children, children fleeing violence and poverty, in other words, refugees.

This is part of a much larger pattern of xenophobic-based cruelty you have promoted, including the separation of children from their families. The U.S. is indefinitely locking up people who are seeking asylum, imprisoning people not for criminal activity, but for fleeing for their lives. This broad scheme of mass civilian detention without trial employs dehumanizing and dangerous facilities that experts on the subject are calling concentration camps. I think they are right on the money. People, including children, are suffering and dying in these facilities. They are kept in solitary confinement for such ordinary human activities as consensual kissing, they are denied adequate medical care, they are sexually abused by guards, they are denied legal representation and, most fundamentally, they are denied their God-given right to freedom.

Dear Oval Office Occupant

Decades from now, the history books will rightfully record that you committed crimes against humanity, all in the name of appearing "tough" on immigration so as to remain in power.

Your ongoing campaign of cruelty must end.

Author's note on the June 14, 2019, letter

I had decided not to address the president by name following his infamous comments about the events in Charlottesville. Yet, somehow, for this letter, I reverted to my old format. Worse, I accidentally sent this on its way with the wrong year — 2017. My best guess is that I was tired and made a mistake cutting and pasting the salutation from an old letter. Yikes.

June 17, 2019

Oval Office Occupant,

For a couple months now, I've had a sign in my front yard saying "hate has no home here" in several languages. My church got them made up after the shooting in New Zealand, to send a message about who we are; our commitment to peace, diversity and inclusion; and that we will not let hate win.

The signs are scattered throughout my small town and beyond, and there are quite a few of them along my street, including at the church, at the vet in the center of town and at friends' houses. Since I live on a main thoroughfare, thousands of travelers see the signs every day.

Today, as my husband was putting out the trash, a young white man driving by angrily bellowed your name at him, presumably inspired by the sign, as there really is no other explanation for what would otherwise

be a very random action. It speaks volumes that a message denouncing hate is interpreted as an attack on you.

You've made hate, anger, cruelty and bigotry central to your presidency; indeed, they are some of your essential characteristics as a human. Sadly, there are those who are all in favor of your approach. It is a sad day in America when a message eschewing hate is met with angry jeers.

June 20, 2019

Oval Office Occupant,

The five teenagers who came to be known as the "Central Park Five" were wrongly accused of a 1989 rape, were coerced into confessing, were wrongly convicted and wrongly imprisoned for years; their sentences were overturned and another man confessed to the attack, a confession that was backed up by DNA evidence. At the time, you further added to the injustices these men endured by purchasing an expensive newspaper ad calling for their execution.

But you? You have no regrets about your actions then, and have no compunctions now about increasing the suffering and possibly endangering the lives of these exonerated private citizens. When asked if you should apologize to them for publicly calling for their deaths, you refused to do so and said: "You have people on both sides of that. They admitted their guilt."

Not only do you owe them an apology for what you did to them in 1989, you owe them an apology and a generous financial settlement for using your position as president to again drag their names through the mud. Such a settlement would allow them to invest in security to

protect themselves from the nutjobs who may take it upon themselves to administer the "justice" that the president of the United States still seems to believe is in order.

Your irresponsibility knows no bounds. You do not deserve to hold public office.

July 2, 2019

Oval Office Occupant,

Have you seen the photos of the men, women and children crammed together in Border Patrol detention facilities? Have you read the report released today by the Office of the Inspector General of the Department of Homeland Security that says DHS must address dangerous overcrowding and prolonged detention of immigrants? The federal government is locking up thousands of immigrants — asylum seekers and children! — in inhumane, unhygienic, unsafe and crowded conditions. No one should be treated this way. If the government is unable to properly care for the people in its custody, then it should let them go. Many of them should not be in custody to begin with.

Meanwhile, my tax dollars are being wasted on corrupting the people's Fourth of July celebration on the Mall into a militaristic political rally glorifying the Dear Leader. Yes, that's what we've become. Innocent people are locked in concentration camps and you are debasing a national holiday by turning it into a celebration of your nationalism and authoritarianism. Am I in America, or Germany in 1933?

July 17, 2019

Oval Office Occupant,

Today the world was treated to a 1992 video of you partying with Jeffrey Epstein, despite your insistence that you weren't particularly close. That, combined with your comment a decade later that Epstein likes his women on the young side, does cause me to wonder just how much you knew about his sexual assaults on young girls at the time.

Something else about the video really strikes me: In it, you are clearly a guy who believes he is entitled to hug and fondle the young women on the dance floor — "when you're a star, they let you do it." This is video evidence of what we already knew: You were speaking the truth in the infamous "Access Hollywood" video.

Epstein may be spilling a lot of beans soon. I am very interested to hear what he may have to say about you. Did you know about his crimes at the time? Not reporting them would have been criminal. I also don't think it's off-base to wonder just what sort of "partying" an entitled guy like you did with Epstein. Whatever the truth of the matter is, I hope that it will soon come out and justice will be served.

THE WHITE HOUSE

WASHINGTON

July 17, 2019

Ms. Kathy S. Hayes
Richfield, Ohio

Dear Ms. Hayes,

Thank you for sharing your views on important issues facing our country.

As President, I am tirelessly working to ensure our Nation continues to succeed so that everyone can achieve the American Dream. Though we may not always agree on how best to address certain challenges, my Administration is working diligently to strengthen and unite our great country.

Thank you again for writing to me. Together, we will work to build an America that is strong, safe, and proud.

Sincerely,

[signature]

July 23, 2019

Oval Office Occupant,

I'm still outraged and disgusted by your comments that four duly elected lawmakers — American women of color — should "go back" to their countries. And I'm appalled that you, your surrogates and supporters claim that what you said wasn't racist. Here's the evidence that the opposite is true:

Various versions of "go back to Africa" and "go back to your own country" have long been hurled by white racists at people of color.

People of color say it's racist.

White supremacists and KKK members publicly praised your statement.

White people never tell white people to go back to their countries.

Your racism is deeply offensive, un-American and disqualifying for public service. You are staining the office of the presidency.

August 3, 2019

Oval Office Occupant,

I don't even know what to say. Somebody has shot a bunch of people at a Walmart in El Paso. Details are few as I write this, but a lot of people are injured and likely many are dead. Earlier this week someone killed two people at a Walmart and another shooter killed three at a garlic festival in California.

What is wrong with us? Why can't our lawmakers treat this like the public health issue it is and budget accordingly to identify and address root causes? Why can't they enact gun laws that the majority of Americans say they would support? Why don't we have a president who can insist that we begin fixing this? Why do we allow this to happen all the time?

August 15, 2019

Oval Office Occupant,

El Paso experienced a horrific tragedy. The mayor, Dee Margo, is surely suffering deeply, grieving for his city and the 22 lives cut short by a mass shooter. Margo has just revealed that when you visited his city after the shooting, you rebuked him because earlier he had contradicted some comments you made about El Paso's crime rate. You called him a RINO — a Republican in name only. Really? Really? How could you even think to bring up politics at a time like that? Even in that private conversation, you were representing the entire nation. You should have been comforting, consoling and offering concrete assistance. I am gobsmacked.

August 18, 2019

Oval Office Occupant,

Last month, two related events made the news: Swiss scientists reported that the most effective way to fight global warming is to plant a trillion trees; and Ethiopia planted more than 353 million trees in *12 hours.*

I'm sure that you consider Ethiopia to be one of those so-called "shithole countries" you have disparaged. It's very inspiring that

Ethiopia accomplished such an impressive project. I think that its success is, in large part, due to the leadership of Prime Minister Abiy Ahmed. Methinks he's got something that you don't have.

Regardless, I do believe that the U.S. can still follow the example of Ethiopia, and the example of the children who created Plant-for-the-Planet, which has planted 13.6 billion trees worldwide, and aims to plant 1 trillion in all. I am grateful that my children and my church have supported Plant-for-the-Planet; today I am also making a donation to this worthy organization.

Although I have no actual hope that you will follow the lead of Prime Minister Ahmed, I am still asking that you give it a try. This is the most urgent issue of our time, and time is quickly running out.

August 25, 2019

Oval Office Occupant,

A few days ago, I asked my friends for some help. I had learned about two families with small children and new babies who are seeking asylum in the U.S. They are living in a nearby community and are struggling to make ends meet while they wait and hope for their cases to be resolved favorably. My friends didn't ask "What's their legal status?" or "Do they speak English?" or "Why should I help someone who isn't an American?" My friends simply showed up. They showed up with diapers and wipes. They showed up with rice and beans and cereal. They brought baby clothes and toys, blankets and books, toilet paper and soap.

This is what Americans do. This is what human beings do. They welcome their new neighbors. They lend a hand when it is needed. This is

the America I know and love, the America I grew up in, where people help each other because it is the right thing to do, and the American way.

You have promoted hate, fear, xenophobia and racism. You have caged kids and separated them from their parents. But the American people are better than your despicable policies and vile words. In spite of you, I have hope, because this weekend I saw the real America in action. We, the people, are so much greater than your stunted heart can imagine. In the end, love and justice will prevail.

August 31, 2019

Hurricane season is upon us, and you have decided to move $158 million from FEMA's disaster relief fund and $116 million from the Coast Guard to fund your "remain in Mexico" program and increase detention of immigrants. How dare you! Vulnerable people will suffer and die from severe weather events so that you can prove to your supporters that you are an immigration hardliner. And immigrants will suffer and die under your cruel policies. Please resign and take Stephen Miller with you.

September 11, 2019

Oval Office Occupant,

Apparently, it is too much to ask that on this national day of mourning you suspend your normal activity on Twitter. You subjected the nation to a barrage of name calling, partisan attacks and your perpetual whining about poll numbers. And, in what passes for solemn remembrance in your world, you posted a picture — not of first responders or a memorial to the victims — but of you and the First Lady, with your name and the words "We will never forget." Yes, it's all about you, as usual.

September 12, 2019

Oval Office Occupant,

I am appalled that the U.S. will not grant temporary protected immigration status to Bahamian hurricane survivors. This comes on the heels of your unsupported statement that the refugees might include "very bad people and some very bad gang members and some very, very bad drug dealers." I think it's clear that your intent is to spread fear, bolster xenophobia and keep people of color out of the country. It would be a fitting punishment if you suddenly developed a fully formed capacity to experience shame and the discernment to know when to exercise that ability.

September 14, 2019

Oval Office Occupant,

I'm not a fan of John Bolton, but it concerns me that you saw fit to kick him to the curb. What alarms me is the shockingly high turnover in your administration, especially when it comes to national security officials. National security advisors come and go and secretaries of state don't even have time to hang pictures in their offices. Pity the advisors below the Cabinet level — they are as disposable as Kleenex! Our allies are left scratching their heads at the chaos, and our adversaries see opportunity in the conflicting messages and lack of continuity.

Not three years into your administration we have had four defense secretaries; three of them were unconfirmed by the Senate and serving in an acting capacity only. We have had four secretaries of state, two of them in an acting capacity. Other advisers need a revolving door to keep from bumping into one another as they come and go. Turnover

for that cohort is a stunning 77 percent, far greater than any of the past five administrations, according to The Brookings Institution. And you still have more than a year to go! Unless of course, you choose to resign, a course of action I highly recommend.

September 19, 2019

Oval Office Occupant,

Over the decades, Cokie Roberts was a constant, reliable source of information for me. I especially appreciated her news reports on NPR, and the depth of knowledge she brought to her coverage. I am grateful that she broke new ground for female journalists. She was widely respected and recognized for her impressive talents and career. When she died a couple days ago, I was saddened by the hole she leaves in journalism, our country and my morning commute.

President and Mrs. Bush said it well: "We are deeply saddened that Cokie Roberts is no longer with us. She covered us for decades as a talented, tough, and fair reporter. We respected her drive and appreciated her humor. She became a friend."

Your self-centered response was cringeworthy: "I never met her. She never treated me nicely. But I would like to wish her family well." Yikes.

Yesterday, on the eve of writing my 1,000th letter to you, I had a completely new experience. I went into a local business and found $1,000 in cash, lying forgotten on a bench. I gave the money to the proprietor, who promised to do his best to locate the owner. Thankfully, the rightful owner was located; in gratitude, he left $100 with the proprietor to pass along to me as a reward. In light of the ongoing dangers reporters face, and your unceasing attacks on journalists and journalism, it seems only

right that I should honor the late, great Cokie Roberts with that money. Today, in her memory, I am donating half to the Committee to Protect Journalists and half to support public radio.

Author's note on the September 19, 2019, letter

I get excited about finding a quarter on the sidewalk, so stumbling upon a cool grand lying around unattended in a pharmacy was quite thrilling. Keeping the money never crossed my mind, but while I waited to hear if the rightful owner would come forward, I did entertain a few fantasies about what I would do with it. Those fantasies usually fizzled out with visions of me sensibly making car payments.

September 30, 2019

Oval Office Occupant,

You continue to claim that you did nothing wrong in your "perfect" phone conversation with the president of Ukraine. And now we find out that back in 2017, in an Oval Office meeting, you told senior Russian officials that you were unconcerned about their nation's interference in the 2016 election. What do these conversations have in common? In both instances, White House officials, alarmed by your comments, decided to limit access to the records of the conversations. In other words, they participated in a coverup. You may think there is nothing wrong with what you did, but your associates obviously are of a different opinion.

Knowing of your immorality, impulsivity and apparent belief that you are above the law, I am assuming that these two occurrences are part of a much larger pattern. How many times have you violated your oath of office, betrayed your country and left flunkies scrambling in your wake to hide the evidence? You need to resign.

October 2, 2019

Oval Office Occupant,

For nearly three years, I have limited each of my daily letters to you to one topic. Many days, that has been a challenge because of the sheer number of abnormal, immoral, ludicrous and even dangerous things you say and do. But this week has been like nothing I've ever seen before. You are providing fodder for at least 10 letters per day.

Shall I focus on your re-tweet that seems to tacitly approve of civil war should you be impeached? How about when you called five members of Congress — two Jewish men and four women of color — savages? What about your use of profanity and referring to jockstraps when speaking to the press? Shall I write about your false, inflammatory attacks against Representative Adam Schiff? I fear that someone will take your absurd accusation that he is guilty of treason seriously and try to harm the man. Then there are your continued threatening and conflicting statements about the whistleblower, whom you both claim to not know and also know to be a lying, partisan scumbag. You had an angry and rude outburst today when speaking to a reporter. And I would be remiss if I didn't take you to task for spreading vicious lies about Joe Biden and his son in a desperate bid to draw attention away from your grievous wrongdoing.

I would need another week's worth of letters to get into recent problematic policy decisions. And how will I have room to delve into what state of mind you had to be in to earnestly share a tweet from a parody website that had taken one of your own tweets and made it about sharks? There is literally no way that anyone could make this stuff up. With apologies to Ozzy Osbourne, you are going off the rails on a crazy train as the rest of us watch in horrified amazement.

October 3, 2019

Oval Office Occupant,

Today you publicly asked China to investigate Joe Biden. Do you think that if you do something wrong openly enough, that it will magically become acceptable? Nancy Pelosi said it best: You are "self-impeaching."

October 21, 2019

Oval Office Occupant,

Here's another offense that ought to be disqualifying for a president: Deriding the Emoluments Clause of the Constitution as "phony." I am so tired of living in this "Twilight Zone" episode! Somewhere, in an alternate universe, the U.S. has a president who understands our laws and system of government and actually cares about doing his or her job responsibly and ethically. I want to go there.

October 22, 2019

Oval Office Occupant,

NO, NO, NO! You cannot compare the impeachment process to a "lynching." How dare you!

I'm confident that most of the nation recoiled in shock and horror at your disgusting statement. But I'm also sure that the nation's white supremacists, neo-Nazis and KKK members were cheering you on for invoking the terror, torture and murder their forebears inflicted upon African Americans for decades. Considering your prior offensive rhetoric, I'm forced to conclude your choice of words was intentional.

You have debased your office beyond recognition. Impeachment can't come soon enough.

October 23, 2019

Oval Office Occupant,

I've read Ambassador Taylor's testimony; it's damning. Your impeachment should be a cut and dried matter.

October 25, 2019

Oval Office Occupant,

Last night I had the privilege of meeting several recent immigrants from Central America, including a young asylum-seeker and her 3-year-old daughter. I was struck by the enthusiastic and warm welcome they gave me and their positive attitude despite difficult circumstances. The fact that we did not have a language in common did not matter. I also met a high school senior, the American daughter of immigrants who, despite the challenges her family continues to face, has excelled in school and athletics and is using her voice to advocate for immigrants in her community.

In short, I saw aspiring American families who have embraced their new country with enthusiasm, despite the many hurdles they have overcome and others that lie ahead. We should be welcoming them and others like them with open arms and giving them the resources they need to settle in and become productive members of their communities as easily as possible.

The hostile climate you have created (including the dangerous "remain in Mexico" policy) drives desperate people to take even greater risks

to enter the U.S. They die in the desert, in the Rio Grande and in the hands of smugglers. The horrible tragedy in England this week, where 39 immigrants perished in the truck that was used to smuggle them, is a stark warning about what happens when desperate people have no good options to escape their circumstances.

Many of our cities have block after block of empty houses and storefronts. As a comedian recently pointed out, we have not just one, but two Dakotas. We have room. Let's change the laws and let more would-be Americans in.

October 31, 2019

Oval Office Occupant,

I haven't forgotten about all the immigrant children who are still in detention, and the ones who were deeply traumatized because your administration separated them from their parents, and the children whom your minions never reunited with their families. Have you?

November 1, 2019

Oval Office Occupant,

And now there's more damning testimony from Lt. Col. Vindman. It seems that those around you knew very well that your call with Ukraine's president was a big problem; the top legal advisor for the National Security Council told Vindman not to discuss his concerns about the call with anyone outside the White House.

Yet you keep insisting that the "transcript" of the call proves that everything was on the up and up, when it does the exact opposite! The

record of the call completely supports the whistleblower's accusation. You can claim there was no *quid pro quo* all you want, but that doesn't make it true.

November 5, 2019

Oval Office Occupant,

It's official, you really are pulling the U.S. out of the Paris Climate Accord. I'm so afraid for my children and all the children yet unborn. Why can't you do the right thing for humanity? Why don't you care?

November 8, 2019

Oval Office Occupant,

A judge is forcing you to pay $2 million in damages to several charities because you "breached [your] fiduciary duty" to your charitable foundation and used its funds to further your political ambitions. It's all there in black and white: You used funds donated for charitable purposes for your own personal gain. That's the definition of corruption and sleaze.

I find myself playing what is now an old game, imagining how Republicans would have reacted if President Obama had done such a thing. They, and you, would have lost their minds. But quite literally any action of the god-emperor is now ok, no matter how immoral, illegal, unethical or tacky.

At the end of the day, I'm glad that some worthy organizations will be able to create something positive from the settlement money. This outcome is a tiny version of a favorite fantasy of mine, in which you are forced to offset some of the damage that you've done in the world

by selling all your assets and donating the proceeds to charity. It really would do you a lot of good to find out what it's like to live on, say, $38,000 per year. You and your family should try it!

November 11, 2019

Oval Office Occupant,

I woke up this morning and remembered that it is Veterans Day, and thought immediately of my dad and the many sacrifices he made and the hardships he endured because of his service in WWII. Those thoughts kept me in a somber mood today until … I opened the Veterans Day email I received from your campaign. The email starts off ok, saying that we can never repay our veterans for their service. Then it takes an illogical, bizarre and offensive turn: "The least we can do is say THANK YOU, VETERANS! Until MIDNIGHT TONIGHT, you can get 25% off EVERYTHING in the Official … Store with code SERVICE."

What in the bloody hell does a sale of your campaign merch have to do with thanking veterans? Absolutely nothing, that's what. How about you thank veterans by making sure that they all have homes and top-notch medical treatment? How about you show your thanks by not deporting non-citizen veterans? How about you demonstrate gratitude by making sure veterans with substance-abuse problems are treated, not incarcerated?

This is not the first time I've written about your offensive campaign merchandise sales; your Memorial Day sale (code REMEMBER) was one of the most repulsive bits of marketing I've ever seen. I don't know which is more disheartening: that you and your campaign persist in this obscene advertising, or that your supporters see nothing wrong with it and take advantage of the sales to acquire MAGA schlock to put under their Christmas trees.

November 12, 2019

Oval Office Occupant,

The Southern Poverty Law Center has exposed new details about the depth of Stephen Miller's racism, xenophobia, white nationalism and hatred, laid out in his own words in about 900 emails to Breitbart. As I have said before, this brownshirt does not belong in your administration and he does not belong in government, period. It is beyond disgusting that his poisonous beliefs continue to shape your policies. Resign, and take Miller with you.

November 16, 2019

Oval Office Occupant,

A telling detail emerged from the impeachment hearings: You are accepting calls on your personal cell phone, without regard for the security of the nation. Experts from prior administrations say it is a certainty that the Russian government was listening in on your call with Ambassador Sondland; this is a shocking security breach. If foregoing the use of your cell phone is a deprivation you feel you cannot endure, then you should not be serving as president. You forget that you are supposed to be working for me. You have failed on every level. Resign, resign, resign!

November 18, 2019

Oval Office Occupant,

Three teenagers are dead from last week's school shooting in California. I can't imagine the agony their parents are enduring. One

student who survived said that she was not surprised at all by the incident.

You have squandered the power of your office by not working with Congress to fix the obscenity of rampant gun violence. The House has passed legislation to start addressing the issue, but Mitch McConnell, with your blessing, has prevented it from ever seeing the light of day in the Senate. How much money do you get from the NRA and gun manufacturers?

November 19, 2019

Oval Office Occupant,

Attacking witnesses testifying in the impeachment hearing is wrong. Stop. Just stop. If you had nothing to fear from the truth, you would remain silent and respect the legal process.

November 20, 2019

Oval Office Occupant,

It's funny how anyone who says anything bad about you during testimony suddenly becomes someone you don't know well or have never met. Who's next? Is Giuliani going to be just some guy you met once at a party?

November 23, 2019

Oval Office Occupant,

It's pretty clear to me: You asked the president of Ukraine to announce an investigation into the Bidens in return for much-needed military aid

and a White House meeting. Plainly, you abused the power of your office to seek an advantage over a political rival. No matter how much your toadies in Congress try to dress it up, they're still just putting lipstick on a pig. You did wrong. You betrayed your oath. You deserve to be impeached and removed from office.

December 2, 2019

Oval Office Occupant,

As I write this, the U.S. national debt is fast approaching $23.1 trillion, up from $19.9 trillion on the day you took office. On the campaign trail you promised that you would eliminate the national debt in eight years. I don't think the country can withstand another five years of your version of "eliminating" debt; it's likely to reach $29 trillion if you remain in office for a second term. That's no way to keep a campaign promise. Resign.

December 11, 2019

Oval Office Occupant,

How fascinating that Christopher Steele, he of the famous so-called "Steele dossier" turns out to have been a friend of your dear daughter and special advisor, Ivanka. Not only was he a friend, he was close enough to give her at least one sentimental gift. Furthermore, he says that he was "favorably disposed" toward your family by virtue of his association with her. It's interesting that you never mentioned that inconvenient fact whenever you criticized Steele, the dossier, its origins and its contents.

Much of the information in the dossier has been independently confirmed by U.S. intelligence. I don't think Steele had it in for you, he

just uncovered some very unfortunate information that you would have preferred remain secret.

December 12, 2019

Oval Office Occupant,

When I saw that *Time magazine* had named Greta Thunberg its person of the year, I knew exactly what you would do: Bully her on Twitter. That you chose to use your platform to harass a child speaks volumes about your low character. You diminish the presidency every day that you remain in office. Resign. And ask your wife how you can "be best."

December 14, 2019

Oval Office Occupant,

I'm mourning again the 26 lives lost to senseless gun violence seven years ago today in Newtown, Conn. I've got nothing to say that I haven't said already in countless other letters urging you to make preventing gun violence a top priority.

December 17, 2019

Oval Office Occupant,

This afternoon I took a break from my work to read the letter you sent to Speaker Pelosi. I was stunned. I am sure that the White House stationery has never before had to endure such sheer lunacy.

Among the many absurdities in six pages of paranoia is the part where you claim that Speaker Pelosi is lying when she says she is praying for you and is thus offending people of faith. Do you believe that you

can read minds? How, precisely, do you know whether or not she is really praying for you? And are you unaware that many faith traditions require followers to pray for those with whom they disagree? As a Christian, I strive to sincerely pray for all those in positions of national leadership. I ask that God grant our leaders the wisdom, discernment, compassion and courage to do the right thing. I would never pray for harm to come to anyone, as you imply Speaker Pelosi might be doing.

But I digress. The real import of your letter is not that you claim to know the content of Speaker Pelosi's prayers, but that it is a window into an unbalanced mind. I do not fault you for having mental health issues. But I do fault you for remaining in office when you are not up to the job. I wouldn't let you steer a golf cart, let alone the Ship of State. Resign and get help.

December 18, 2019

Oval Office Occupant,

The House of Representatives has impeached you. You brought this upon yourself. Your pattern of corrupt behavior all but guaranteed that this day would come. Despite my many predictions in previous letters that you would meet this fate, it gives me no joy that you made this drastic step necessary.

How does it feel to be held accountable for your actions for the first time in your life? Although conviction in the Senate is unlikely, it is not impossible. I suggest that you resign and not risk finding out.

December 21, 2019

Oval Office Occupant,

In previous letters I have remonstrated with you for falsely claiming that President Obama ordered that your tower be wiretapped during the presidential campaign. It was a complete fiction. Now the DOJ Inspector General Michael Horowitz has confirmed that there is not a shred of evidence to support your wild fabrication.

Your behavior was, and is, unacceptable. You should apologize to President Obama and resign.

December 23, 2019

Oval Office Occupant,

Over the course of just a few days, you tweeted about how Speaker Pelosi "striped" away due process and about how you are raising the "smocking" age to 21. And you said this about windmills: "But they're manufactured tremendous if you're into this, tremendous fumes. Gases are spewing into the atmosphere. You know we have a world, right? So, the world is tiny compared to the universe. So, tremendous, tremendous amount of fumes and everything."

The typos on their own are funny and could be chalked up to clumsy fingers, as opposed to dementia or eyesight issues. But there's no explaining away your incoherent and nonsensical ramblings about windmills. I am genuinely alarmed about your mental health. Can't someone get you some help? Please retire and take care of yourself.

December 24, 2019

Oval Office Occupant,

The *Philadelphia Inquirer*, *Los Angeles Times*, *Tampa Bay Times*, *USA Today* and the *New York Times* are among the dozen or so major U.S. newspapers whose editorial boards have called for your impeachment and conviction. The evangelical magazine *Christianity Today* and the staunchly conservative *National Review* have recently joined their ranks. It's not just progressive-leaning publications that think you are a danger to the Constitution; very conservative magazines are recognizing that your actions are not compatible with the traditional values of conservatism, Republicanism or Christianity.

I've found that courage is contagious. These public stands will open the floodgates for other conservatives, Republicans and patriotic Americans in general to make their voices heard about your immoral, oath-breaking and un-American ways. Perhaps some Senate Republicans will begin to grow some vertebrae as a result. Here's hoping.

December 25, 2019

Oval Office Occupant,

The presents are unwrapped, the dinner is eaten and the visiting has wound down. Every Christmas for 50-plus years I have participated in church services, heard scripture readings, celebrated with family and both offered and received the traditional "merry Christmas" greeting. No one has ever tried to thwart me from participating in any aspect of the holiday, whether secular or sacred. "Merry Christmases" abound at my office, church, home and elsewhere.

Thus, it is perplexing that you claimed — yet again — a couple of days ago that some unspecified "they" had been trying to take "Christmas" out of Christmas. "Do you remember? They didn't want to let you say 'merry Christmas,'" you said, while implying that your ascendency to the presidency is somehow responsible for the supposed return of the greeting. More perplexing is that anyone believes this humbug.

I've been saying and hearing "merry Christmas" for half a century. Whether anyone says it or not has absolutely nothing to do with you or anything you have done. "Merry Christmas" will get along just fine without you, as will the rest of us.

December 31, 2019

Oval Office Occupant,

I think it might be edifying for you if I summarize my correspondence for the year. In 364 letters, I have called you out about 30 times for your racist and bigoted statements and policies. Your administration's appalling treatment of immigrants earned 54 missives while my opposition to your border (or is it "boarder"?) wall was the subject of eight letters.

Your corruption, lying and nepotism inspired 51 letters and your fondness for autocrats and autocracy drew my ire about 10 times. Your lack of action on gun violence and the environment reaped 10 letters each; attacks on journalists drove me to write 20 times. Your fishy dealings with Russia and reaction to the Mueller Report were the subject of about 20 letters.

I wrote about my very genuine concerns for your mental health in more than 15 epistles, while your boundless capacity for crude, rude

and abnormal behavior motivated me to express my objections at least 60 times. Some two dozen letters detailed the sheer incompetence of you and your administration.

I have tackled military matters, the economy, your struggles with spelling and a handful of other subjects in the remainder of the letters and a smattering of bonus postcards I wrote at postcard parties.

What's the main takeaway? I have requested your resignation at least 107 times in 2019 because you are wholly unfit for the office you hold.

When I composed my first letter to you in December 2016, I never dreamed that I would correspond daily for three years. But your presidency has been far worse than I ever imagined it could be, so here I am, wrapping up my 1,103rd letter holding you to account.

I will continue to volunteer, attend demonstrations, donate to charities and political campaigns, call Congress, speak out publicly and hold you accountable on a daily basis until you leave office. I hope you are looking forward to hearing from me in 2020.

January 1, 2020

Oval Office Occupant,

I am steaming mad at the treatment of a 23-year-old Guatemalan woman and her 6-year-old niece at the hands of ICE, as reported by *The Guardian*, the Associated Press and others. The woman, Maria, is the only living family member that her niece has because gangs murdered the rest of the family. Maria fled with the child to the U.S. border to seek asylum, where the two were forcibly separated, despite Maria having extensive documentation of their situation and her relationship to the girl. Now the niece is in foster care and ICE continues to keep Maria in detention in dismal conditions, denying her parole three times for no legitimate reason.

This is unconscionably cruel. I hold you personally accountable for their shameful situation. Maria should be immediately released and reunited with her niece while their asylum case is pending. For more specifics on her case, you can contact Arizona state Representative Kelli Butler, who is advocating for her release, or Phoenix immigration attorney Suzannah Maclay, who is representing her. Fix this.

January 2, 2020

Oval Office Occupant,

Current tallies show you've spent 30 percent of your time as president at your various properties, largely golfing. I've expressed my

dismay before that millions of taxpayer dollars are being funneled into your very own businesses when you do this; it is unethical in the extreme that you profit off of your position. However, considering your environment-destroying, civil-rights-shredding agenda, perhaps it is money well-spent. Any time you are not doing your job is probably a good thing.

January 3, 2020

Oval Office Occupant,

I woke up this morning to the alarming news that our military had used a drone to kill Iranian General Qasem Soleimani. Pompeo says that the killing is justified because it will prevent American deaths, but why on earth should I believe anything that comes out of your administration? It seems to me that more U.S. troops — America's sons and daughters — are likely to die because you have thrown gas on the already-smoldering Middle East.

Why shouldn't we expect other countries to start using our tactics — sending drones to kill important leaders in the U.S. military and the militaries of our allies?

Was this legal? Why was Congress not informed? What about all the other people killed in the strike? Who were they? Is there any chance you have a plan to de-escalate this terrifying situation?

Have you started a full-blown war to distract us from the impeachment trial and get yourself re-elected?

January 7, 2020

Oval Office Occupant,

I am so afraid right now. In retaliation for your assassination of a top Iranian general, Iran has used missiles to attack bases in Iraq where U.S. troops are, and we don't know the fate of all the people there. I'm really scared that Iran's attack will be your excuse to also launch some missiles or drop some bombs, and the whole thing will spiral completely out of control. Is there any chance that you could turn to diplomacy to de-escalate the situation? I'm not hopeful, but that's what I'm praying for.

I get it. General Soleimani was a bad dude. But what on earth could he have been doing to justify bringing us to the brink of war? I have no confidence in your administration's assurances that this action was necessary or even legal. And whatever Soleimani was up to, won't his successor merely pick up where he left off? I don't think you had any plan whatsoever to deal with the aftermath of his assassination.

I am vehemently opposed to us going to war in Iran. I'm opposed to us assassinating government officials of sovereign nations. I'm appalled by your rashness and incompetence. You need to resign.

January 12, 2020

Oval Office Occupant,

The news from Australia has been unbearable — I admit that I've avoided reading about it because I don't want to spend all my time crying. But we can't bury our heads in the sand: Australia's catastrophic fire season is a symptom of man-made climate change and we're heading in the wrong direction under your leadership. Supposedly, you're the

most powerful guy in the world. Why can't you change your mind about the Paris Climate Accord and get the U.S. government on board with tackling this existential crisis? I want all the kids of the future to have a decent place to call home.

January 15, 2020

Oval Office Occupant,

Did you see Rachel Maddow's interview with Lev Parnas tonight? He sang like a canary, explicitly spelling out your corrupt motives for withholding military aid from Ukraine, while implicating Pence, to boot. Additionally, Parnas explained that the only reason you wanted Ambassador Yovanovitch removed from her post was because her presence was a hindrance to your corrupt scheme. Further, he said that John Bolton has a lot more to reveal about your interactions with Ukraine.

For the first time, I think there's a real chance your Republican buddies in the Senate will vote to convict.

January 16, 2020

Oval Office Occupant,

Unsurprisingly, the Government Accountability Office concluded that your administration broke the law by withholding military aid to Ukraine — aid approved by Congress — for political reasons. The crime syndicate you are running out of the White House is making Nixon look like a choir boy.

January 19, 2020

Oval Office Occupant,

Credible threats of violence have led the FBI to make arrests ahead of tomorrow's pro-gun rally in Richmond, Va. The rally is expected to be much larger than in previous years, with militia members from out of state and right-wing extremists among the expected participants. False rumors are flying, such as reports that United Nations "disarmament officers" are prepared to confiscate guns. The governor has declared a state of emergency, law enforcement personnel are on high alert and Virginia House Minority Leader Todd Gilbert, a Republican and stalwart supporter of gun rights, is standing with the governor, declaring his opposition to hate, violence and civil unrest.

At a time like this, here's what I want to hear from the president: "The right of Americans to peacefully assemble and publicly express their opinions is at the heart of our democracy. I urge everyone demonstrating tomorrow in Richmond, Va., to express their views peacefully, to respect the rights of others and to listen to our law enforcement officers and first responders so that everyone can exercise their rights safely. Thank you to the Governor, law enforcement and event organizers for all the work they have done to ensure the safety of all participants. Violence and threats of violence have no place in our civic life. I call on all Americans to do the hard work of strengthening our democracy by voting, running for office, engaging with your elected officials and peacefully exercising your First Amendment rights."

Here's what we got instead, via tweet: "Your 2nd Amendment is under very serious attack in the Great Commonwealth of Virginia. That's what happens when you vote for Democrats, they will take your guns away. Republicans will win Virginia in 2020. Thank you Dems!"

How disgusting, frightening and dangerous. You are the fearmonger-in-chief, turning away from your duty to promote the public welfare and instead throwing a match into a tinderbox in order to score cheap political points. God forbid, if anyone is hurt tomorrow, you will share at least some of the blame.

January 27, 2020

Oval Office Occupant,

I thought you might like to know that every single day I call all five of Senator Rob Portman's offices to urge him to muster his courage and demand that the Senate call witnesses — particularly Bolton — to testify. My coworkers and kids are calling. My friends and followers on social media are calling. Even my 90-year-old mother is calling Senator Portman.

Just in my own little corner of Ohio, I am aware of dozens of people calling and demanding a fair trial with witnesses. Sometimes, the line is busy. Other times, the voicemail is full. Combine my efforts with those of countless others across the nation and I think it's fair to say that Senate Republicans are feeling pressure from their constituents. If they don't listen, they will pay the price at the ballot box for being complicit in your corruption and participating in a coverup.

Author's note on the January 27, 2020, letter

I've called and written Ohio Republican Senator Rob Portman many times during the last four years and have been consistently underwhelmed with his responses to my concerns — when I have gotten a response at all. I know I wasn't alone in making daily pleas to his staff during the impeachment hearings; local grassroots groups I follow were working hard to keeping the pressure on. For a brief period, frustrated

with Portman's inability to grow a backbone and stand up to the president, I embarked on the "five-a-day challenge" with a friend, in which we would attempt to leave a message on each of his phone lines every day. Pointless? Perhaps, but you can't say I didn't try.

February 2, 2020

Oval Office Occupant,

While I have been discouraged, to say the least, by Senate Republicans emasculating themselves in service to you, today my hope was renewed by an inspiring talk given by Senator Sherrod Brown and moderated by his wife, Connie Schultz. They are the real deal: Honest, hard-working people who are in it to make the world a better place. I was heartened by the depth and breadth of Senator Brown's knowledge and experience, by his genuine caring and dedication to the people of Ohio and his respect for the Constitution and the institution in which he serves.

But do you know what really buoyed my spirits? The fact that an auditorium that seats 425 was packed, as was an overflow room, with enthusiastic, engaged and progressive citizens, people who stand ready to make sure that you are a one-term president. A 17-year-old high school student from my alma mater — a classmate of my niece — asked the senator how he can help boot you out, since he will not be old enough to vote. A Vietnam veteran moved me to tears when he spoke of the disrespect you have shown to our veterans and military members. His full-throated call for your ouster in November tells me that many of those who have served see you for who you really are.

The icing on the cake? Senator Brown and Ms. Schultz love that I hold you accountable every single day. I am the proud owner of a copy of his book with the inscription: "Kathy, keep writing. Sherrod Brown."

February 4, 2020

Oval Office Occupant,

I'm pretty laid-back about the national anthem; I don't get my pant-
ies in a wad if others choose to stand, kneel, sit, sing, not sing or eat a
hotdog while it's playing. You, however, have gone bonkers when people
have quietly kneeled during The Star-Spangled Banner to protest police
violence, saying that such folks are un-American, that they disrespect our
troops, that they aren't suitably grateful and should leave the country.

Imagine my surprise today when I saw a video of you at a Super
Bowl party, pretending to "conduct" the national anthem while the
First Lady and your son stand with hands on hearts. Obviously, the
hypocrisy is staggering, but to be honest, I'm more worried about your
mental health. You looked a bit deranged. Is there anything you should
be talking to your doctor about?

February 5, 2020

Oval Office Occupant,

Today I listened as the Republican Party gave up the ghost, suc-
cumbing to its fear of a mean tweet from the Dear Leader. Serving an
oath-breaking, law-breaking, obstructionist, corrupt autocrat was more
important to Senate Republicans than adhering to the Constitution.

In memory of the GOP, I made a donation to the Senate campaign of
Democrat Mark Kelly of Arizona. I also contributed to the Indivisible
Payback Project, which is fighting to put Democrats in the majority in the
Senate in November. Like John Paul Jones, I have not yet begun to fight.

Dear Oval Office Occupant

February 10, 2020

Oval Office Occupant,

I remember that when I was very little, my dad let me feel a particular spot on his head — the spot where a piece of shrapnel was permanently embedded in his skull. At the time, I didn't understand the significance of that strange lump, and I don't think that the term "traumatic brain injury" even existed. The medical and military communities have come a long way in understanding traumatic brain injuries since my dad nearly died from a mortar shell explosion in WWII. For those who survive them, these wounds can be devastating, permanently disabling and sometimes invisible to those around them. My dad had lifelong health problems from his various war wounds; I now believe that his head injury was responsible for his periodic bouts of depression.

I was really troubled today to find that the number of service members who suffered traumatic brain injuries in the Jan. 8 Iranian missile attack on the al Asad base has climbed to 109. That news is bad enough, but my concerns are compounded by how the story keeps changing and your seeming unconcern. Originally, you said that no service members were injured. Later in January, we found out that a small number of troops were injured, but you dismissed their trauma as not serious and consisting of headaches. Since your first cavalier statement, I have not been able to find any evidence that you commented at all about their injuries. As commander in chief, you are required to express gratitude for their sacrifices, voice genuine concern for their wellbeing and assure them and the nation that they will receive the best care possible. Why are you ignoring these soldiers whose injuries you have downplayed?

February 12, 2020

Oval Office Occupant,

It is clear from your attacks on Mitt Romney's faith that not only do you not really know Senator Romney, you also are not acquainted with honor or Christianity.

February 21, 2020

Oval Office Occupant,

U.S. intelligence officials have determined that Russia, yet again, is meddling to tip the outcome of the presidential election in your favor, a conclusion that surprises me not at all. Your response was anger — not that Russia is trying to subvert the will of the American people by tampering with our elections — but that officials had dared to brief Congress on the matter. You are afraid that Democrats will make political hay out of Russia's preference for you.

Thus, you unceremoniously booted Director of National Intelligence Joseph Maguire to the curb and installed Richard Grenell as acting director, a lickspittle whose sole qualification is that he will serve you and not the American people.

You are a traitor to our country. Authoritarianism has no place here. I am just one of the millions of people working hard to make sure you lose in November.

February 24, 2020

Oval Office Occupant,

Epidemiologists say we're teetering on the brink of a global pandemic of the coronavirus. Yet, your proposed budget drastically cuts funding for the Centers for Disease Control and the Department of Health and Human Services. You also want to slash more than $85 million from the CDC's National Center for Emerging and Zoonotic Infections Diseases. And $3 billion from global health programs. To say that you need to get your priorities straight is an understatement of epic proportions.

February 26, 2020

Oval Office Occupant,

You've spouted a bunch of pure nonsense about the coronavirus and have been immediately contradicted by government officials with actual expertise. Instead of shutting up and letting them get on with their jobs of informing and protecting the public, you have muzzled them. Now Pence will be the gatekeeper who makes sure that only information that makes the Dear Leader look good will reach the public. I am so tired of this authoritarian bullshit.

THE WHITE HOUSE

WASHINGTON

February 27, 2020

Ms. Kathy S. Hayes
Richfield, Ohio

Dear Ms. Hayes,

Thank you for taking the time to write me on important issues concerning our country's national security.

For far too long, the world has tolerated Iran's destructive and destabilizing behavior in the Middle East and beyond. Those days are over. Over the last 3 years, we have invested $2.5 trillion in restoring America's military might, and we are stronger than ever before. America's military and economic strength are our best deterrents in the fight against terrorism.

Peace and stability cannot prevail in the Middle East as long as Iran continues to foment violence, unrest, hatred, and war. I urge our Nation's allies and strategic partners to join us in sending a clear and unified message to the leaders of Iran: Your campaign of terror, murder, and mayhem must end.

The Iranian people deserve a future of peace and prosperity at home and harmony with the nations of the world. The United States stands ready to embrace peace with all who seek it, and we will continue working with our partners around the globe to advance these shared goals.

Again, thank you for taking the time to write. I appreciate your sincere concern on matters involving our country and your fellow Americans. To read my full address to the Nation in January of 2020 on matters concerning the Iranian regime, please visit: www.whitehouse.gov.

Melania and I join the American people in continuing to pray for the safety of the men and women of our Armed Forces. May God bless these brave patriots, and may He bless the United States of America.

Sincerely,

[signature]

February 29, 2020

Oval Office Occupant,

Wow. We have a brave whistleblower to thank for revealing that Department of Health and Human Services workers who met evacuees from China did not have sufficient training or protective equipment. They've probably been spreading coronavirus all over the place.

Could this terrible oversight have anything to do with your disdain for science, persistent refusal to fill key positions and ongoing efforts to purge federal agencies of people who aren't sufficiently loyal to you? It turns out that what you call "the deep state" is actually a bunch of people we need to be doing their jobs. It's no wonder you hate whistleblowers: They keep letting us know how corrupt and incompetent you are. Resign.

March 3, 2020

Oval Office Occupant,

Monday's coronavirus roundtable was a showcase for your incompetence and declining mental health. Drug company executives were unable to make you understand that it is not possible to have a vaccine ready in a few months, despite repeated explanations of the timeframe required for clinical trials. Then you asked if the flu vaccine could be used to prevent the coronavirus. (In case you've forgotten since then, the answer is "no.") God help us, because you and Pence certainly aren't up to the task.

March 8, 2020

Oval Office Occupant,

Let me set the stage. The nation is scrambling to prepare for a pandemic in the absence of competent leadership or adequate information from you or your administration. Understandably, people are frightened as both the number of infections and the death toll grow. You spend the weekend at the golf course (at taxpayer expense) to ignore the situation more enjoyably.

Enter your social media director, who is so ignorant that he doesn't know a historical legend when he sees one. He tweets a meme showing you playing a fiddle and the words: "My next piece is called nothing can stop what's coming." You retweet it, cheerfully saying that you have no idea what it means, but you like the sound of it.

Sadly, this is not satire from The Onion. You and your staff really are that ignorant and incompetent.

I suggest that you ask someone to help you Google "Nero" and the phrase "fiddling while Rome burns."

March 9, 2020

Oval Office Occupant,

Your recent tour of tornado-damaged neighborhoods in Tennessee revealed both your dementia and sociopathy. You seemed oddly obsessed with the story of a young boy who was swept up by the winds and deposited unharmed a few blocks away, and waved your hands vigorously while recounting the tale. When you were told that the

boy's parents died, you went right back to talking about how the boy had been spun around by the wind. When you were informed that his sister also was killed, you said "So, we're going to go see some of the folks." No acknowledgement of the tragedy. No expression of sympathy. No change in expression. No emotional reaction whatsoever.

You are not well. You are not normal. You are not capable of doing your job, which includes the very simple responsibility of offering comfort to those affected by tragedies. Just resign. It is so painful to watch you fail every single damn day.

March 10, 2020

Oval Office Occupant,

On Jan. 22, 2018, I wrote a letter asking what you were doing to ready the nation for an inevitable pandemic. I never heard back from you, and it's clear that the answer, had you replied, would have been "nothing." Indeed, not long after I wrote my letter, you shut down the National Security Council's global health security unit, got rid of the epidemic team at the Department of Homeland Security and gutted the global health portion of the Centers for Disease Control. Not only were you not preparing the nation for a pandemic, you were eliminating the tools for it to do so.

Now, here we are, on the edge of disaster while you golf and blame President Obama, Democrats and the media for the spread of the coronavirus when it is your incompetence that is to blame.

You are a danger to the populace. Resign.

Dear Oval Office Occupant

March 11, 2020

Oval Office Occupant,

For years, you've been bragging about how the stock market has performed during your tenure. Now that it has tanked, will you be taking responsibility?

March 12, 2020

Oval Office Occupant,

Yesterday, you spoke to the nation from the Oval Office, reading from a teleprompter. Despite the scripted nature of this self-congratulatory, xenophobic and wholly inadequate address, you got a few key points so completely wrong that others had to clarify your statements immediately after your performance. This is what happens when you are an incompetent boob who hires only sycophants and relatives who have no relevant experience. You and your circus full of clowns are endangering people's lives.

March 13, 2020

Oval Office Occupant,

You have been exposed to people infected with coronavirus. Why in God's name are you still shaking hands with people? Why aren't you setting a good example for the nation?

March 19, 2020

Oval Office Occupant,

Now it's personal. My daughter and her husband are sick with suspicious symptoms. But because of the shortage of testing kits, they have not been tested and are quarantined in their home. My son visited them before coming home from his college. He isn't feeling well either. Our doctor has ordered our entire household quarantined. Unless, God forbid, one of us becomes extremely ill, we will probably never be tested and never know whether we are carrying the virus or not. This is unacceptable. You lied when you said that everyone who needs to be tested can be tested.

Why didn't you accept those testing kits from the WHO? Why didn't you act decisively in January to prevent the spread of the virus? When the crisis is past, I will be lobbying my members of Congress to launch an investigation into where, how and why you and the rest of our government failed. Then, perhaps, we can elect leaders capable of learning from your mistakes and effectively protecting the American people.

Author's note on the March 19, 2020, letter

Thankfully, my husband and I did not get sick, our son's illness was not serious (he later tested negative for novel coronavirus antibodies) and my daughter and her husband recovered fully. We still don't know whether or not they had Covid-19, but it sure seems likely. Their symptoms lasted for weeks, and were unlike any cold or flu I know of.

March 24, 2020

Oval Office Occupant,

What price do you put on the life of my mother? What about my children, my husband or me? Ignoring the clear guidance of doctors and scientists, you have professed your desire to get everyone back to work by Easter, making it clear that getting the economy back on track is more important than the lives of the people you were elected to represent. Let the bodies pile up, folks! As long as the restaurants, malls and, not incidentally, your resorts and golf clubs, are open, it's ok with you.

Ohio Governor Mike DeWine — a Republican I respect — has it right: We need to save lives first and get the economy going again second. Unlike you, he has taken the difficult steps needed to protect our health. Resign, and get out of the way of the people who have the qualifications to get us through this crisis.

March 27, 2020

Oval Office Occupant,

You have, from the beginning, failed to understand the fundamentals of your job. It is your responsibility to serve the American people — ALL the people, not just Republicans, not just those who live in states with Republican governors. You said that you asked Pence, in his capacity as coronavirus czar, to not call governors who have not been "appreciative" enough of your efforts to deal with the pandemic. "Don't call the woman in Michigan," you said, referring to Governor Gretchen Whitmer, who rightly has been critical of the federal government's inability to distribute critical supplies and equipment to where they are needed. Good God.

I am crying for all the sick people, the families of the dead and the brave and exhausted health-care workers. I am frustrated every day that I am unable to help in any substantive way, other than by staying home. You had, and have, the ability to make a difference, but instead persist in making things worse by spewing lies at your press conferences and by indulging in petty, self-serving partisan attacks on governors who are struggling to save lives.

You are a sorry excuse for a president, and an even worse human being.

April 3, 2020

Oval Office Occupant,

I am so tired of living in a George Orwell novel. Your son-in-law Jared Kushner, who has no qualifications to be doing anything whatsoever within your administration, popped up at one of your coronavirus briefings and delivered this load of nonsense: "The notion of the federal stockpile was it's supposed to be our stockpile. It's not supposed to be states' stockpiles that they then use." Who, exactly, is the "our" he is referring to?

It gets worse. Facing backlash from Kushner's perplexing and disturbing remark, your administration quietly changed the description of our Strategic National Stockpile on the Department of Health and Human Services website to harmonize with Prince Jared's statement. Originally, it was described as "the nation's largest supply of life-saving pharmaceuticals and medical supplies for use in a public health emergency severe enough to cause local supplies to run out. When state, local, tribal, and territorial responders request federal assistance to support their response efforts, the stockpile ensures that the right medicines and supplies get to those who need them the most during an emergency."

Now, the description describes the Strategic National Stockpile as a "stopgap." Here's the text: "The Strategic National Stockpile's role is to supplement state and local supplies during public health emergencies. Many states have products stockpiled, as well. The supplies, medicines, and devices for life-saving care contained in the stockpile can be used as a short-term stopgap buffer when the immediate supply of adequate amounts of these materials may not be immediately available."

I doubt that you have ever read "1984," but nonetheless, you are working to make it our reality:

Every record has been destroyed or falsified, every book rewritten, every picture has been repainted, every statue and street building has been renamed, every date has been altered. And the process is continuing day by day and minute by minute. History has stopped. Nothing exists except an endless present in which the Party is always right.

April 4, 2020

Oval Office Occupant,

Your administration failed to provide routine maintenance on ventilators in the nation's strategic stockpile. This means that more than 2,000 of these precious and desperately needed pieces of equipment are not working and cannot be deployed to save lives. You have created the most incompetent and chaotic administration in U.S. history and people are dying as a result.

Although it's rather late in the game, why don't you put a general in charge of the coronavirus response team? A general would know how to efficiently deploy resources where they're needed. Kicking Pence and Kushner out of the way and letting an expert take charge might help a little as this national disaster reaches its deadly and horrifying climax.

April 12, 2020

Oval Office Occupant,

Criticizing the World Health Organization and threatening to withhold financial support is a transparent effort on your part to distract from your own abysmal failures in handling the coronavirus pandemic. Working with other nations to address global health issues through organizations such as WHO is exactly what we should be doing. Viruses are no respecters of borders. Please go back to private life; people are dying because of your bad ideas.

April 13, 2020

Oval Office Occupant,

Today, the death toll in the U.S. from coronavirus topped 23,000. A term you coined in your inaugural address — "American carnage" — is tragically apt. Considering the many ways that you have failed to protect the public from this plague, I think you should adopt "American carnage" as your campaign slogan.

April 14, 2020

Oval Office Occupant,

You: "When somebody is the president of the United States, the authority is total."

The Constitution of the United States of America, Amendment 10: "The powers not delegated to the United States by the Constitution, nor prohibited by it to the States, are reserved to the States respectively, or to the people."

Stop trying to be a dictator.

April 20, 2020

Oval Office Occupant,

The U.S. accounts for one-fourth of the death toll from the coronavirus worldwide. Since we're only 3 percent of the world's population, we've clearly failed as a nation in how we handled this. In the midst of this epic failure, you are encouraging the armed protestors who are demanding that their governors get their states open for business again.

It's no coincidence that Georgia's Republican governor will open up gyms, salons and bowling alleys this week. This is far too soon, based on everything I've read about the conditions that need to be met to protect public health. I pray for the people of Georgia; I'm afraid that thousands of them will be victims of the ignorance and incompetence that is oozing down from the top.

April 26, 2020

Oval Office Occupant,

I got my stimulus check a few days ago. Although I need the money to pay bills, I'll be using a portion of it to support Joe Biden and Democrats running for Senate seats. I'm not alone: My former boss, a successful entrepreneur, told me that you have inspired him to use his entire stimulus check to support Democrats running for office.

Another former colleague, a wealthy, lifelong Republican, informed me that he has registered as an Independent and will be voting for Joe Biden. Additionally, a friend who is a retired corrections officer said he is so disgusted with you and the entire Republican party that he will vote a straight Democratic ticket, despite the fact that he has always voted for Republican judges.

Plastering your name on stimulus checks in an attempt to buy votes isn't going to cut it; you've made a travesty of the presidency and the Republican party and Republicans know it. You've already been impeached; next you're going to lose an election.

April 28, 2020

Oval Office Occupant,

More than 59,000 people are dead from coronavirus in the United States. I'm telling you this because, based on your behavior, it appears that you haven't noticed. Or, more likely, you really don't care, do you? You should ask your wife if that controversial jacket of hers comes in your size.

May 8, 2020

Oval Office Occupant,

Set an example: Put on a damn mask!

May 10, 2020

The pandemic rages on; more than 80,000 people have died in the U.S., with no end in sight. We still don't have enough testing kits or personal protective equipment. We also don't have a nationwide plan for getting out of this mess. And you spent Mother's Day working on the mother of all tweetstorms. Sure, that seems like a good use of your time.

Dear Oval Office Occupant

May 11, 2020

Oval Office Occupant,

Today's White House press briefing featured props paid for with my tax dollars: banners emblazoned with the lie "America leads the world in testing."

During the briefing, you boasted that our testing rate per capita is higher than that of South Korea. That would have been a good boast a couple months ago, when South Korea aggressively tested its citizens for the coronavirus, isolated those who were infected and diligently identified those who had been in contact with infected people. All those actions allowed South Korea to limit the spread of the virus and — guess what — reduce the need for testing now. Public health experts say that our rate of testing is far below what is needed. You also repeated your old lie that anyone who wants a test can get a test. Without sufficient testing, isolation and contact tracing is impossible.

With you and your clown car of bunglers at the helm, eradicating the virus is not even the goal. The Administration's goal is to normalize some 2,000 COVID-19 deaths per day. Go back to the mall, folks! Pay no attention to the 81,000 corpses in the corner! Re-elect the Dear Leader!

May 19, 2020

Oval Office Occupant,

You stunned the world by announcing that, to prevent COVID-19, you are taking an unproven drug that has dangerous, sometimes fatal side effects. The risks you take with your own health are none of my concern. However, your announcement is a clear signal to your followers that

hydroxychloroquine is the miracle they have been looking for. Since a significant number of your fans appear to be fact- and science-averse, it's only a matter of time before someone follows your lead and gets seriously ill or dies.

Your irresponsible behavior is unacceptable and not normal for a U.S. president.

Incidentally, I have my doubts about whether you're actually taking hydroxychloroquine. Perhaps your doctor got tired of listening to you ask for the drug and is giving you a sugar pill to keep you quiet.

May 20, 2020

Oval Office Occupant,

By the official count, nearly 94,000 Americans are dead from COVID-19. But the reality is likely much worse, based on the number of deaths that are occurring above what would be normal. Yet you have no feasible plan. You crow and bleat about opening the economy and about miracle vaccines that will be ready faster than is humanly possible. You toss out shiny objects made of fool's gold (Obamagate) to distract us from your incompetence and the carnage. I will not be distracted. 94,000 people are dead. You have failed far beyond my worst nightmares. Please resign.

May 25, 2020

Oval Office Occupant,

Memorial Day arrived with a heavier burden this year. As always, I mourn my dad, who paid dearly for his service to his country. I try to fathom the loss of the women and men in uniform today and yesterday

and the yesterdays before that. And I find myself thinking about all those lost around the world to the pandemic. The health-care workers, the babies, the grandparents, the sisters and brothers and best friends and parents. Pause. Reflect. Contemplate. Mourn. Be grateful that they were. That they lived. That each was everything to someone else.

A grieving nation needed a simple gift from you today: quiet. A reprieve from the sexist tweets, the victimhood, the blaming, the false accusations, the faux patriotism. A moment of silence for grieving. You did not — nay could not — oblige.

Amidst the day's reflections, I sat down and wrote letters encouraging potential voters to head to the polls in November. I will mail them in October, sending each on its way with a prayer that, as a nation, we will vote for decency, for humanity, for competence, unity and healing.

May 30, 2020

Oval Office Occupant,

The nation is reeling — I am reeling — from the murder of George Floyd at the hands of police officers. Protests across the land have turned violent. In a series of tweets, you took sinister pleasure in imagining how the Secret Service would have handled protestors if they had breached the White House fence: "they would have been greeted with the most vicious dogs, and most ominous weapons, I have ever seen. That's when people would have been really badly hurt, at least. Many Secret Service agents just waiting for action." Then: "Tonight, I understand, is MAGA NIGHT AT THE WHITE HOUSE???"

That last bit is truly alarming: You are calling on your MAGA thugs to show up at 1600 Pennsylvania Ave. to mix it up with the protestors.

I cannot express how angry and sickened I am at your reckless, dangerous, irresponsible and inflammatory statements. You are no leader. You are no president. You are a bully, a coward and a would-be dictator. I pray to God that no one is hurt tonight because of your reprehensible behavior.

May 31, 2020

Oval Office Occupant,

Philonise Floyd, in the throes of grief for his brother George, who died at the hands of Minneapolis police, had to endure the additional pain of a phone conversation with you. He said that he was barely able to get a word in edgewise.

You are incapable of performing any of your duties, even speaking to a grieving man. Resign.

June 2, 2020

Oval Office Occupant,

As a Christian, I am deeply offended that you would use a Bible and a church as props in a transparent and pathetic attempt to pander to your white evangelical base. As a human being, I am deeply offended and sickened that law enforcement violently removed peaceful protestors near the church to make your photo op possible.

After tendering your resignation, you should get that Bible back from whoever loaned it to you and spend some time reading it.

June 4, 2020

Oval Office Occupant,

At least 110,000 Americans are dead from the pandemic, tens of millions are unemployed and uncounted thousands of protesters across the nation are demanding an end to racism and justice for a black man murdered by police. Looters and vandals have set buildings and cars on fire. Police have beaten, tear-gassed and shot peaceful protesters with rubber bullets. This would be a good time for the nation to have a president.

Instead, we have a coward, a would-be dictator, cowering behind fences and barriers and better men than him in uniform. We have a craven, using helicopters, tear gas and military and law enforcement personnel to intimidate, harass, injure and menace citizens trying to exercise their First Amendment rights.

You cannot lead: You divide, you inflame, you appeal to humanity's worst instincts. You trample on the Constitution, your oath of office, human rights and human lives. From family separation to tear-gassing protesters in the way of your photo op, you have left devastation in your wake.

We have had enough. Our country can take no more. You've already been impeached; the vice president and Congress need to remove you via the terms of the 25th Amendment, a fact I remind Senator Portman of daily.

June 9, 2020

Oval Office Occupant,

Buffalo police shoved peaceful protestor Martin Gugino to the ground a few days ago, severely injuring him. This 75-year-old man is still in the hospital. Without a shred of evidence, you have suggested that Gugino, a private citizen and longtime peace advocate, is an "ANTIFA provocateur" and that he appeared "to scan police communications in order to black out the equipment." This is even more monstrous and deranged than usual for you. I fear for this man's life, not just because of his injuries, but because some nutjob might decide to act on your delusional tweet.

To top off the crazy cake, you said that "he fell harder than was pushed." That statement is incomprehensible.

This is just the latest evidence that you are a deranged lunatic incapable of performing the duties of your office, a fact I noted in my call to Senator Portman today. Pack your bags. Leave your bunker, you coward, and return to private life before you hurt anyone else.

June 11, 2020

Oval Office Occupant,

As far as I can tell, "antifa" isn't an actual organization, it's more of an ideology shared by a variety of individuals and unaffiliated, autonomous groups. Trying to get something that isn't an organization at all declared a terrorist group is just more of your fearmongering, distraction and an excuse to surveil the citizenry. We would all be better served if actual terrorist groups like the KKK were labeled and treated as such. For

what it's worth, I am anti-Fascist, as was my dad, who put his life on the line serving as an infantryman in the Rainbow Division in the Battle of the Bulge. If that makes me part of a "terrorist group," then so be it.

June 12, 2020

Oval Office Occupant,

Today, my son starts putting his brand-new Bachelor of Science degree in Chemistry to use, sterilizing N95 masks for health-care workers in Little Rock, Ark. It's a temporary gig; he'll work 12-hour shifts for 21 consecutive days. He will likely do a second round after a short break. I'm very proud that he is helping to keep doctors and nurses safe and to conserve our nation's supply of personal protective equipment. He has always been a very caring person, and is grateful for the opportunity to help his fellow human beings in this time of crisis.

In contrast, having found that magical thinking and your band of incompetents and sycophants can't end the pandemic, you and your administration have moved on to other matters. But we haven't moved on; the number of new cases reported each day is going up in at least 20 states. Arkansas is a hot spot, with new cases spiking dramatically. My son may be in real danger going out and about in Little Rock.

Doctors, nurses, EMTs, hospital staff, nursing home staff and people like my son are working tirelessly to help the sick and get our nation through this. As the number of dead Americans equals the number lost in all of WWI, you are being criminally negligent, encouraging the populace to act as if there is no danger at all. You have blood on your hands. You will go down in history as an impeached, one-term, failed president.

June 21, 2020

Oval Office Occupant,

What a flop! Fewer than 7,000 people showed up for your rally last night, and thank goodness. A full house would have produced untold carnage from Covid-19. Hosting a 100 percent unnecessary political rally indoors during a pandemic is possibly the most selfish thing I have ever heard of. Clearly, killing off some of your fans is an acceptable price for the adulation required to fill the vast emptiness within you. A real leader, like Vice President Biden, respects his supporters by not endangering their health and lives.

June 22, 2020

Oval Office Occupant,

Calling the novel coronavirus "the kung-flu" is racist and you know it. You demean the office which you so unfortunately hold. Resign.

June 25, 2020

Oval Office Occupant,

Captain Mark Kelly is a highly decorated naval aviator who flew dozens of combat missions. As an astronaut, he went on multiple missions and spent a total of nearly two months in space. As a husband, he stood faithfully by the side of his wife, Congresswoman Gabby Giffords, during her long and arduous recovery from gunshot wounds sustained in an assassination attempt, an attempt that has permanently affected her health.

But that's not all. Kelly and Giffords have worked tirelessly in the years since the shooting to solve the epidemic of gun violence that plagues our nation. Despite fierce opposition, personal attacks and worse, they have fearlessly demanded that our government implement measures that will work.

Kelly is the author of several books and, as I can attest from first-hand experience, is a riveting public speaker. In short, he is an accomplished, intelligent, courageous man of character who has stood by his family and selflessly served his country at great personal danger. My husband and I have been delighted to donate both to his Senate campaign and the couple's political action committee.

A few days ago, you called this American hero "weak." Kelly's strength is unquestionable. It's actually the weakling you see in the mirror that you despise.

Author's note on the June 25, 2020, letter

My husband and I have never forgotten a spellbinding presentation that Captain Kelly and Gabby Giffords gave several years ago at the University of Akron. The president's attack on Kelly really rankled me and inspired me to write to thank him for his service and extend the couple my best wishes. He is the kind of guy we need in government.

June 26, 2020

Oval Office Occupant,

We're setting records — more than 41,000 new cases of coronavirus were reported in the U.S. yesterday. And at least 125,000 Americans are dead. Yet Pence emerged today to tell us that we have made remarkable

progress. Bullshit. Those new case numbers yesterday will be new record death numbers in a week or two. The virus is raging out of control while you mislead, downplay and distract. How many more of us must die because of your malignancy?

June 27, 2020

Oval Office Occupant,

Let me get this straight. Putin offered — and possibly paid — bounties for the lives of American soldiers in Afghanistan and you did nothing? No sanctions? No discussions with our allies on how to respond? And then you lobbied to get Russia back into what is now the G7? What hold does Putin have on you? Is it because you know that the only way you can get re-elected is if Putin puts his thumb on the scale? Why are you still president?

June 28, 2020

Oval Office Occupant,

Tweeting a video in which a supporter of yours chants "white power" is inexcusable. Promoting white supremacy is despicable. You are not normal and are incapable of serving ALL the American people. RESIGN!

July 3, 2020

Oval Office Occupant,

A few days ago, you said that painting the words "Black Lives Matter" on Fifth Avenue in New York will be "denigrating this luxury Avenue."

Furthermore, you claimed that the words are a "symbol of hate." The phrase is not a symbol of hate, it is a rallying cry for justice, equality and an end to police brutality. I think those words will dress up Fifth Avenue quite nicely.

Do you want to know what has truly become a symbol of hate? Your face. On a daily basis you employ racial slurs, demeaning nicknames and alarmist rhetoric to divide, frighten and anger the populace.

I have a sign in my yard that says "Hate has no home here." I want that to be true not only in my heart and home and neighborhood, but in my country as a whole. The American people deserve a leader with the genuine strength that comes from a wellspring of love and compassion for all citizens. You will be voted out.

July 12, 2020

Oval Office Occupant,

Thank you for wearing a mask in public. I am hopeful that this belated effort to do the right thing will inspire people to follow your example and will save some lives.

July 13, 2020

Oval Office Occupant,

New Zealand has no cases of coronavirus. Let that sink in. Everyone there can go back to business as usual and get their economy humming again. Parents can feel safe sending their kids to school. Meanwhile, in the U.S., the number of new cases is soaring, some hospitals are close to being overwhelmed, deaths are nearing 140,000 and we're running

low on PPE again. (My son is still in Little Rock, sterilizing medical workers' used masks.)

The sad irony is that this pandemic could have been your shining moment and an opportunity to get the praise you so desperately crave. You could have embraced the challenge in January, dusted off the pandemic response plan left by your predecessor and behaved like President Bush did after 9/11, inspiring Americans to pull together and take care of each other in terrifying times.

Since you are incapable of such leadership and persist in sowing confusion and division, we are doomed to untold death, disease and suffering, in addition to sky-high unemployment and a recession — a hellish worst-case scenario that is now all too real.

My mother turned 91 today. She has paid close attention to politics and current affairs for her entire adult life — in fact, you have gotten a few letters from her. She says that in her nine-plus decades there has never been a worse president than you — and it's not even a close contest. She's protecting her health by staying home; her goal is to make it to Nov. 3 so she can vote you out of office and get the country back on track. My mom is a patriot. You are not.

July 14, 2020

Oval Office Occupant,

As Black Lives Matter protesters exercised their First Amendment rights by marching through a St. Louis neighborhood, a white couple came out of their house and brandished guns at them. When asked about the homeowners today, you veered off into fantasy land: "They were going to be beat up badly, if they were lucky. If they were lucky.

They were going to be beat up badly and the house was going to be totally ransacked and probably burned down, like they tried to burn down churches."

There is no evidence that the marchers were violent or threatening or that they had the materials necessary to start a fire.

Not only are you a racist, you are delusional.

July 22, 2020

Oval Office Occupant,

At a White House press briefing yesterday you sent your well wishes to Ghislaine Maxwell, whom the feds are prosecuting for her alleged role in helping Jeffrey Epstein recruit, groom and rape children. "I just wish her well, frankly," you said.

You know what I think? I think that Maxwell knows some very unsavory things about you, and that you wanted her to know that you've got her back as long as she doesn't squeal, with the implied threat of your retaliation should she turn state's evidence. What other explanation could there be for the president of the United States publicly showing support for someone charged with child molestation?

July 23, 2020

Oval Office Occupant,

Federal troops that you inappropriately and wantonly deployed to Portland are tear-gassing pregnant moms, breaking the bones of peaceful protesters and kidnapping them off the streets and throwing them into

unmarked vans. Those who have been arrested have reported that they have no idea who arrested them or why. Some have reported that they were held without being read their rights.

Meanwhile, more than 1,000 people in the U.S. are dying every day from the novel coronavirus. In less than four years you have reduced the country to a fascist hellscape.

July 24, 2020

Oval Office Occupant,

For 240 years we have had a peaceful transition of power, as one president quietly stepped back to make room for the next. Yet, recently you were asked if you will accept the results of the November election. "I have to see," you said. "No, I'm not going to just say yes." In other words, if you win, you'll accept the results. If not, well, all bets are off.

You have intentionally tried to divide the American people from the moment you came down that tacky golden escalator to announce your candidacy. In a time of great turmoil and danger, as Americans are dying in great numbers from the pandemic and are struggling with the realities of police brutality and racism, you have worked hard to further inflame divisions and fear, even using federal forces to intimidate and violate the rights of protesters.

When Joe Biden wins in the fall, if you refuse to accept the election results you may tip the country into civil war. You are a loser. You will lose. Accept it and go quietly.

July 26, 2020

Oval Office Occupant,

I see your actions for what they are: authoritarianism, the implementation of martial law, fascism. Today I donated to a bail fund for protesters in Portland. Earlier this month I donated to the ACLU, which is taking the fight to protect protesters' Constitutional rights to the courts. I'm calling Congress and exhorting my friends to do so as well. This is not a drill! I will not let you win.

July 30, 2020

Oval Office Occupant,

Just in the span of a couple days, American deaths from coronavirus topped 150,000, you announced the costly withdrawal of troops from Germany (a gift to Putin) and we found out that the U.S. economy shrunk by a staggering 32.9 percent annual rate from April through June — by far the worst such contraction ever recorded. That last bit is due in large part to your epic mishandling of the U.S. response to the pandemic.

Is it any wonder that Biden's poll numbers are surging? If the election were held today, you would lose. Perhaps that is why you decided to create yet another distraction: a tweet musing about the feasibility of postponing Election Day. You could save face by resigning now for health reasons. I strongly urge you to do so.

August 4, 2020

Oval Office Occupant,

When confronted with the fact that 1,000 Americans are dying PER DAY from the novel coronavirus, you said "It is what it is." Tragically, maddeningly "it is what it is" because you refused to implement nation-wide testing and contact tracing. "It is what it is" because you downplayed the severity of the illness and said that like a "miracle" it would go away. "It is what it is" because you misled the gullible among us into believing that masks are useless and that dangerous and unproven treatments are the answer. "It is what it is" because you didn't follow the pandemic playbook left behind by your predecessor.

Now you continually demand that schools reopen. When the nation's children and teachers start dying in large numbers, you will look out upon the carnage without a twinge of guilt and say: "It is what it is."

August 5, 2020

Oval Office Occupant,

Countless times you have asserted that if the U.S. performed fewer diagnostic tests, we would have fewer cases of COVID-19. At first, I thought you were having trouble expressing the thought that performing more diagnostic tests *reveals* more cases of COVID-19. After seeing your recent interview with Jonathan Swan, it is clear to me that you really believe that tests cause the disease. It was painful to see how confused and lost you were. You are utterly addled, probably by some combination of longstanding mental illness and dementia.

People are dying by the thousands because you are incapable of understanding basic concepts or performing your job. It is astonishing

that your handlers think that they can disguise your incapacity. If you start relieving yourself in the potted plants or running around naked in the Rose Garden, will they admit defeat?

August 11, 2020

Oval Office Occupant,

Undermining the post office to tamper with the election is having dire consequences: Veterans report that they are experiencing criminal delays in receiving critical medications. This is just the latest example of you screwing over veterans and our military members. Do you really think veterans and service members will be voting for you? How could they when you are interfering with their medical care and allowing Putin to go unpunished for paying bounties for the deaths of U.S. soldiers? You should resign in shame and turn yourself in to law enforcement for your crimes.

August 12, 2020

Oval Office Occupant,

When the news broke that Joe Biden had chosen Kamala Harris to be his running mate, my colleagues and I started betting on how soon you would start slinging sexist slurs. It took only about an hour for you to call her nasty, mean, horrible and disrespectful. In response, this nasty woman was happy to donate to the Biden/Harris campaign today.

August 15, 2020

Oval Office Occupant,

I was relieved to hear that you will not be giving your acceptance speech for the Republican Party nomination at Gettysburg; the thought of you desecrating that hallowed ground made me sick to my stomach. However, using the White House grounds instead is not much better. Politicizing the People's House, where you are supposed to be conducting the nation's business, is offensive. It also may be legally problematic for staff, who are likely to violate the Hatch Act by helping with the event. I'm sure their liability doesn't concern you one bit. Please just stop. Resign. Give up. You're going to lose.

August 21, 2020

Oval Office Occupant,

The Democratic National Convention was a virtual event — no one could buy tickets or attend in the usual sense — but the wonders of modern technology allowed participants to take part from around the country. This is a simple concept to understand. Imagine my surprise when you tweeted this: "To get into the Democrat National Convention, you must have an ID card with a picture...Yet the Democrats refuse to do this when it come to your very important VOTE!" The grammatical errors were expected, but the breathtaking stupidity was unusual, even for you.

Are there more important things for me to be writing about today? Of course. You've recently encouraged the dangerous nuts who believe in QAnon conspiracies. Russia is, at this very moment, working to get you re-elected. The death toll in the U.S. from COVID-19 is galloping toward 200,000.

But I don't think it's possible to overstate how abnormal this presidential communication is. If President Obama had said something so ludicrous, the nation would have concluded that he had lost his mind. Any other politician on the national stage would have had to apologize for such an ignorant and humiliating gaffe, remove the offending tweet and pray that it wasn't career-ending.

Since batshit-crazy is your normal operating mode, most people will ignore just how deranged this tweet is or will blow it off as just you being you. So, for the record, this tweet isn't normal. Your behavior is not normal. There is something very, very wrong with you. You are not fit to be president or hold any office whatsoever. Sad.

August 22, 2020

Oval Office Occupant,

Did you hear Brayden Harrington, a brave 13-year-old boy with a stutter, speak at the DNC? I did. He shared how Joe Biden spent time with him, encouraged him and gave him tips on overcoming his stutter when giving speeches. My first thought? Wow, what a contrast with you, the bully who publicly made fun of a disabled reporter. Biden has compassion. You do not. That one characteristic alone makes him eminently more qualified to preside over the nation's business. You are going to lose.

August 23, 2020

Oval Office Occupant,

A judge ruled that you cannot delay E. Jean Carroll's defamation lawsuit against you from moving forward. Therefore, she is one step

closer to getting a sample of your DNA. She claims that you raped her and that your genetic material is on the dress she wore at the time. You claim that you don't even know her and that she's a liar, which is the basis for her defamation suit. If you are innocent, wouldn't it be simplest for you to provide the sample and get the case over with? But that's not your style. Over the years, thousands of people have sued you and your businesses, and your strategy has always been to countersue and drag proceedings out so long that your opponent is forced by economic necessity to give up.

I admire Ms. Carroll's tenacity and bravery. I also strongly suspect that she's telling the truth. I look forward to the resolution of this case and justice being served.

August 27, 2020

Oval Office Occupant,

Instead of tweeting about "LAW and ORDER!" you should be working to end police brutality and extrajudicial killings. You should be seeking justice for Jacob Blake, Breonna Taylor, George Floyd and so many other people of color who have been maimed and murdered by law officers who walk away free. The protests and vandalism are a symptom, not the illness.

August 28, 2020

Oval Office Occupant,

More than 180,000 people have died in the U.S. from the coronavirus. Resign.

August 29, 2020

Oval Office Occupant,

I don't talk about it much in my letters to you, but I am terrified about the future of the planet. Admittedly, things were looking really bad before you took office. But after almost four years of anti-science policies, climate-change denial and the gutting of environmental regulations, I tremble to think what the planet will look like when my children are old.

Just during your presidency, we have seen more frequent and more deadly hurricanes, fires, floods and more. Every year is hotter than the last. And as wildlife habitats are destroyed, deadly pandemics become ever more likely.

While the actions of everyday people such as myself are important, we also need bold — very bold — leadership to keep the planet inhabitable. Joe Biden, Kamala Harris and a Democratic-majority Senate will make changes to protect our home. For the sake of future generations, you cannot win the election.

September 2, 2020

Oval Office Occupant,

Now you're telling your supporters to vote twice. Don't you know that could land them in jail? Isn't that the kind of voter fraud you're always freaking out about?

September 3, 2020

Oval Office Occupant,

The Department of Homeland Security withheld information from the public about how Russia is actively interfering with the 2020 election, specifically, that it is spreading lies about Joe Biden's mental health. Interestingly, attacking Biden's mental fitness has been one of your key strategies. Aren't you tired of being Vlad's tool?

September 7, 2020

Oval Office Occupant,

While the citizens of many countries can now travel freely, the borders of dozens of countries remain closed to us because the virus is running amok here. I am so tired of all the "winning" you've subjected us to.

September 9, 2020

Oval Office Occupant,

You knew. You knew how bad this virus is and you LIED to the American people. You knew that it is highly contagious, but you didn't warn us, you said it would go away, like a miracle. You knew that COVID-19 is a killer, but you didn't muster national testing, tracing and isolation protocols. You knew that the virus kills children and you urged schools to reopen. You said that you downplayed its seriousness because you didn't want to cause panic; it's more likely you didn't want the stock market to go down.

You had a duty and a responsibility to use the powers of the executive branch to inform and protect the nation, but you knowingly and willfully chose not to. You are no better than a cold-blooded murderer.

September 10, 2020

Oval Office Occupant,

I want to know why the full might of the Justice Department (paid for by my tax dollars) will be used to defend you in the defamation lawsuit brought by E. Jean Carroll. You should have to pay for lawyers out of your own pocket. This is an abuse of the Justice Department. What are you holding over Attorney General Barr? Why does he do what's best for you, not the nation?

September 15, 2020

Oval Office Occupant,

The West Coast is on fire. This tragedy is too much to bear. The people we have lost. Those who are now homeless. The exhausted and injured firefighters. The millions suffering from breathing in smoke. All those animals and trees. The destroyed homes and businesses.

On Monday, California officials begged you to work with them to fight climate change.

"It'll start getting cooler. You just watch," you said.

"I wish science agreed with you," replied Wade Crowfoot, the state's natural resources secretary.

"Well, I don't think science knows, actually," you said with a smirk.

How many people must suffer and die because you refuse to believe in science?

September 18, 2020

Oval Office Occupant,

Ruth Bader Ginsburg has left us and we are diminished. I wonder how she felt in her final days as you publicly released a list of possible replacements for her on the Supreme Court. Did you know her death was imminent? Couldn't you have waited until after her funeral?

In 2016, the conniving Mitch McConnell infamously blocked President Obama's Supreme Court nominee because it was an election year, even though nearly a year remained in Obama's term. With no shame for his blatant hypocrisy, he has declared his intention to confirm your nominee ASAP. It was Ginsburg's wish that her replacement be chosen by the next president. In light of those facts, I honored her memory tonight by donating to the Senate campaign of Amy McGrath, McConnell's opponent. May she defeat him in a landslide.

September 23, 2020

Oval Office Occupant,

Today a reporter asked you point blank, more than once, if you would commit to a peaceful transfer of power after the election, win, lose or draw. "Absolutely" was the correct answer, an answer you refused to give. You are a clear and present danger to our nation.

September 26, 2020

Oval Office Occupant,

Nearly 500 national security leaders — retired admirals, generals, secretaries of state, ambassadors and others — of all political persuasions wrote an open letter endorsing Joe Biden, citing his honesty, integrity, decency and wisdom.

Here's what they had to say about you: "The current President has demonstrated he is not equal to the enormous responsibilities of his office; he cannot rise to meet challenges large or small. Thanks to his disdainful attitude and failures, our allies no longer trust or respect us, and our enemies no longer fear us. … The president has ceded influence to a Russian adversary who puts bounties on the heads of American military personnel, and his trade war against China has only harmed America's farmers and manufacturers."

I am glad to be in such excellent company in my belief that you are utterly unfit for office. I look forward to Joe Biden's inauguration and a return to competence and decency in the executive branch.

September 27, 2020

Oval Office Occupant,

For years, I've been hounding you to release your tax returns, but the *New York Times* has essentially beaten you to it. It has obtained loads of tax returns and they reveal an ugly picture. Your businesses lose tons of money and you use those losses to avoid paying federal income taxes. You have employed a host of fishy deductions, including "consulting fees" that likely lined Ivanka's pockets. And, you are feeling the squeeze,

knowing that hundreds of millions of dollars of debt is coming due very, very soon.

No wonder you are so desperate to stay in office indefinitely. If you lose, you face financial ruin and possible criminal liability. I am dreading to see what dirty tricks you will resort to when Biden wins and you refuse to concede.

September 29, 2020

Oval Office Occupant,

Ruth Bader Ginsburg's granddaughter told the world about the justice's dying wish: That the next president should choose her successor. When your friends at Fox News asked you about RBG's deathbed aspiration, you slipped into a fantasy in which Chuck Schumer and Nancy Pelosi fabricated the story.

It really is impossible to describe how aberrant your behavior is.

September 30, 2020

Oval Office Occupant,

That wasn't a presidential debate, that was a humiliating spectacle. You bullied, you lied, you interrupted, you refused to denounce white supremacy and you issued a call to the violent Proud Boys to "stand by." Your behavior is frightening and unacceptable. We will fire you on Nov. 3.

October 2, 2020

Oval Office Occupant,

I was sorry to learn this morning that you and the First Lady have tested positive for coronavirus. I hope that you both have a speedy recovery and that the rest of your family remains healthy.

October 3, 2020

Oval Office Occupant,

I am angry. I am angry that you have jeopardized our national security with your recklessness. I am angry that you have thrown our country and our election into further chaos. I am angry that you have endangered those around you: your family, staff, Secret Service agents and White House personnel. I am angry that you mingled indoors with campaign donors without a mask or any concern for their safety, likely knowing that you had been exposed to the virus.

I am angry that more than 7 million people in the U.S. have contracted this dreadful disease and I am even angrier that almost 210,000 Americans have died, and there is no end in sight.

I am angry that because of your culture of lies, we can't trust your staff to tell the truth about your condition. The doctors who lined up today outside Walter Reed gave a rosy assessment of your health; shortly thereafter, your chief of staff contradicted their remarks.

You could have been the most-protected person in the world, but you insisted on hosting one rally after another and ensured that mask-wearing would be at a minimum by mercilessly mocking those who chose to

take that simple step to protect others. How many infections, including yours, could have been prevented if you had set an example early and worn a mask?

To sum up: Unemployment is rampant, COVID-19 deaths are likely to reach 3,000 per day by the end of the year, our election feels like it's hanging by a thread and the executive and legislative branches are looking vulnerable as, one after another, top officials test positive for the virus. We look like a nation on its knees, and our enemies are watching.

October 5, 2020

Oval Office Occupant,

May I remind you that at least 210,000 Americans are dead from the novel coronavirus and uncounted thousands are fighting for their lives this very moment. Saying "Don't be afraid of Covid" because you are "Feeling really good!" is obscene. You are unfit.

October 10, 2020

Oval Office Occupant,

I've been closely following the *New York Times'* deep dive into your tax returns and business dealings. The details released today are new, but the basic idea is no surprise: Individuals and companies who wanted something from your administration spent big at your properties and, oftentimes, you delivered. Even if you didn't dish out goodies, you still made money off unsuccessful supplicants. Financially, there was no way you could lose. You are the swamp.

October 11, 2020

Oval Office Occupant,

During the past week, the *New England Journal of Medicine* endorsed Joe Biden for president ... and the Taliban endorsed you. Which one should I listen to?

October 12, 2020

Oval Office Occupant,

Top health experts say that there should be no mass gatherings of any kind in the U.S. right now. Holding campaign rallies is beyond irresponsible — it's criminal. Do you actually want your supporters to get sick and die? Furthermore, even if you are no longer contagious, what about the staff and security people who travel with you? I doubt that the contagion in the White House has been brought under control. Stay put and keep your mask on. People's lives depend on it.

October 13, 2020

Oval Office Occupant,

Today I voted for decency, compassion and integrity. I voted for competence, experience and intelligence. I voted for the future of the planet and the rights of the downtrodden. I voted for a government guided by facts, science and common sense. Today I voted for Joe Biden and Kamala Harris.

October 18, 2020

Oval Office Occupant,

You tweeted an image of Joe Biden's head photoshopped onto the body of a person in a wheelchair at a nursing home. While you were attempting to mock Vice President Biden, you also managed to disparage senior citizens and disabled people. Cruel and classless. I can't wait until you are in the nation's rearview mirror.

October 21, 2020

Oval Office Occupant,

The children have been haunting me for years now. You know, the ones you ripped away from their families. Their moms and dads are haunting me, too. Their anguish must be indescribable. Today I learned that no one is able to find the parents of 545 immigrant children. Your heartless and cruel policies have destroyed families and lives.

You and a lot of other people in your administration belong in jail for committing crimes against humanity.

October 22, 2020

Oval Office Occupant,

The other day you attempted to make fun of Joe Biden by saying that he will "listen to the scientists." Your magical-thinking "strategy" has resulted in the deaths of more than 222,000 people. I think I'll give the science guy a try.

Dear Oval Office Occupant

October 23, 2020

Oval Office Occupant,

Your debate performance was long on lies and short on policy, but that's not what is depressing me. At every opportunity you demonstrated that you have zero empathy for your fellow travelers on this planet.

Mass casualties from Covid-19? "We're learning to live with it."

At least 4,000 kids ripped from their parents' arms? "They are so well taken care of. They're in facilities that were so clean."

Do you understand why Black parents fear for their children? "No one has done more for the Black community than Donald Trump."

Not once did you express any human feeling for pandemic victims, immigrant families, frightened Black parents or anyone at all. After four years of observing you in action, this is not a surprise, but it is still dispiriting as hell.

I have noticed that there is no joy or warmth in your infrequent smiles. It must be bleak and empty being you. But your tragic deficiencies pale in comparison to the catastrophes they have wrought. We are a nation in mourning because of your inability to see beyond your own political needs.

When Joe Biden is inaugurated, please go quietly and leave us alone to grieve and heal.

October 25, 2020

Oval Office Occupant,

Today, your chief of staff, Mark Meadows, admitted on national television that your administration has given up on containing the coronavirus pandemic. "We are not going to control the pandemic. We are going to control the fact that we get vaccines, therapeutics and other mitigation areas," he said. On a related note, Mike Pence can't even bother to quarantine after several people close to him tested positive. Yep, just like his boss, he's perfectly content being a potential vector and harming those around him.

There was a day when there was no challenge too great for the U.S. to take on. Under your chaotic reign we are surrendering to a virus, even though there are proven ways to save lives now, before a vaccine is even available.

The American people deserve a president who is capable of leadership, someone who will promote and model the steps we need to take to protect one another. Joe Biden's inauguration on January 20 can't come soon enough to suit me.

November 1, 2020

Oval Office Occupant,

I watched a video of numerous vehicles sporting your campaign gear surrounding a Joe Biden campaign bus as it drove down a Texas highway a couple of days ago. It looked like your supporters were trying to stop the bus or run it off the road; a minor accident not involving the bus also appears in the video. People on the Biden bus were so alarmed

that they called 911. Law enforcement ended up escorting them to their destination, and the FBI is investigating the incident.

I shouldn't have to explain that this malicious and dangerous behavior is horrifying. But apparently, I do, because on Twitter you shared a video of the hemmed-in bus and commented "I LOVE TEXAS!"

You are a very sick man.

November 3, 2020

Oval Office Occupant,

I've waited for this day for four years. I admit, I am very much on edge as I sit in my den, listening to early election results and writing this letter. It's all on the line tonight — all of it. LGBTQ rights and racial equality. Justice and civil liberties. The course of the pandemic. American lives. Economic recovery. The health of the planet.

I am praying for a course correction, a hard turn toward competence, stability, truth and decency.

I am sure that you also are following the election results, albeit from behind that wall you built around the White House. You look worried, hiding there. You have good reason to be concerned; it's all on the line tonight for you, as well.

Will you be free of the last restraints on your power, or will you be a lame duck, abandoned by your party? Will you keep filling the Justice Department and courts with your lackeys, or will you face justice in the Southern District of New York and elsewhere? Will your position continue to shield you from creditors, or will you have to pony up more

than $400 million? Will you see a winner in the mirror, or face utter humiliation?

For you, the stakes are high, but for the rest of us, they are even higher. I know I am not alone tonight in fearing, hoping and praying for the soul of our nation.

November 4, 2020

Oval Office Occupant,

This is where we part company, you and I. For almost four years I have documented the failures, abnormalities and absurdities of your presidency. There were so many low points: You looked the other way when Vladimir Putin put bounties on the heads of American soldiers. You abused your power and obstructed justice, leading to your impeachment. You praised white supremacists and told congresswomen of color to go back where they came from. You kidnapped children and babies from their parents. You were unable to muster an adequate response to the pandemic, and more than 233,000 Americans are dead — so far.

And today? Today you tried to sabotage our electoral process by declaring victory long before the result was known and falsely claiming that the counting of legitimate ballots somehow constitutes fraud. In other words, you are up to your old authoritarian tricks.

You will keep doing what you do, but you won't be hearing from me. And I won't be hearing from you, either; I have unsubscribed from your campaign's emails.

Don't worry, I'm not abdicating my civic responsibilities. Being active in our nation's affairs has become an unbreakable habit; these letters of mine have done their job.

Dear Oval Office Occupant

Whether you remain in office or Joe Biden becomes president, I'm starting a new journey today. I have found my voice and am looking forward to using it.

Sincerely,
Kathy Hayes

November 7, 2020

Dear Vice President-elect Harris,

Congratulations! I am thrilled and grateful that you will be the next vice president of the United States!

These are extremely difficult times, but I know that you are ready to hit the ground running. Do you hear that sound? That's me, in small-town Ohio, cheering you on!

Sincerely,
Kathy Hayes

November 7, 2020

Dear President-elect Biden,

Congratulations on being elected the 46th president of the United States! Today's news fills me with profound relief, great joy and, most importantly, hope.

I am exhausted by the chaos, the incompetence, the corruption and racism of the current administration. I am yearning for some dignity and compassion, for humility and honesty. An executive branch that values science and facts will be a blessed relief.

We have become so divided as a nation, and it makes me afraid. I have been struggling to imagine how we can begin to heal and move forward together. I don't know what that work looks like, but with you and Vice President Harris at the helm, I know I will have a good example to follow.

I am confident that you both will work hard to serve the American people. Know that millions of citizens like me are behind you, ready to help get us back on track. Thank you for being willing to lead during these extremely difficult times.

Sincerely,
Kathy Hayes

AFTERWORD

As the dust settled from the 2016 election, millions of everyday people mobilized to participate in what would become one of the largest demonstrations in U.S. history, the Women's March, held January 21, 2017, the day after Inauguration Day. Some participants were lifelong activists; many more were holding signs and chanting slogans for the very first time, spurred to action by the new president's misogynistic statements, but also fueled by concerns for the environment, health care, immigration and a host of other issues.

At the same time, progressive grassroots organizations, including thousands of Indivisible groups across the country, sprang up, seemingly from nowhere, and doggedly began lobbying their elected officials to address issues at local, state and national levels.

It felt like an overnight awakening, as people coalesced organically to protect values that seemed very much under threat. Much more was to come from courageous folks across the land: #metoo; the March for Our Lives; Black Lives Matter.

During the last four years, millions of ordinary people have stood together, calling for change and refusing to give up. Are you one of them? I am grateful to you. You *are* changing the world, even if those changes are agonizingly slow in coming and fraught with setbacks.

In light of such passion and bravery, writing a letter to the president doesn't sound like much.

Still, that one letter turned into two, and without knowing quite how it happened, I found that I had besieged the White House with some 1,400 letters, more than 160,000 words of protest, advice, outrage and resistance.

I didn't think for a minute that the president would read even one of my letters, let alone take them to heart. Does that mean it was all a waste of time? What was the point?

Looking back, I realize that I wasn't holding the president accountable; I was holding *myself* accountable.

Every day, I forced myself to not look away. Even when the news emerging from the White House was discouraging, distressing or just plain loony. I felt compelled to dig deeper, to learn more about our nation's affairs and history. (I'm sure I'm not the only one surprised to find an interest in the Foreign Emoluments Clause.) As I stuffed each day's missive into a No. 10 envelope, I would ask myself, can I help fix this? Should I call Congress? Donate to a charity? Write a letter to the editor? Encourage friends to get involved? More days than not, I chose to do something, even if it was a single phone call to Ohio Republican Senator Rob Portman's office.

Although I didn't launch a national movement, I can look myself in the mirror and know that I didn't remain silent. I spoke up. I recognized bad things for what they are and called them by name: Racism, corruption, cruelty, authoritarianism.

During the past four years, I have been shaken by the fragility of our norms and institutions, alarmed by white supremacy's ascendency and troubled by the polarization of our society. The 2020 election results (which are not final as I write this) reveal that more than 70 million voters don't think 45's bigotry, misogyny, malfeasance and lies are deal breakers. That so many people are actively in favor of four more years of his malignancy, or found reasons to overlook it, is very troubling.

Yet, Joe Biden and Kamala Harris won! This is not only a repudiation of the chaos of the last four years, it is an affirmative vote for

competence, decency and inclusion. We cannot reach our full potential when women and minorities are denied a seat at the table; the election of Harris to the vice presidency is not only a victory for Black women and Asian American women, it is a cause for celebration for us all.

Our nation doesn't magically change when we elect new leaders. No matter who is in the White House, it is our duty to ensure that elected officials are answerable to "We the people."

The challenges we face are too great and numerous to list here. There's a lot of healing and work to be done. Let's tackle it together.

Don't be afraid to speak truth to power. Your voice matters. How will you use it?

ACKNOWLEDGEMENTS

Without the tireless efforts of thousands of journalists, I would not have had the information necessary to write my letters. I am grateful to them for holding our government officials accountable every day.

Thank you, Andrea Simakis, for telling my story in the *Cleveland Plain Dealer*.

Many dear friends, colleagues, fellow church members and members of Unite Against Hate have supported me throughout this project with countless kind words, favors and cups of coffee. Thank you so much — you know who you are.

Lisa Sarkis and Bob Pope, thank you for early reads, last-minute advice and telling me to go for it.

Thanks to Robert Martin and the team at City Limits Publishing for taking this leap with me and handling the thousand details that have turned my dream into a reality.

I am grateful to my entire family for their bottomless love and encouragement. Ruth and Will, thank you for being the best teachers I have ever had. Chris, without you beside me, I would have given up; thank you for telling me to keep going when I thought I couldn't.

Last, but not least, thank you, Sheri Gregg, for being the first person to say: "This should be a book!"

© Chris Hayes

About the Author

Kathy Hayes has spent more than 15 years working in business-to-business publishing and has been featured in the Akron Beacon Journal and the Cleveland Plain Dealer for her activism and letters to the White House. In addition to her presidential correspondence, she frequently writes letters, postcards and thank-you notes to other elected officials, political appointees and public figures.

Her civically engaged family and a childhood full of lively, dinner-table discussions about politics and current events are the foundation for her stubborn quest to hold the president accountable.

Some of her fondest memories include seeing orcas and moose in the wild, and getting to sit in the copilot's seat on the Goodyear blimp. Kathy has two grown children and lives in Ohio with her husband, a boisterous dog, two cats and an unreasonably large number of books she hopes to read someday. This is her first book.

CPSIA information can be obtained
at www.ICGtesting.com
Printed in the USA
LVHW092118020321
679376LV00034B/445/J

9 780998 76265